365 DAYS of

UNICORNS

HOW TO DRAW UNICORNS AND FRIENDS EVERY DAY OF THE YEAR

EASY STEP-BY-STEP DRAWING

CLÉMENTINE DERODIT

DAVID & CHARLES

www.davidandcharles.com

Welcome to the wonderful world of unicorns and their friends!

In this book, you will find a huge range of drawings!
To help you navigate, you'll find a symbol at the top of each page to indicate the theme.

 Discover an endless array of different unicorns!

Explore kawaii objects, buildings, food and scenery from the unicorns' magical land!

 Meet all of the unicorns' cute and funny friends!

Communicate with the unicorns through funny letters and pretty designs – they even have their own emoticons!

The secrets of kawaii drawing

Use a pencil to create your drawings. Some lines will need to be erased.

 1 Use simple shapes (shown in blue) to start your drawing.

 2 Continue by adding details bit by bit. These appear in red at each step so that you can easily spot them.

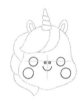 **3** Use the blue marks to guide you when drawing the facial details.

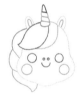 **4** Go over the outlines with markers. Use lots of colours – it's more fun! Erase the construction lines when the ink is dry to prevent it bleeding.

 5 Colour with markers or coloured pencils and add small patterns around your drawing. Wow!

Which colours to choose?

Unicorns ride rainbows!
Bright or pastel – which range do you prefer?

You can also use metallic or glitter gel pens to make your unicorns and all your other cute drawings shine!

Cute Unicorn

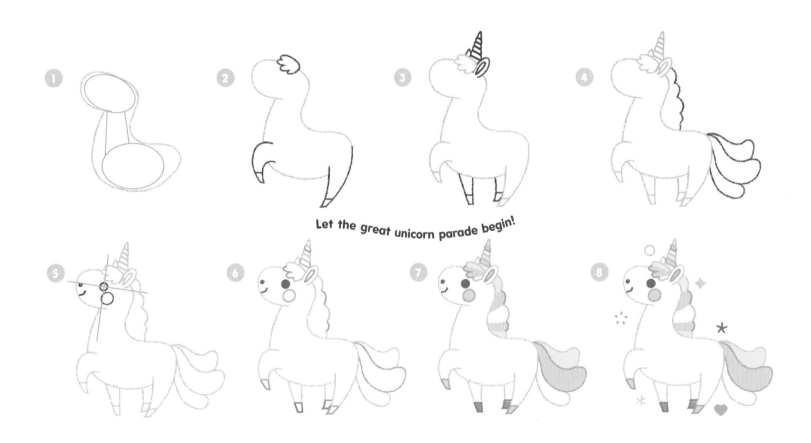

Let the great unicorn parade begin!

Winged Unicorn

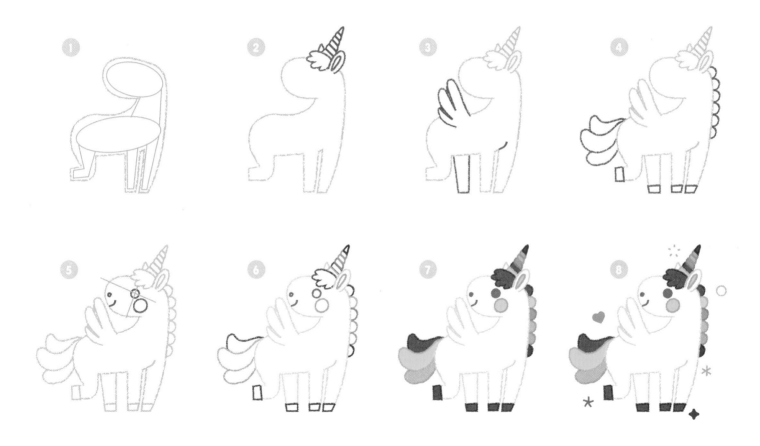

Sitting Unicorn

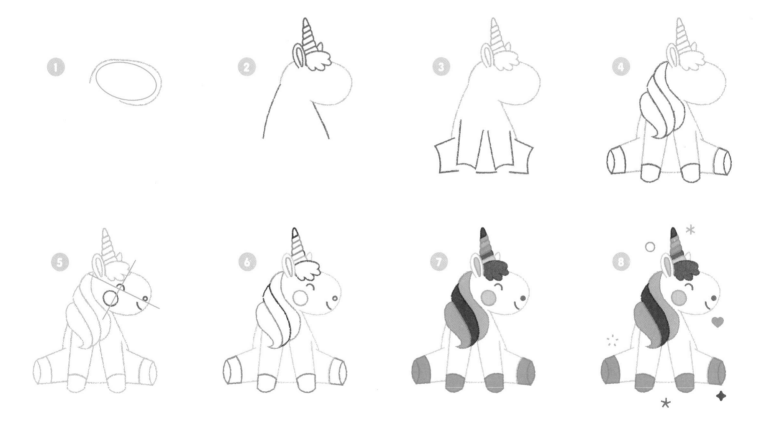

Rearing Unicorn

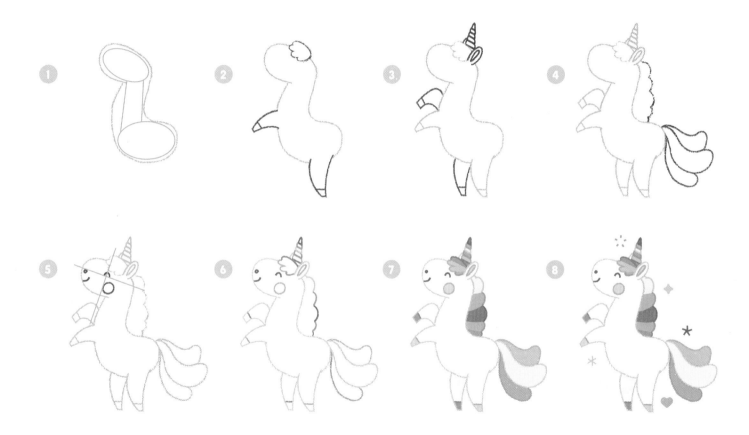

Flamboyant Unicorn

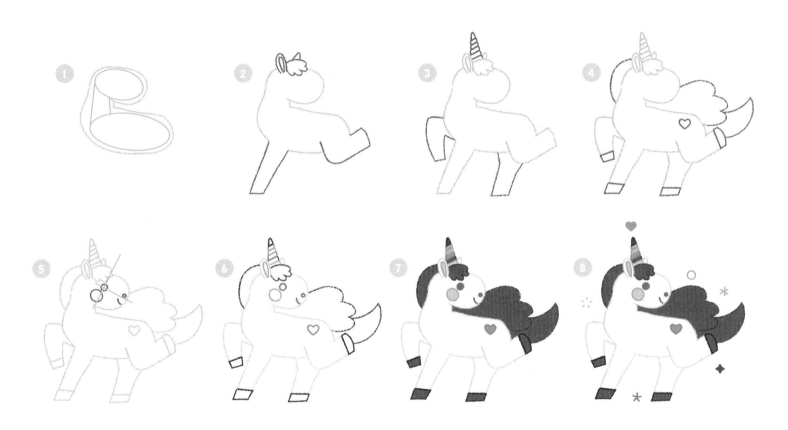

Celestial Unicorn

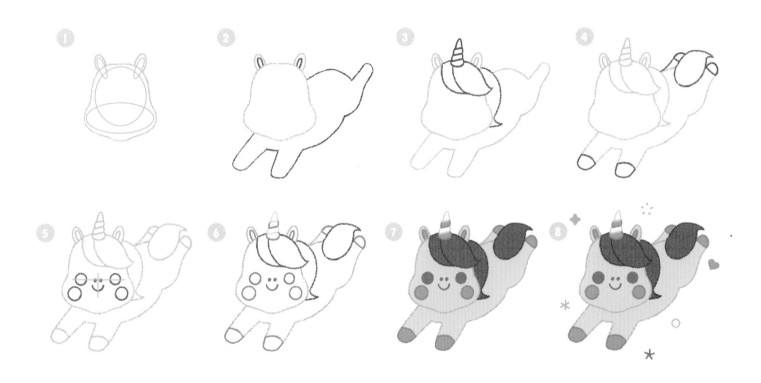

Romantic Unicorn

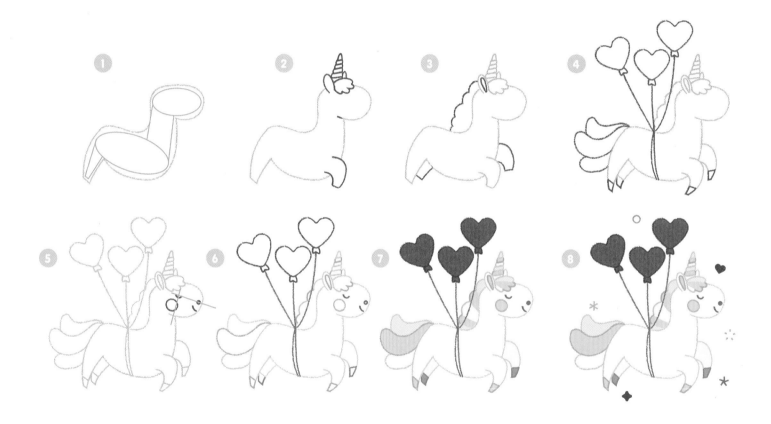

Floating Unicorn

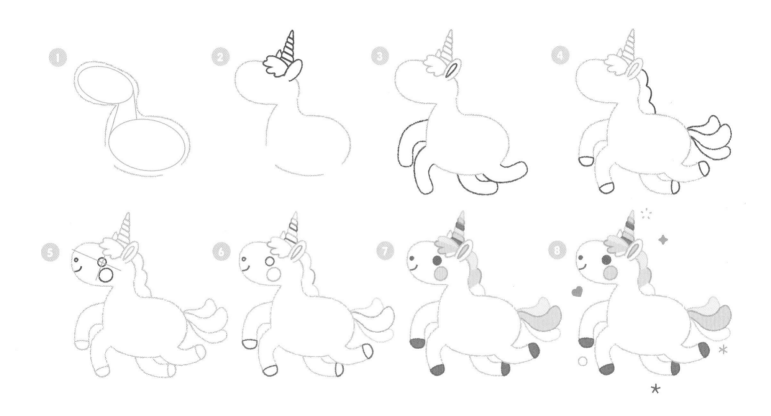

Loving Unicorn

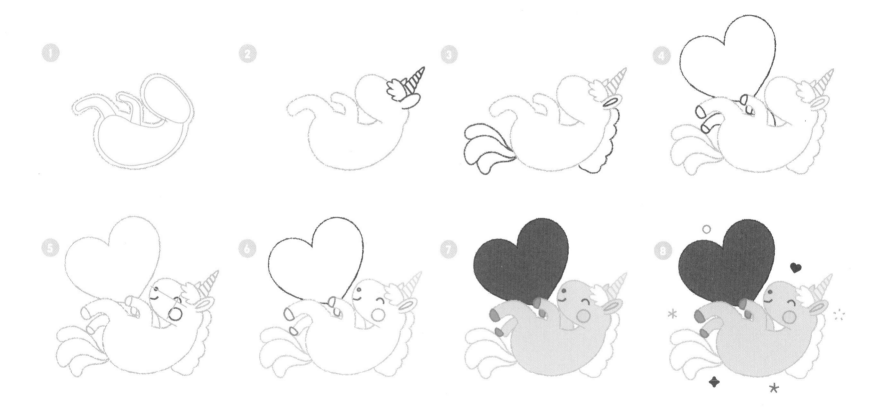

Cupid Unicorn

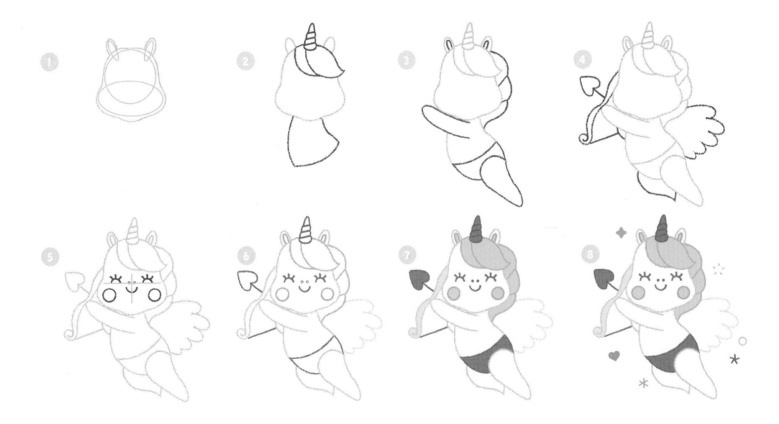

Meditating Unicorn

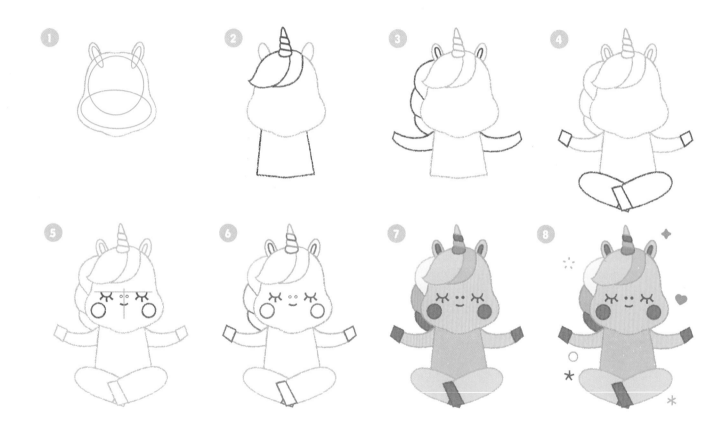

Thoughtful Unicorn

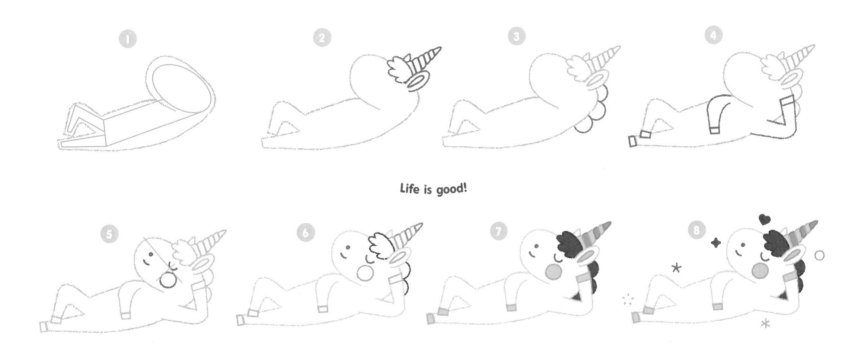

Life is good!

Tired Unicorn

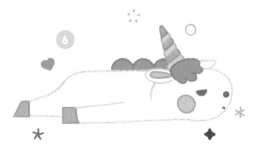

Sleeping Unicorn

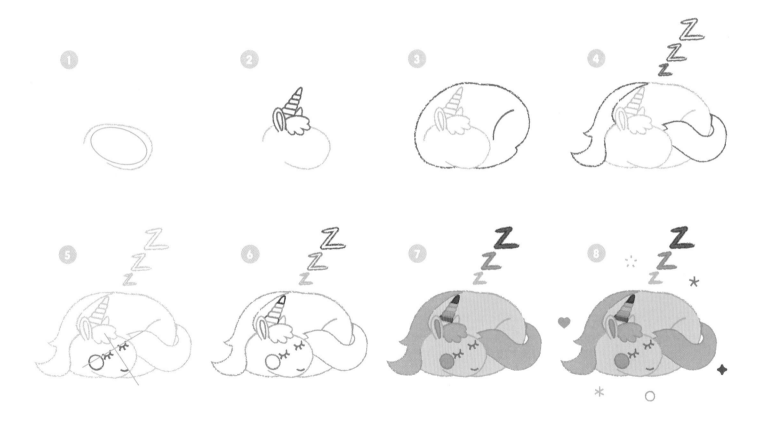

Dreaming Unicorn

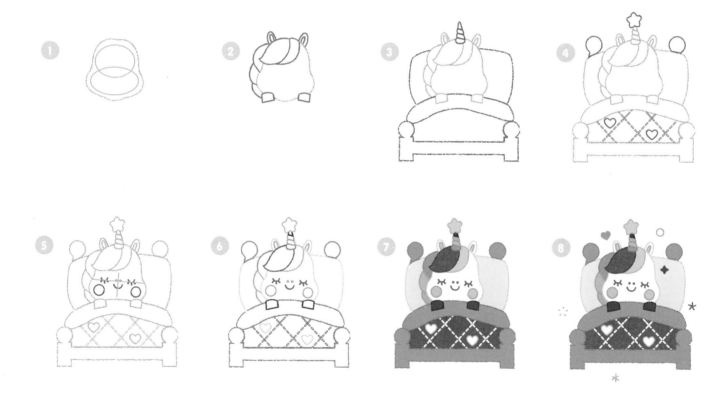

Angel Unicorn

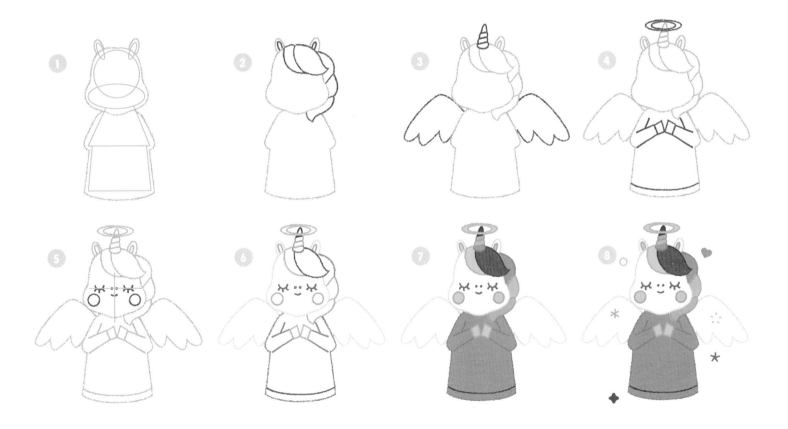

Babushka Unicorn

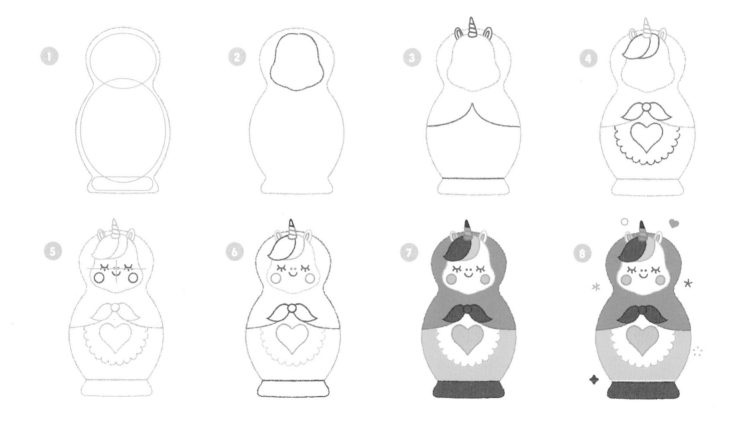

Dala Unicorn

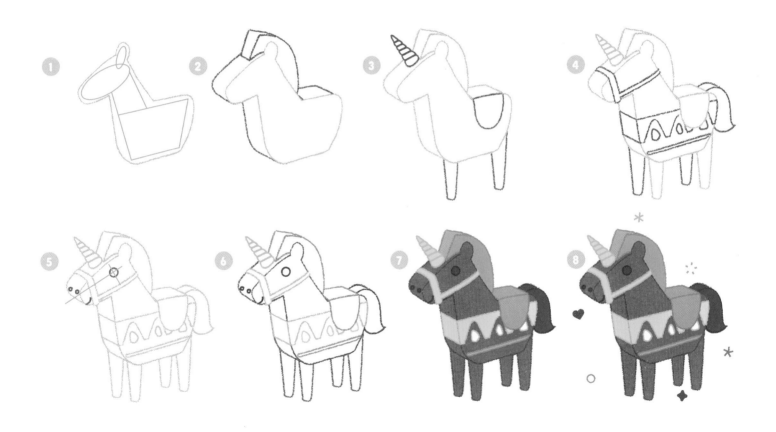

Piñata Unicorn

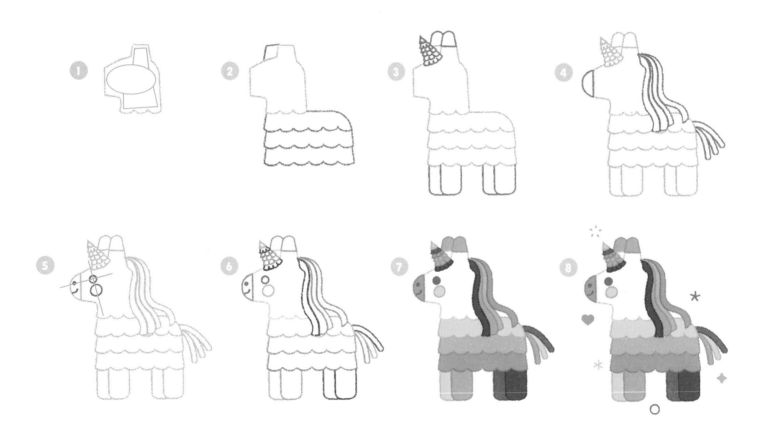

Fairground Unicorn

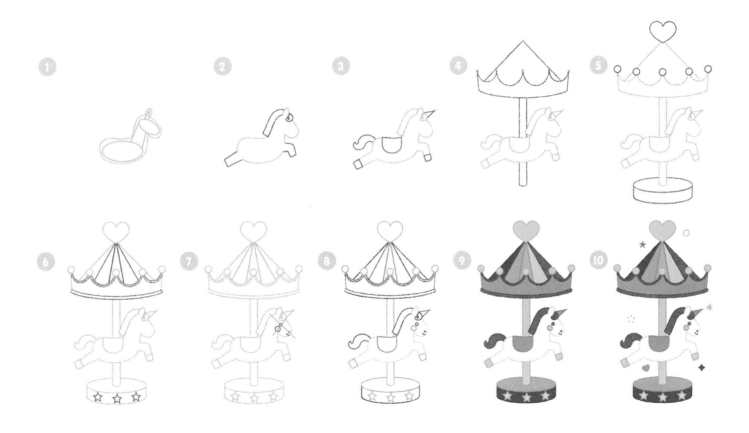

Skipping Unicorn

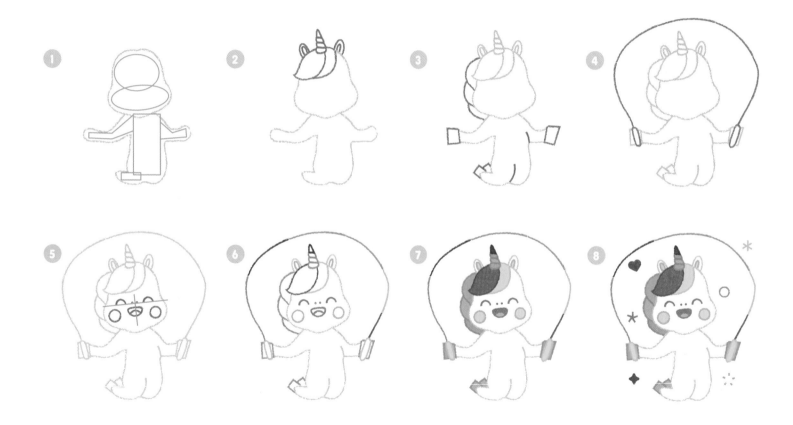

Hula-Hooping Unicorn

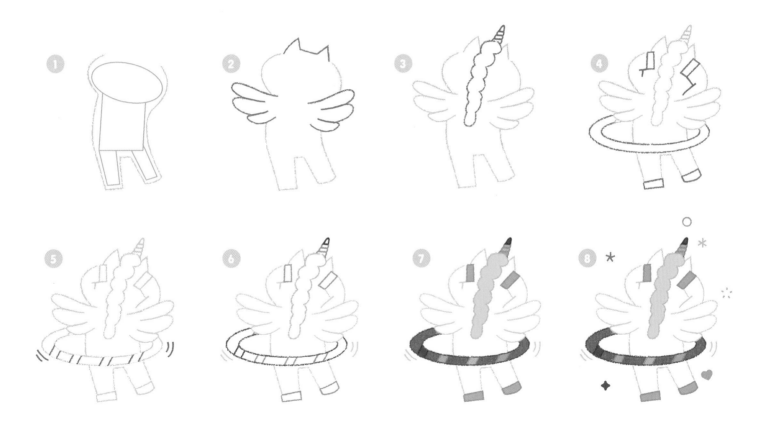

Horse-Riding Unicorn

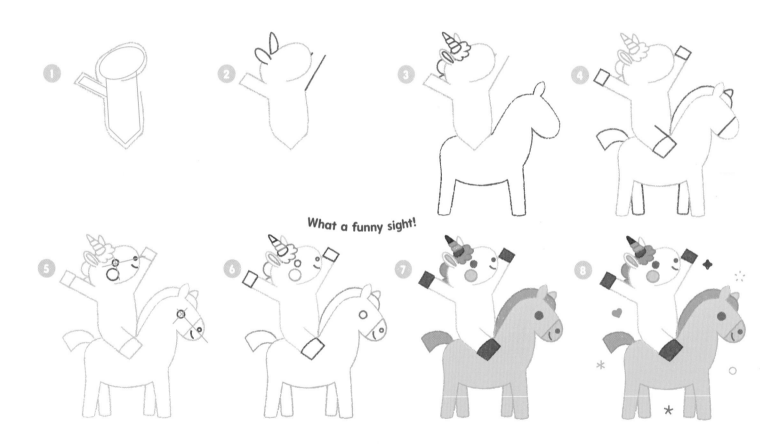

What a funny sight!

Rocking Unicorn

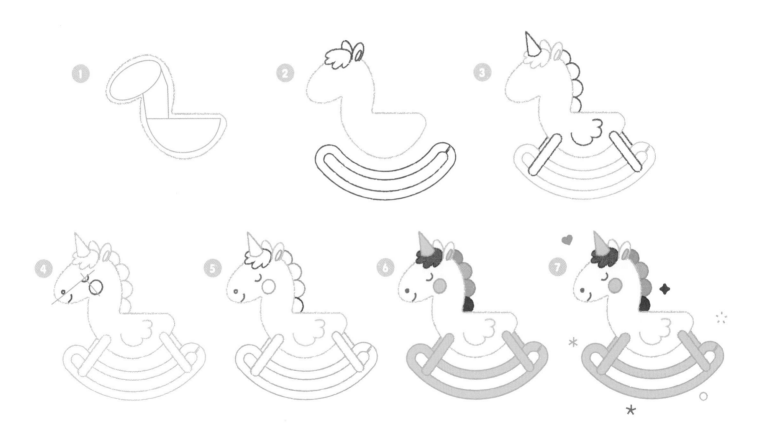

Wobble Unicorn

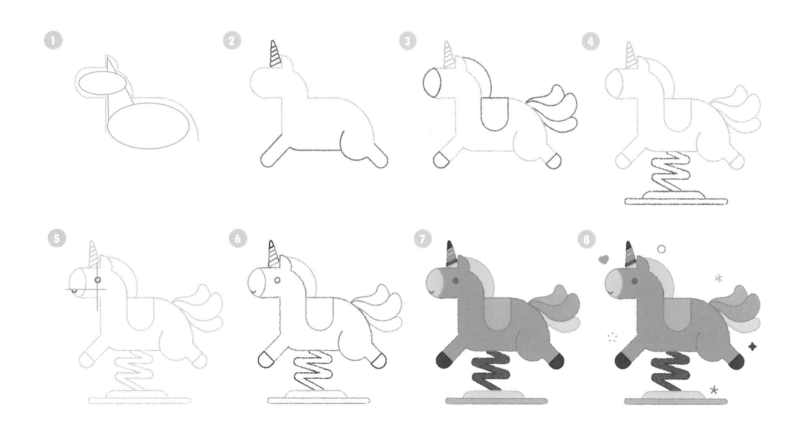

Roller-Skating Unicorn

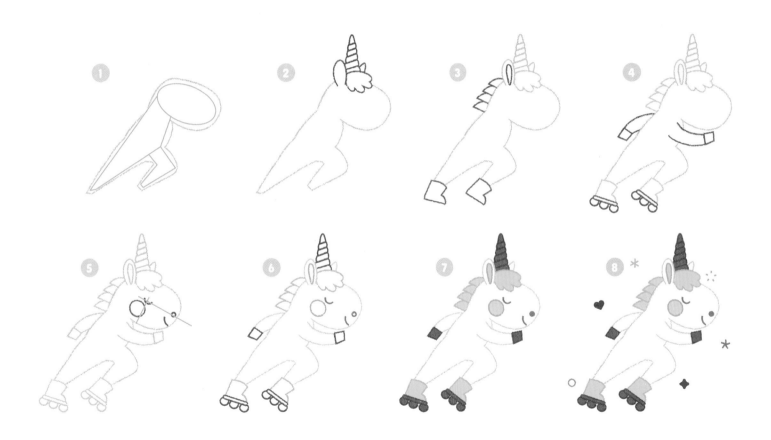

Ice-Skating Unicorn

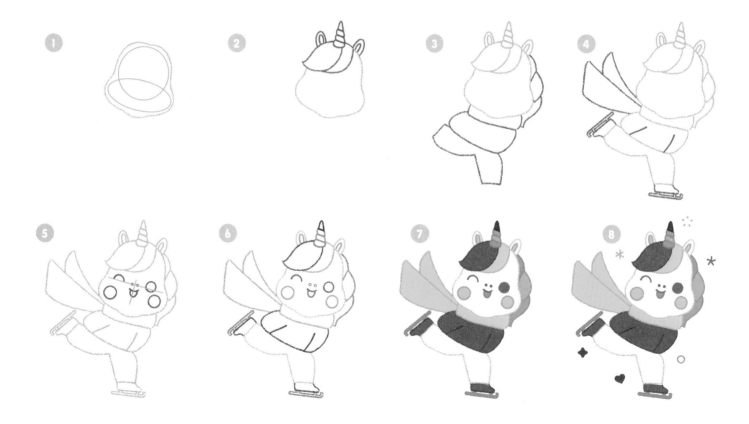

Ice-Dancing Unicorn

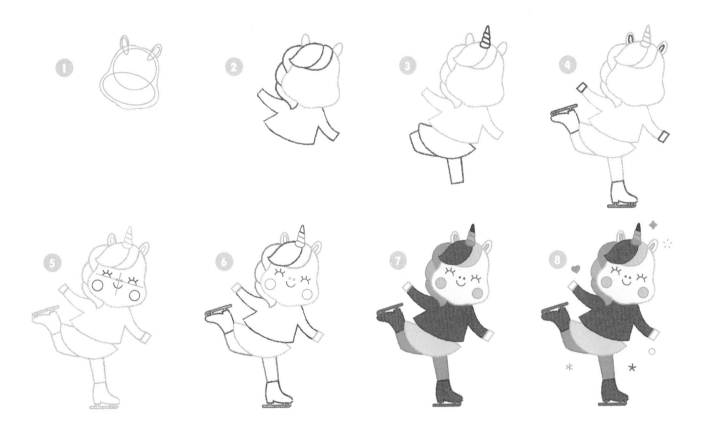

Skateboarding Unicorn

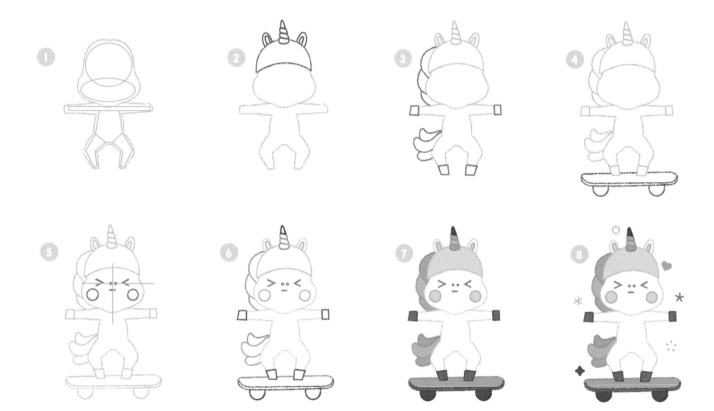

Scooting Unicorn

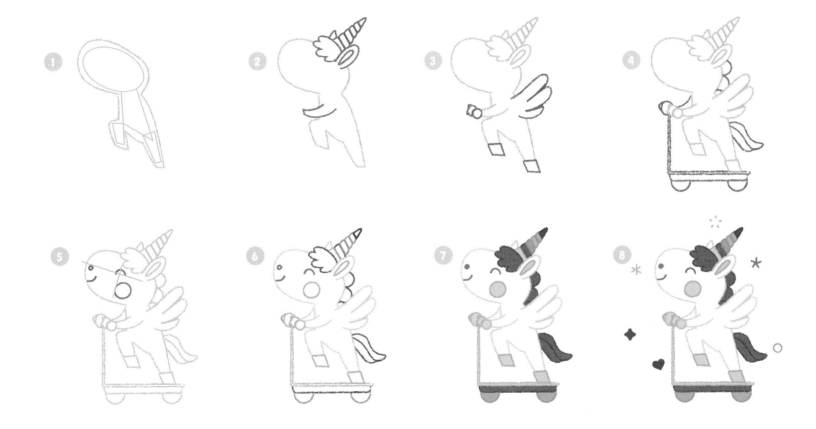

Boxing Unicorn

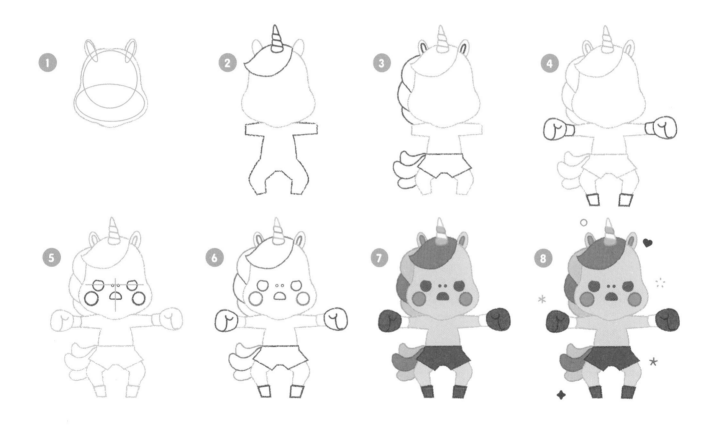

Footballing Unicorn

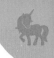

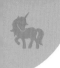

Unicorn in a Plane

Unicorn in a Car

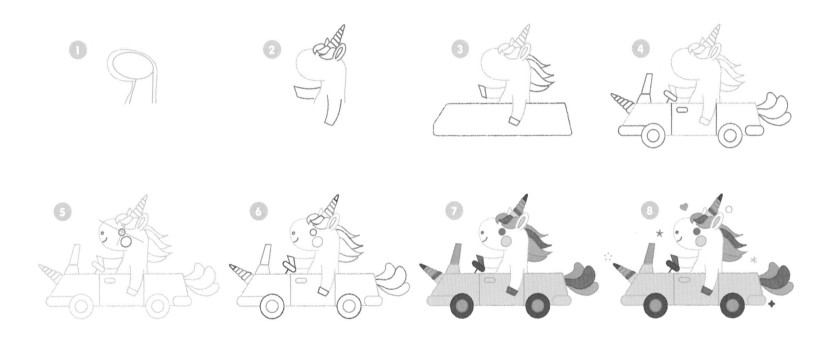

Ballerina Unicorn

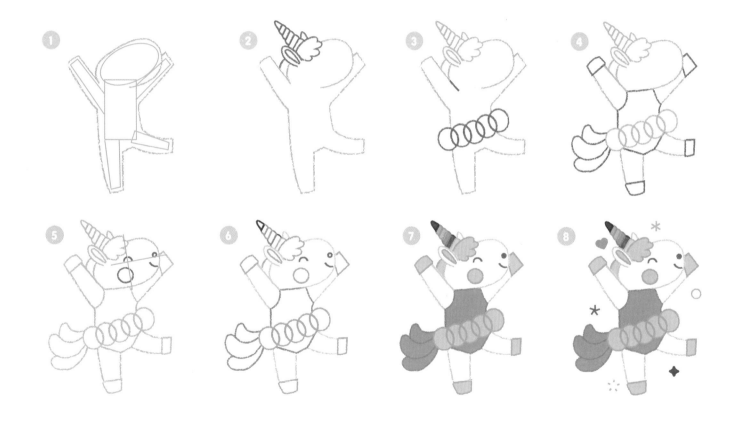

Dancing Unicorn

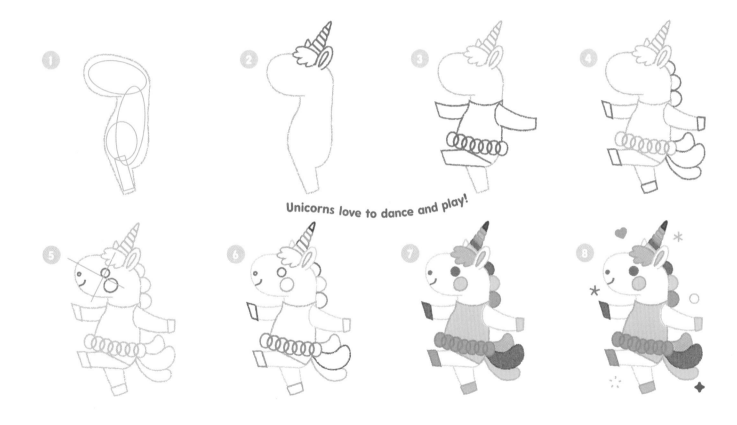

Unicorns love to dance and play!

Breakdancing Unicorn

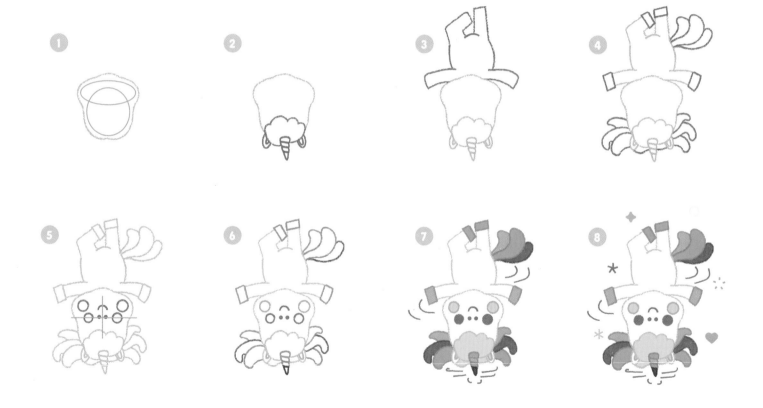

Hula Girl Unicorn

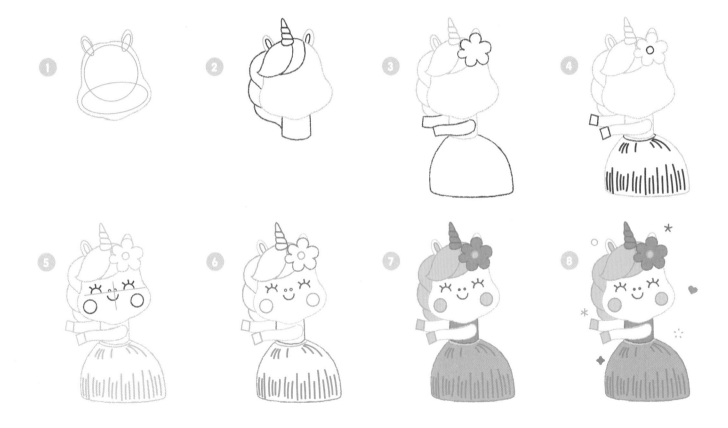

Dabbing Unicorn

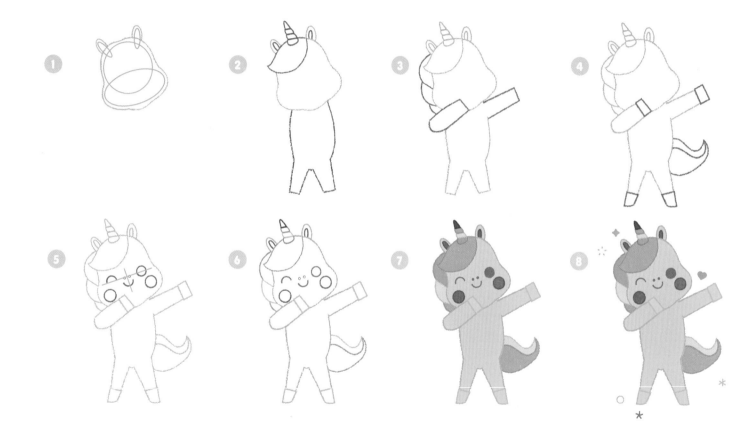

Cheerleading Unicorn

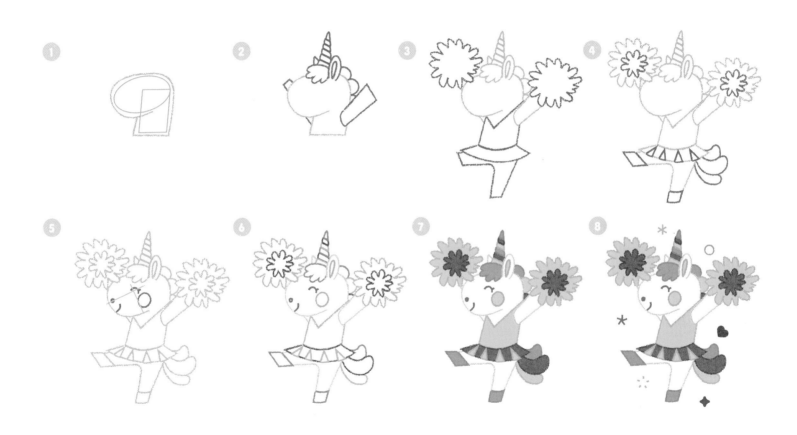

Rockstar Unicorn

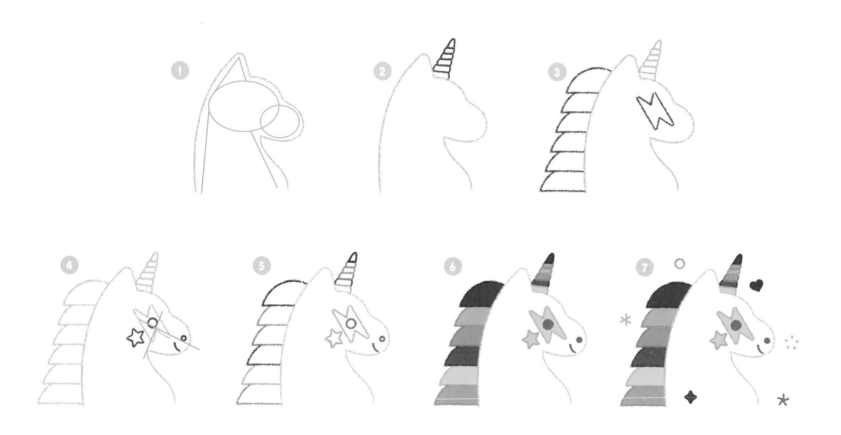

Guitarist Unicorn

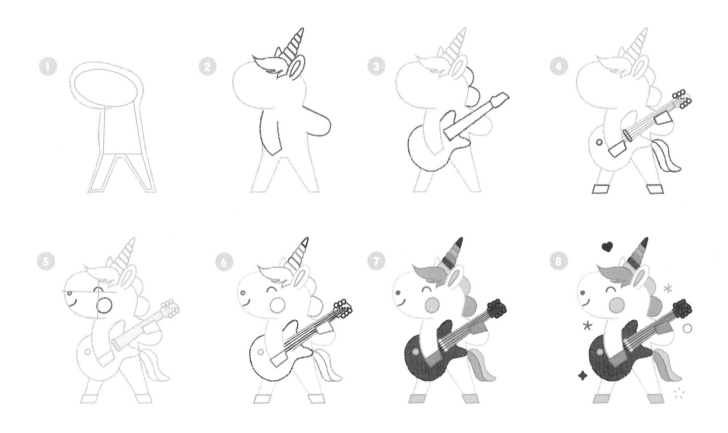

Bling Unicorn

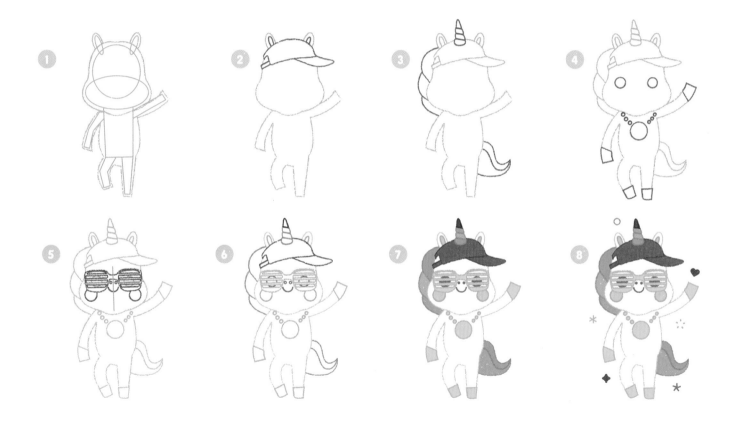

Punk Unicorn

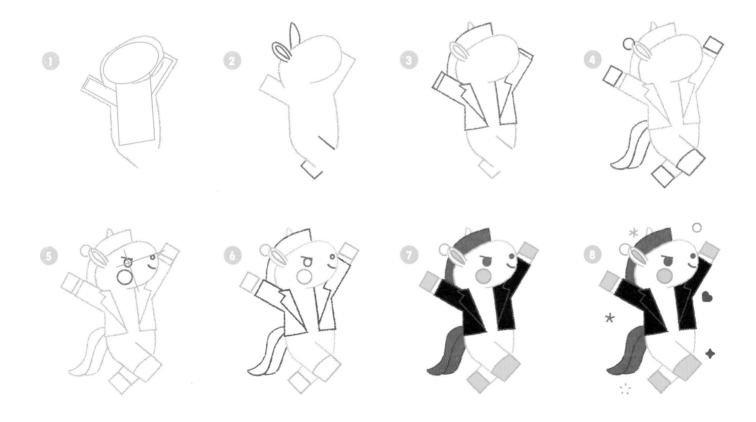

Artist Unicorn

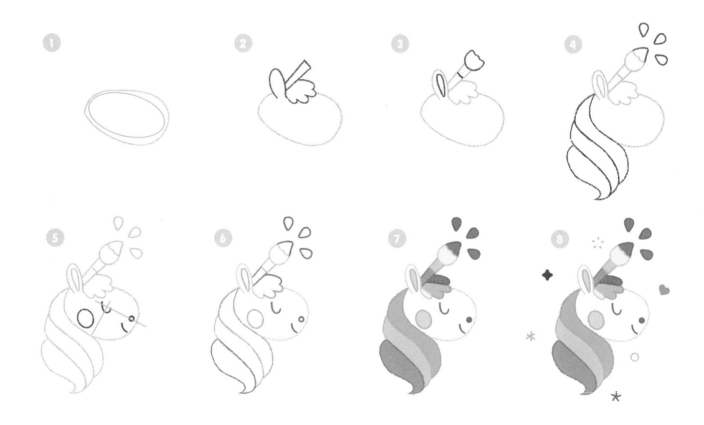

Cartoon Unicorn

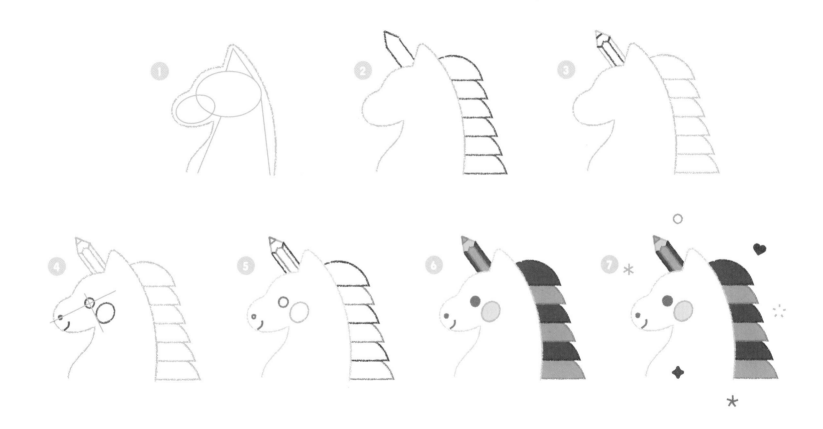

Unicorn of Love

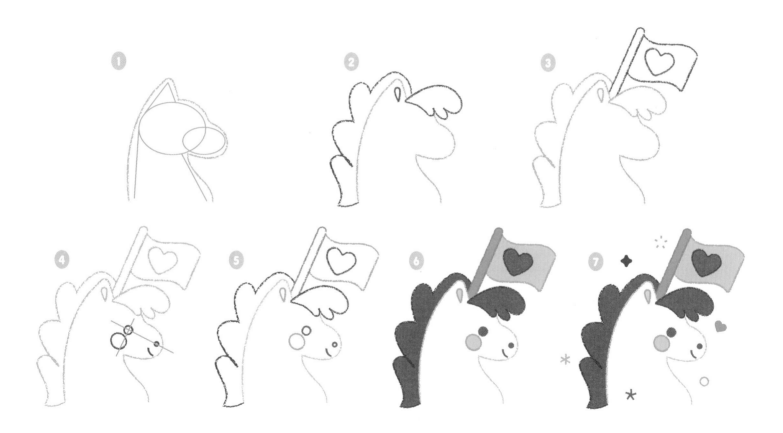

Unicorn on a Cloud

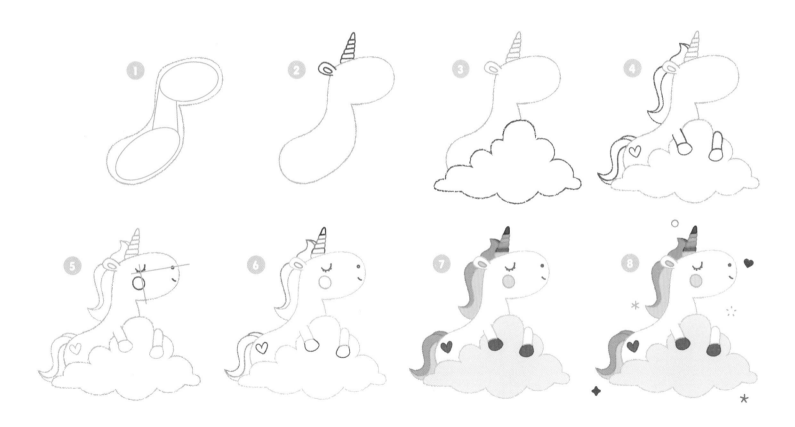

Unicorn in a Hat

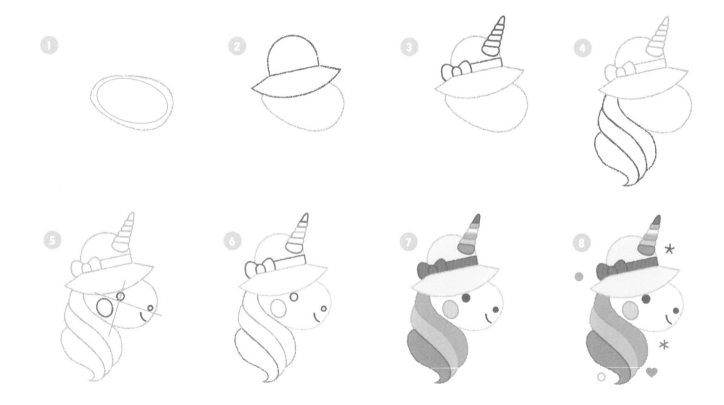

Unicorn in a Helmet

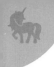

Unicorn with a Bouquet

Flower-Horned Unicorn

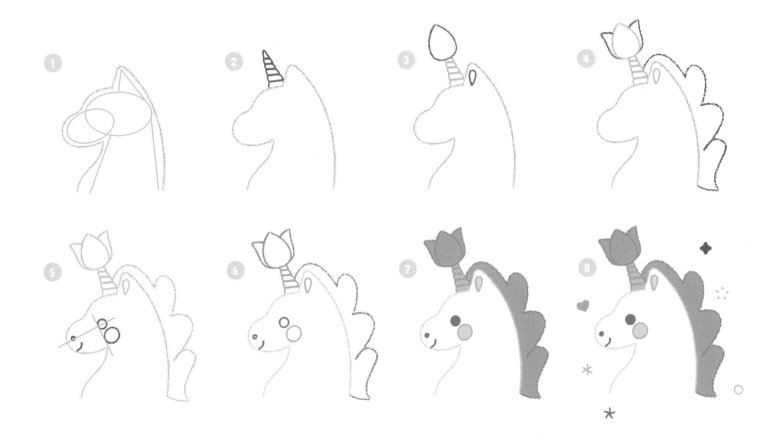

Candle-Horned Unicorn

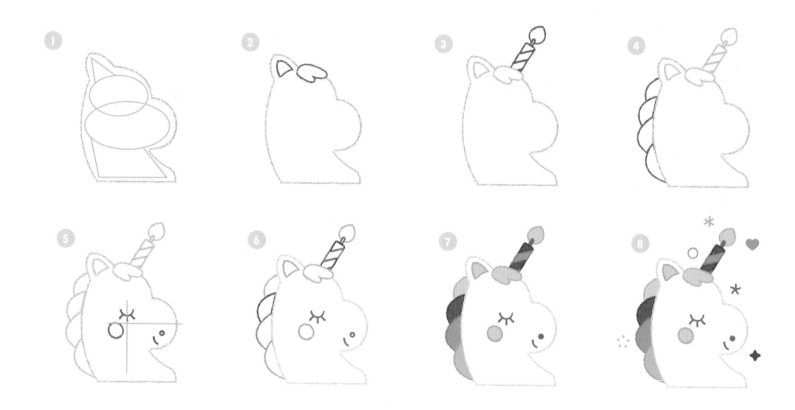

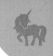

Rainbow-Horned Unicorn

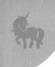

Happy Unicorn

Intrigued Unicorn

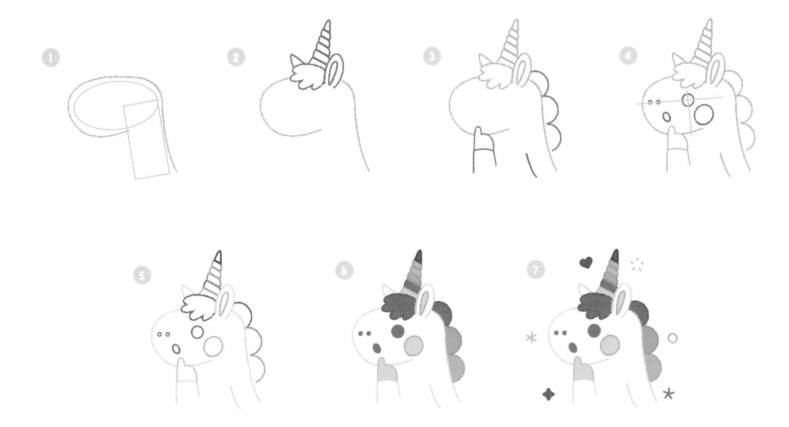

Sad Unicorn

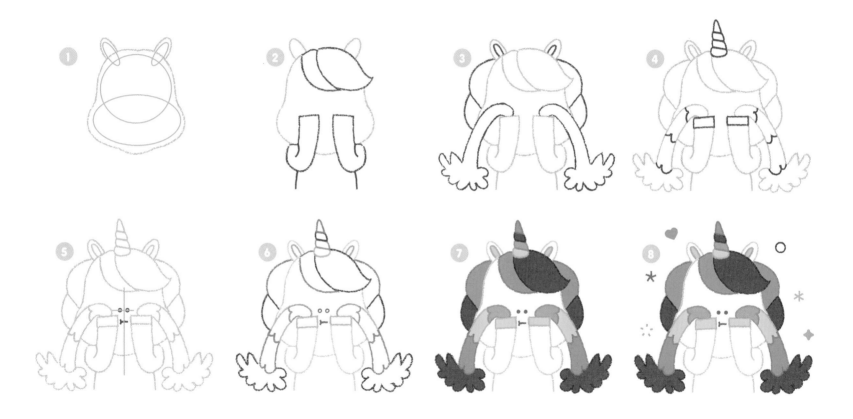

Angry Unicorn

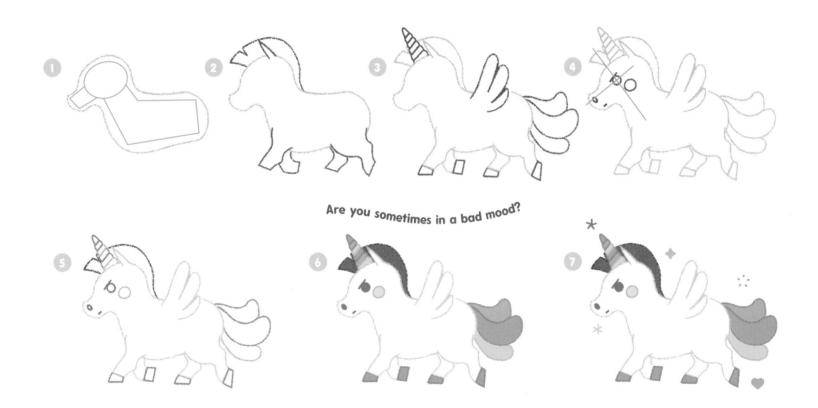

Are you sometimes in a bad mood?

Clown Unicorn

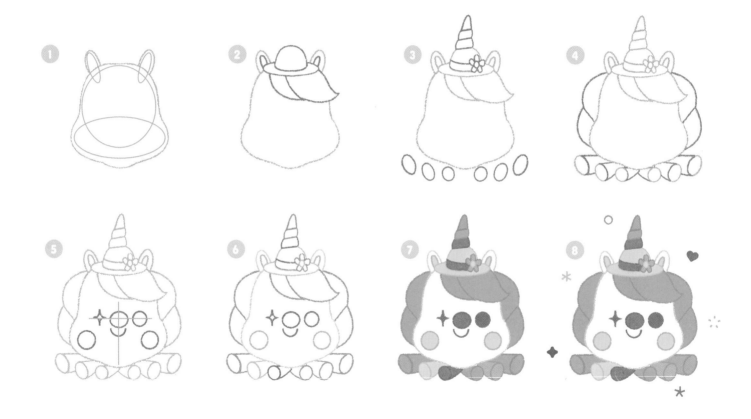

Cowboy Unicorn

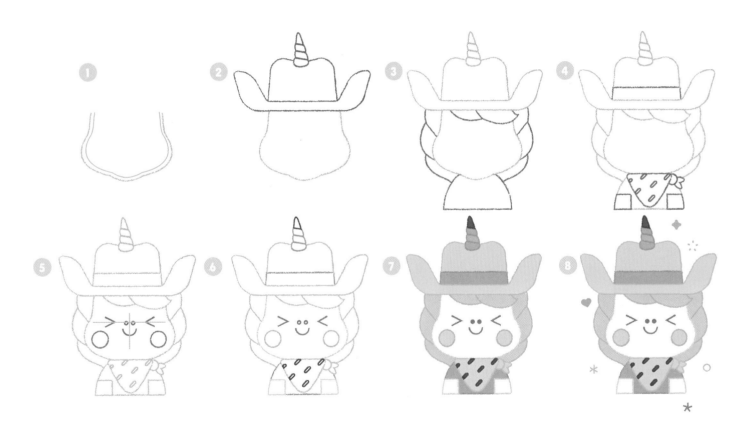

Frida Unicorn

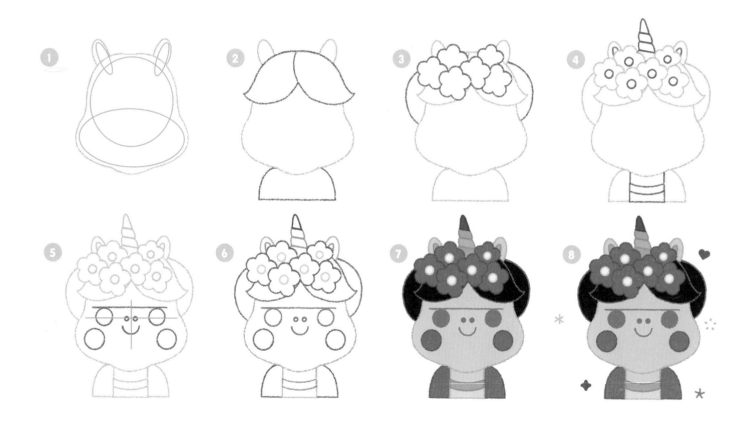

Queen's Guard Unicorn

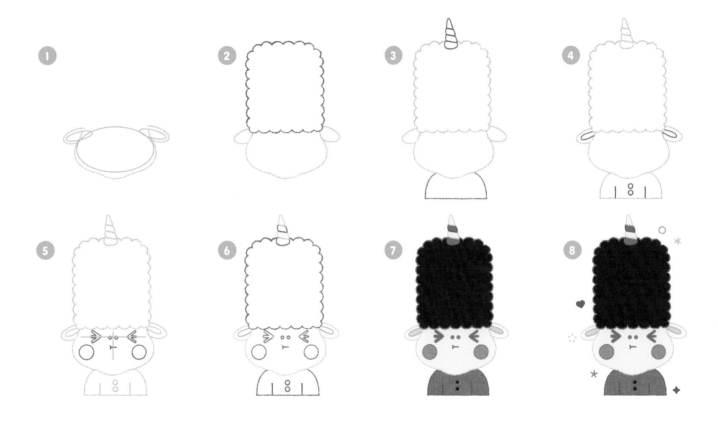

Unicorn in a Beret

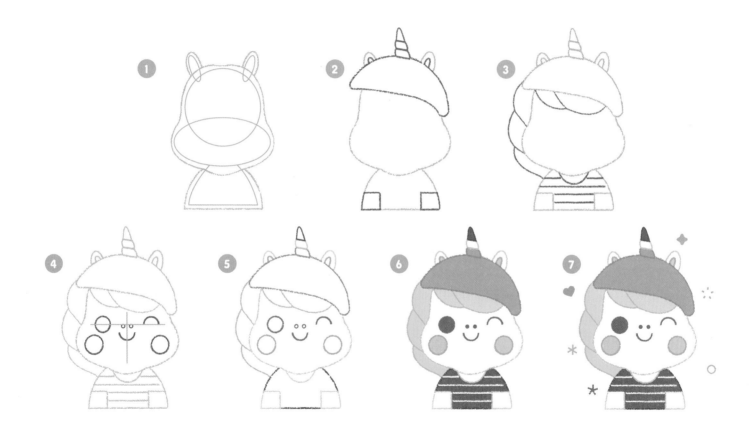

Unicorn on Holiday

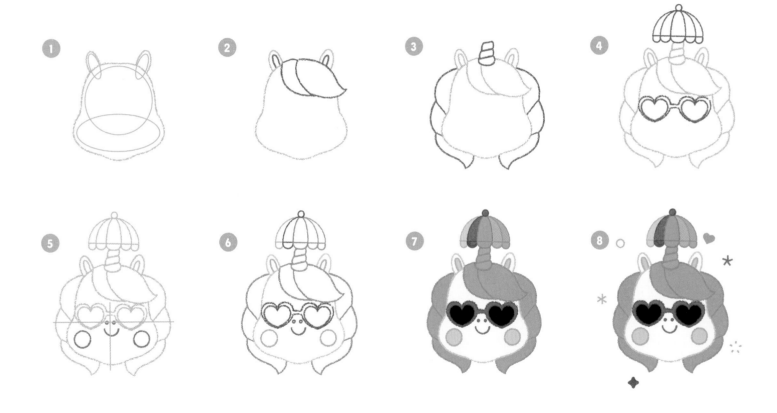

Diving Unicorn

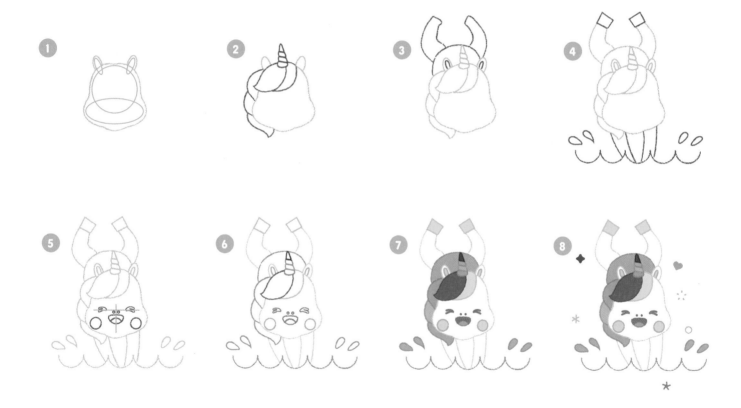

Snorkelling Unicorn

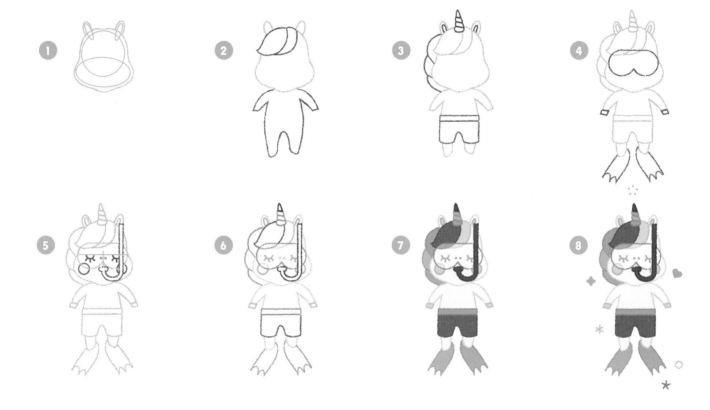

Rainy Day Unicorn

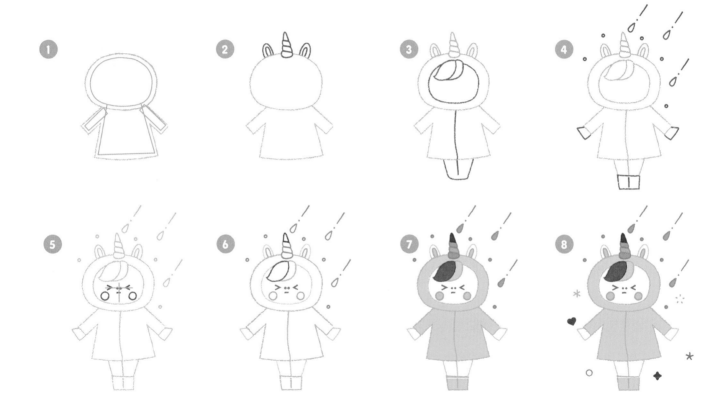

Unicorn in the Bath

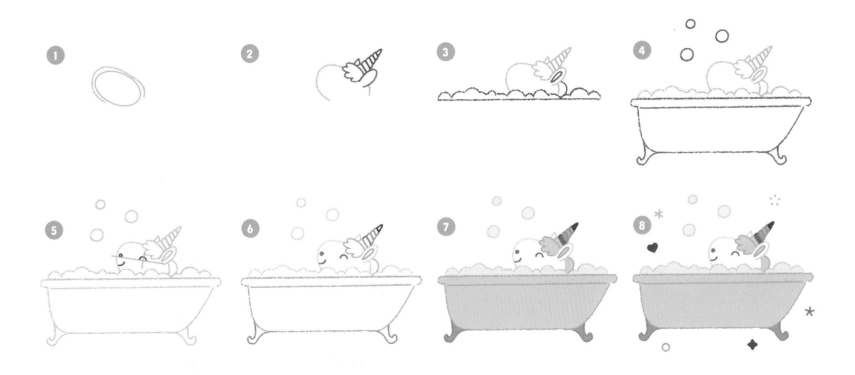

Halloween Unicorn

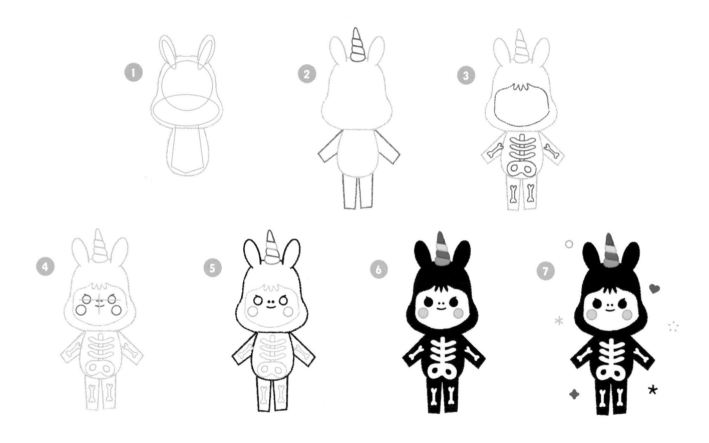

Ghostie Unicorn

Not even scary!

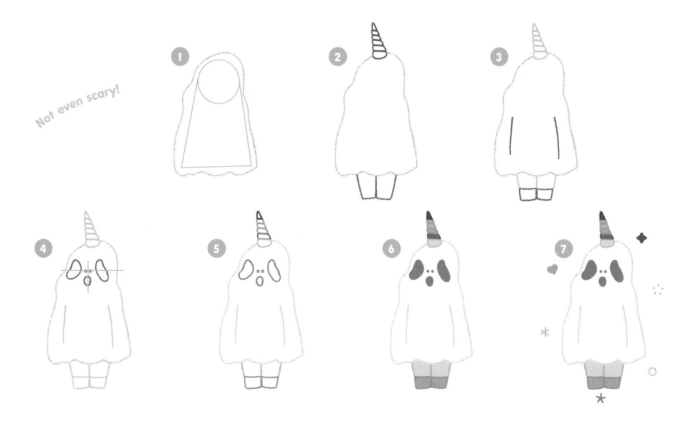

Cinco de Mayo Unicorn

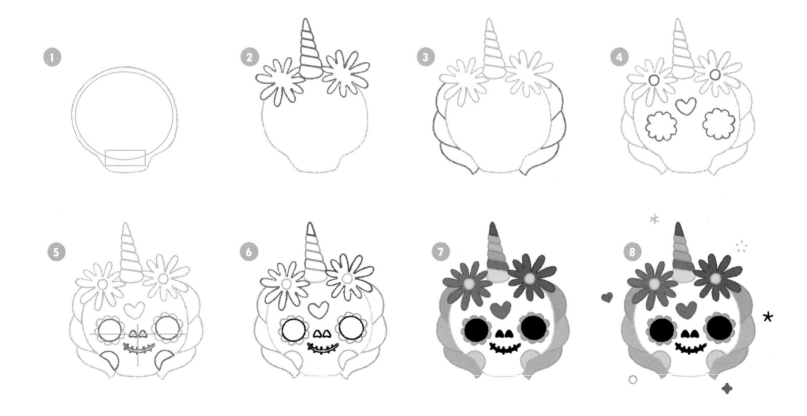

Pumpkin Unicorn

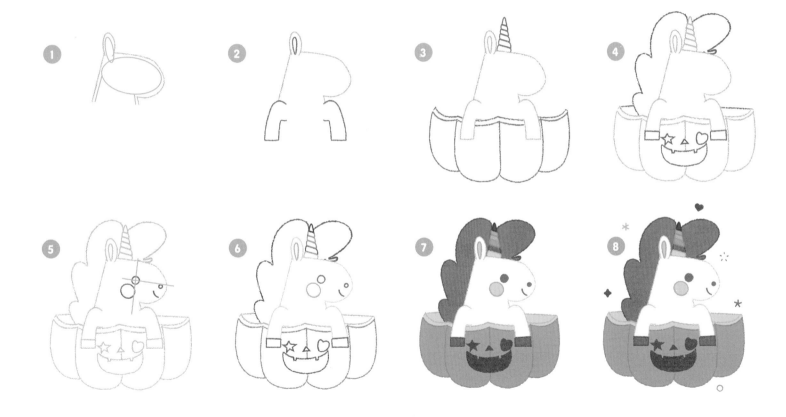

Snowman Unicorn

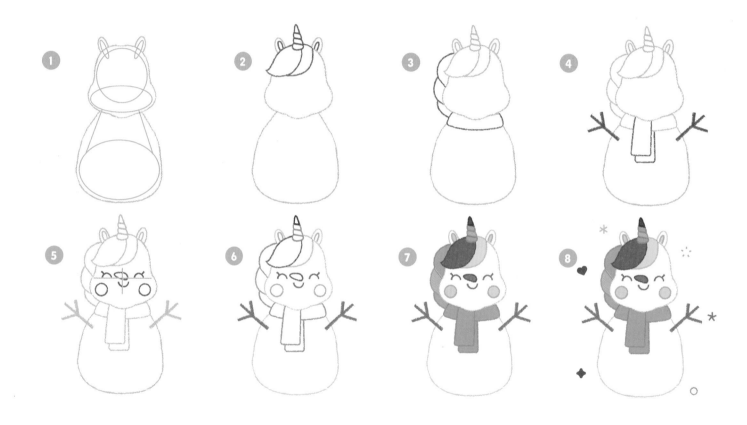

Santa Unicorn

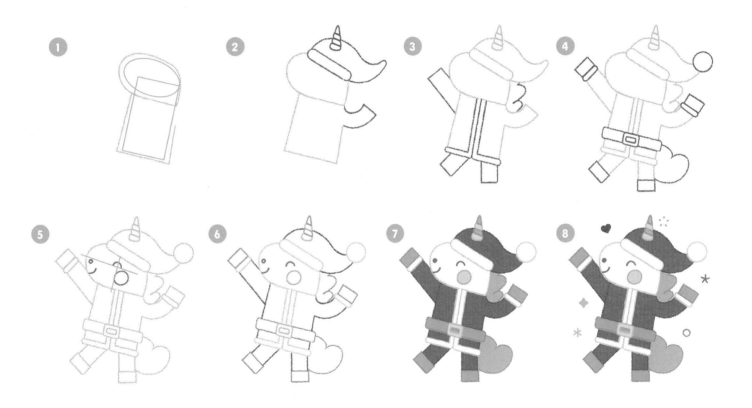

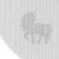

Hobby-Horse Unicorn

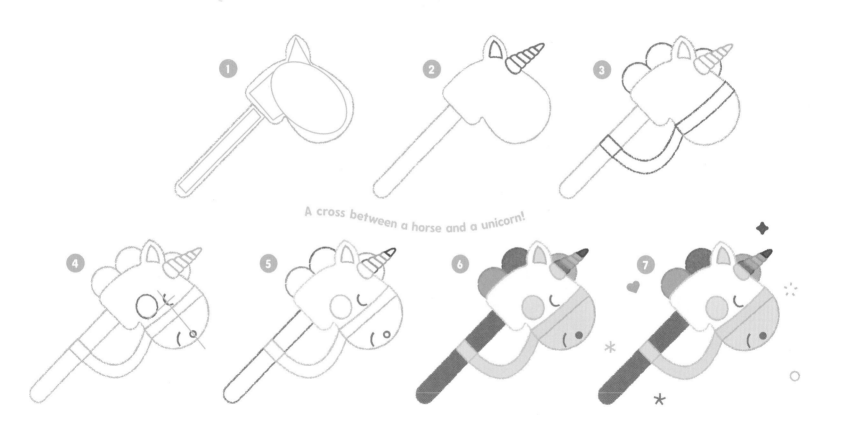

A cross between a horse and a unicorn!

Christmas Unicorn

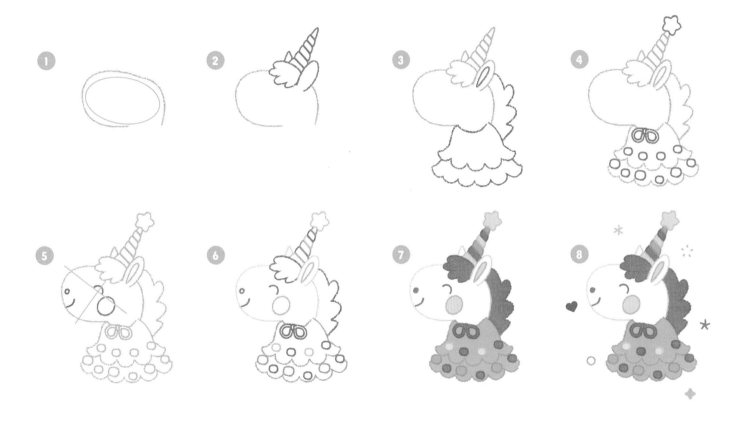

Baker Unicorn

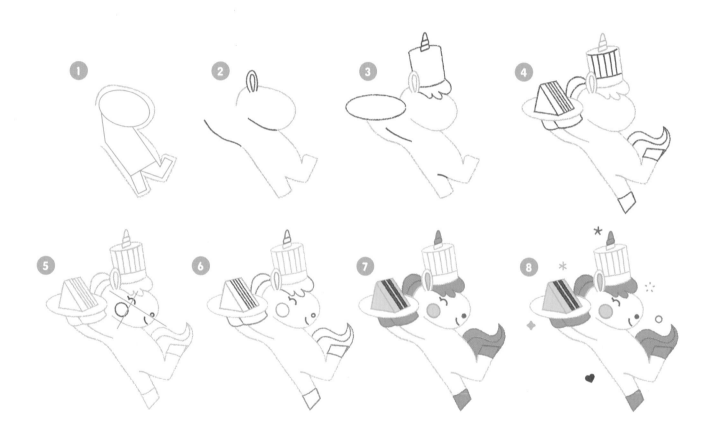

Unicorn Cake

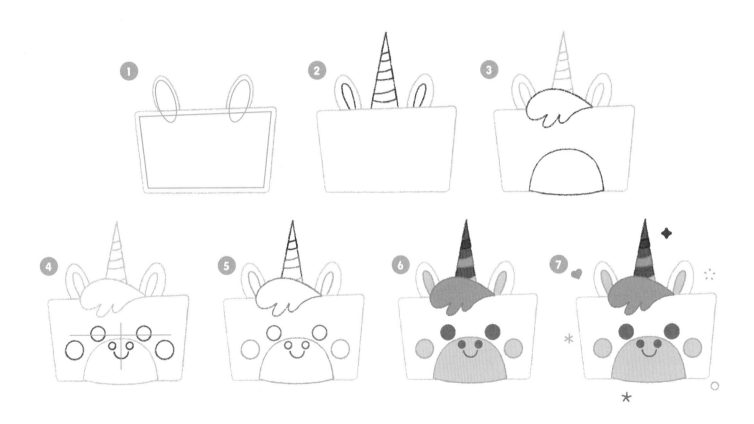

Chess-Piece Unicorn

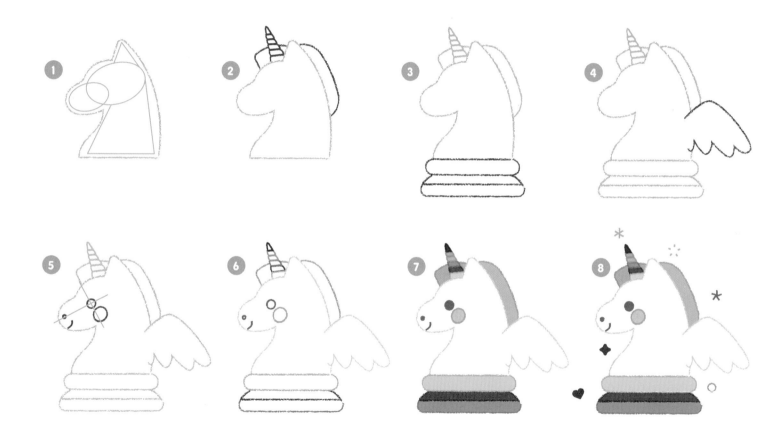

Dinosaur Unicorn

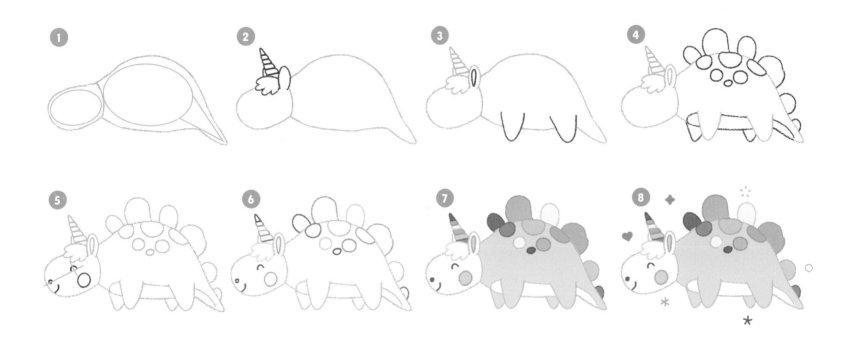

Mermaid Unicorn

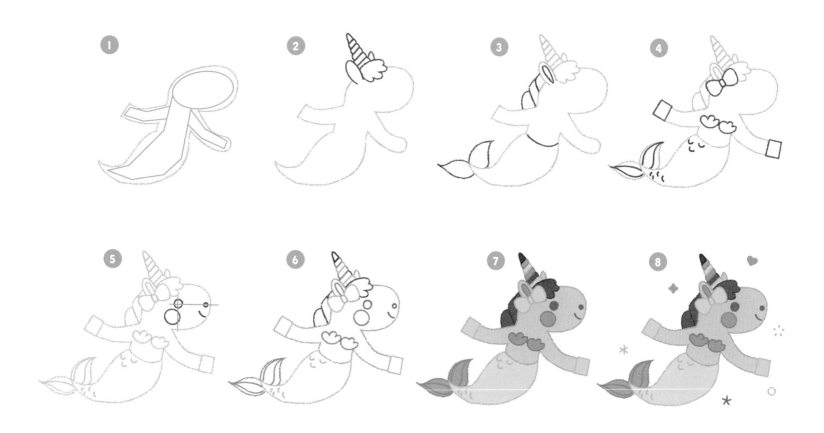

Dragon Unicorn

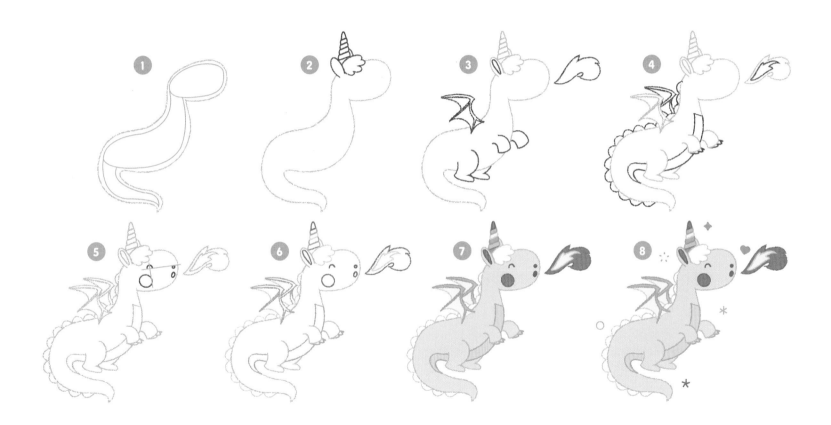

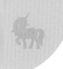

Astronaut Unicorn

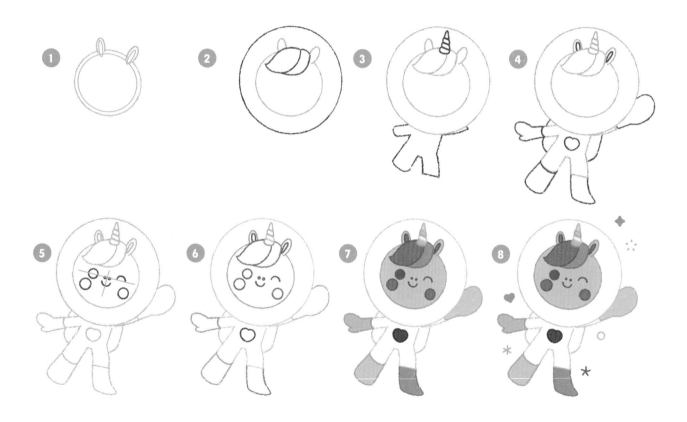

Unicorn UFO

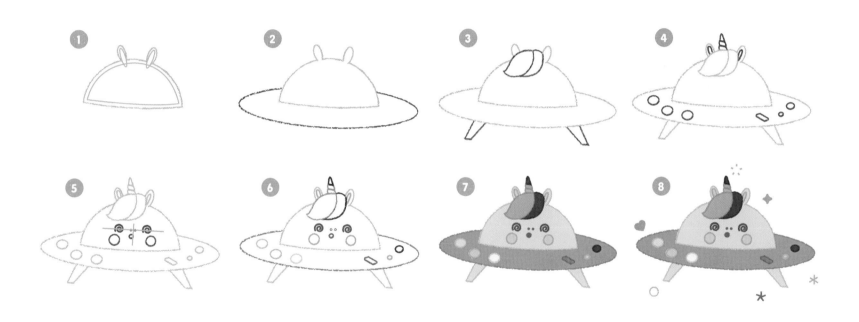

Pixel Unicorn

1

2

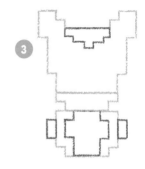

3

4

5

6

7

8

Gaming Unicorn

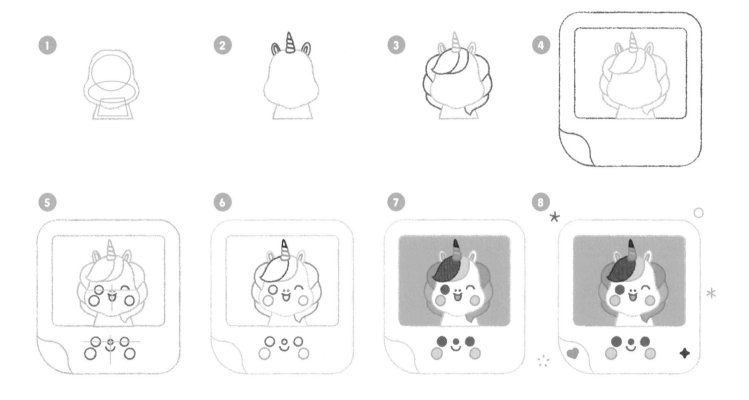

Unicorn Selfie

I love taking pictures of myself!

Reading Unicorn

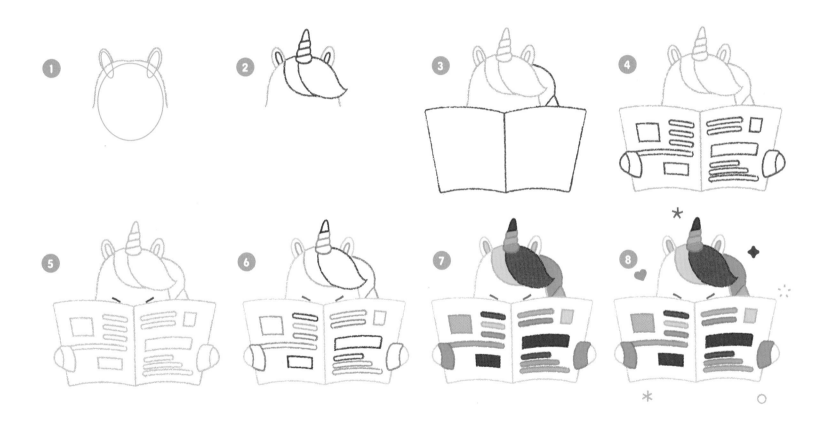

Party Unicorn

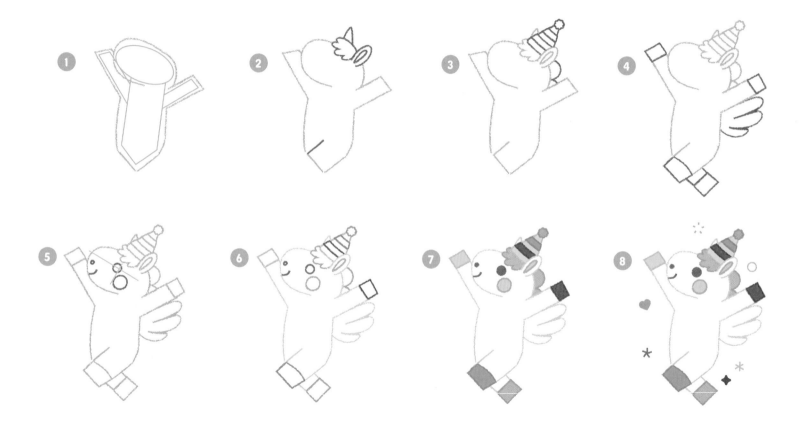

Kimono Unicorn

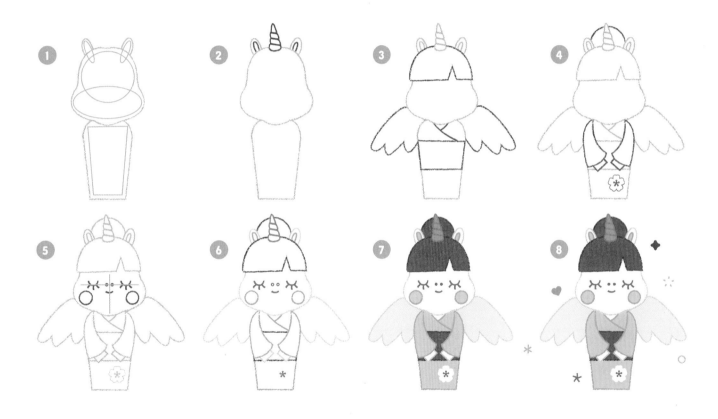

Baby Unicorn

 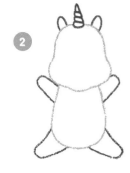 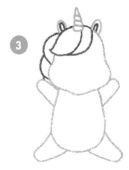 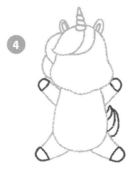

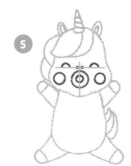 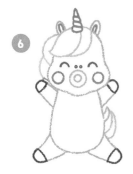 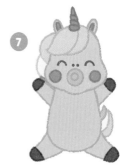 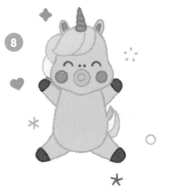

Unicorn Twins

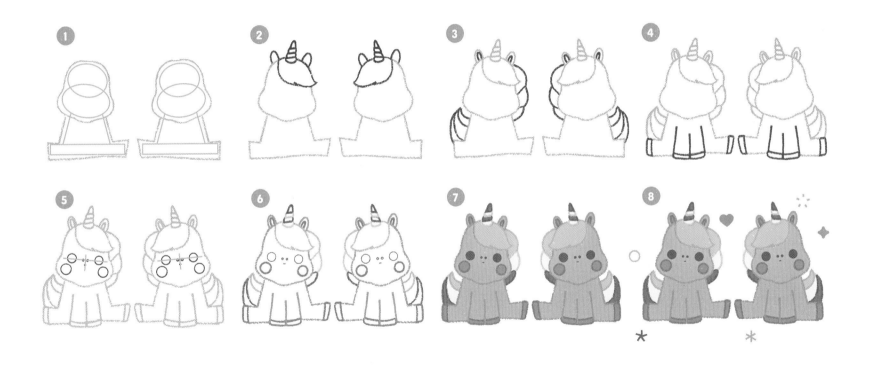

Windy Unicorn

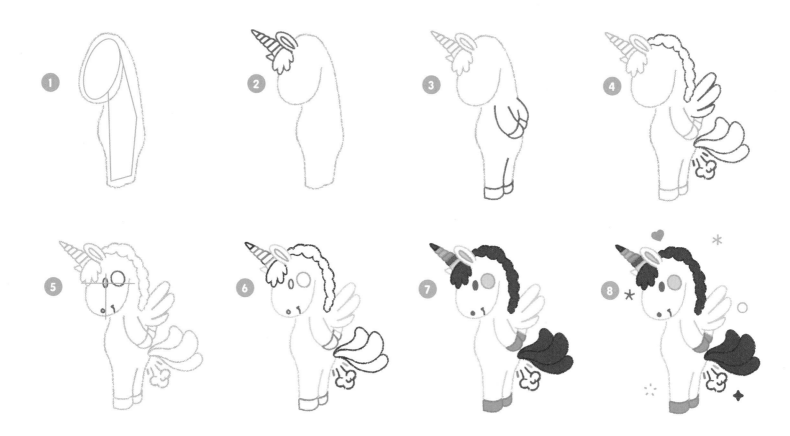

Unicorn Poop

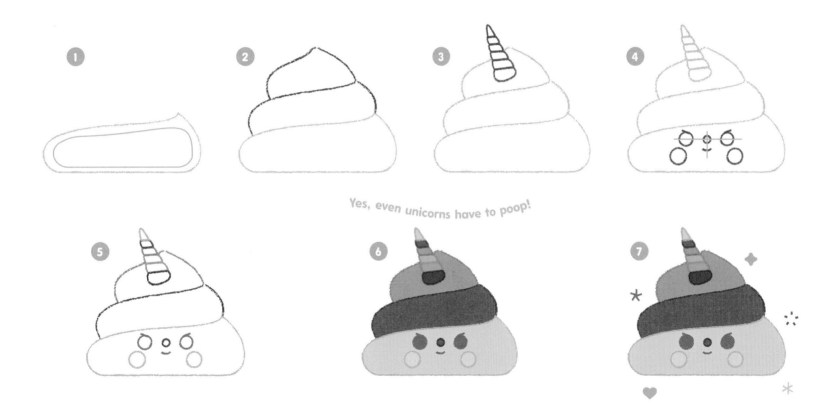

Yes, even unicorns have to poop!

Candy House

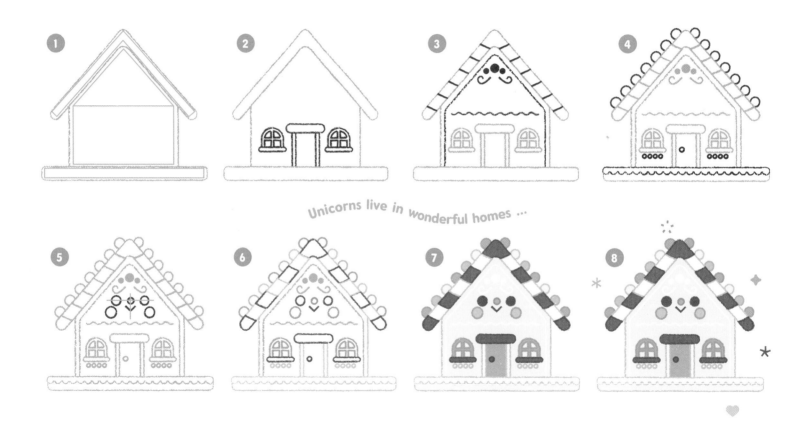

Unicorns live in wonderful homes ...

Gingerbread House

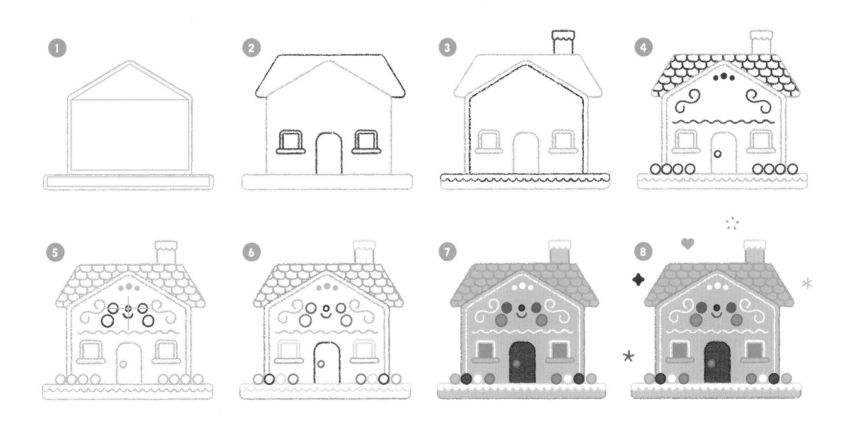

Windmill

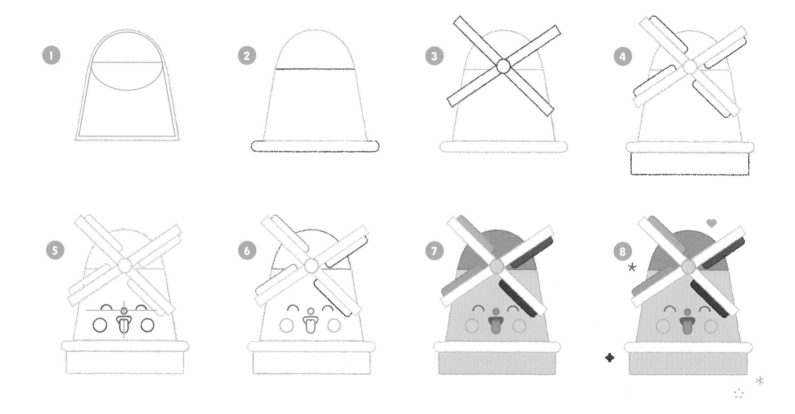

Apple Tree

Enchanted Forest

1

2

3

4

5

6

Magic Car

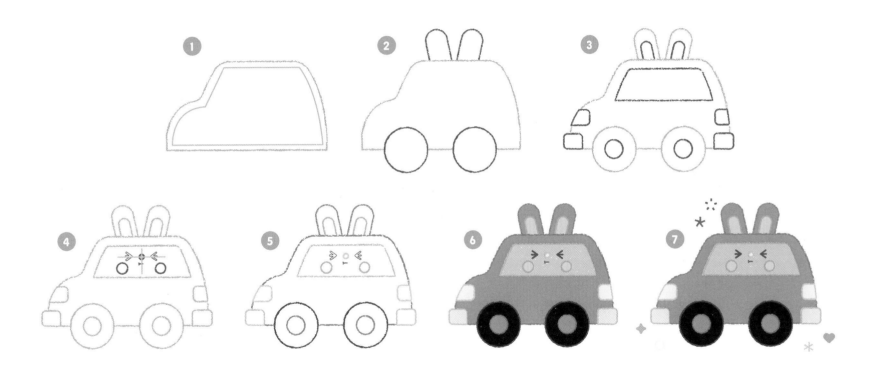

Cat-ctus

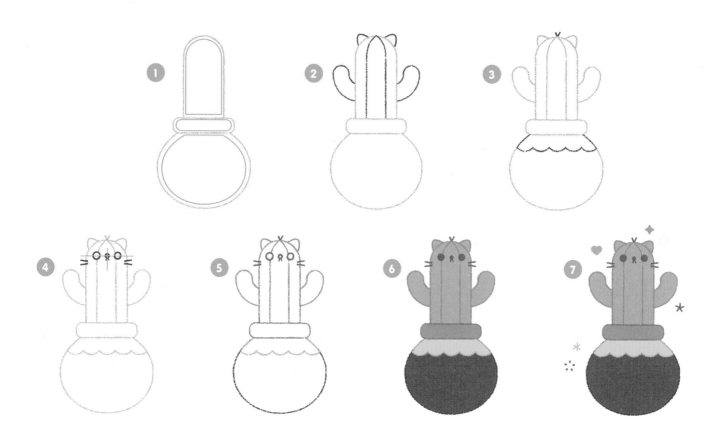

Sad Cactus

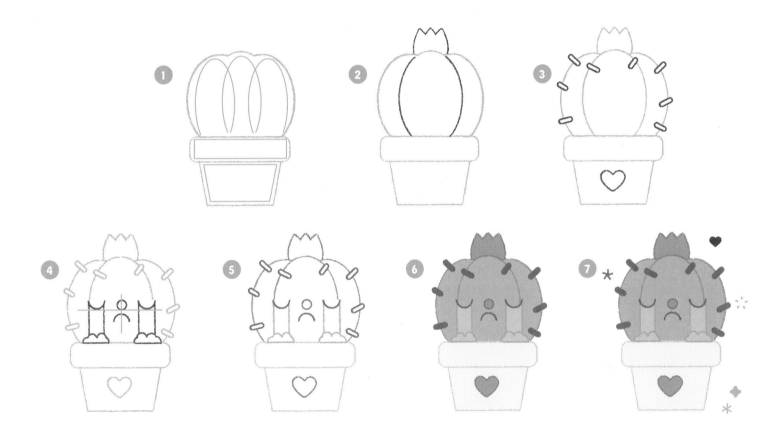

Spring Flower

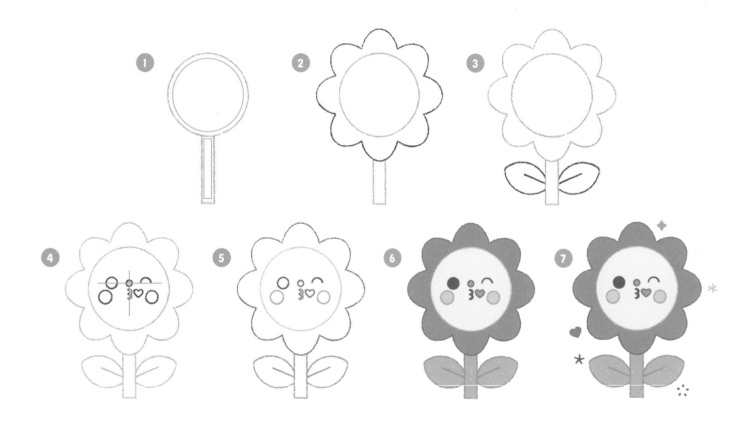

Tulip

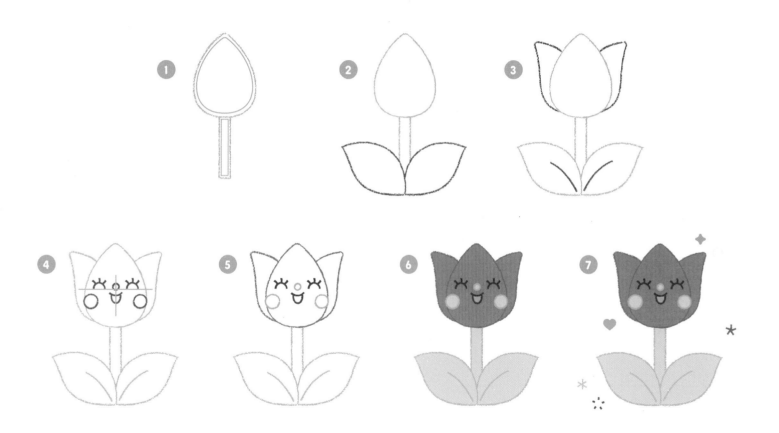

Sunflower

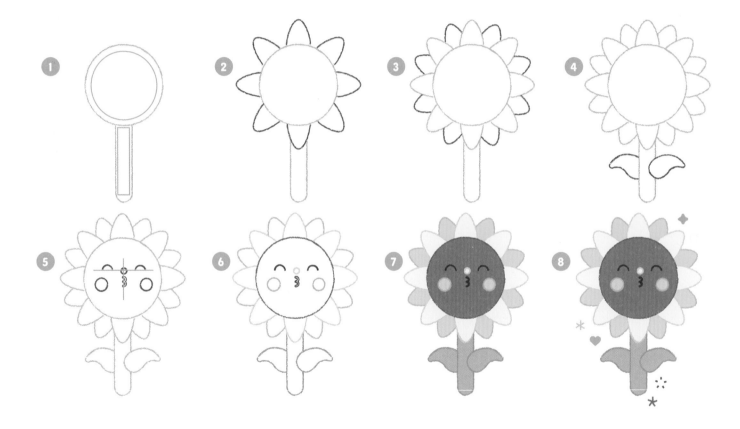

Rose

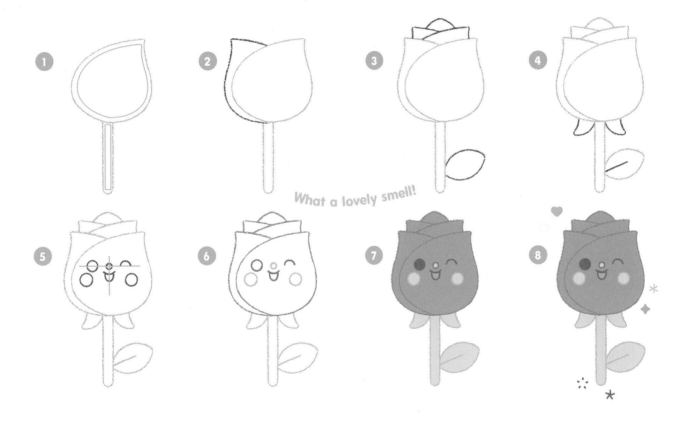

What a lovely smell!

Lotus Flower

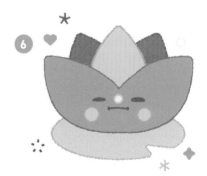

Flower Pot

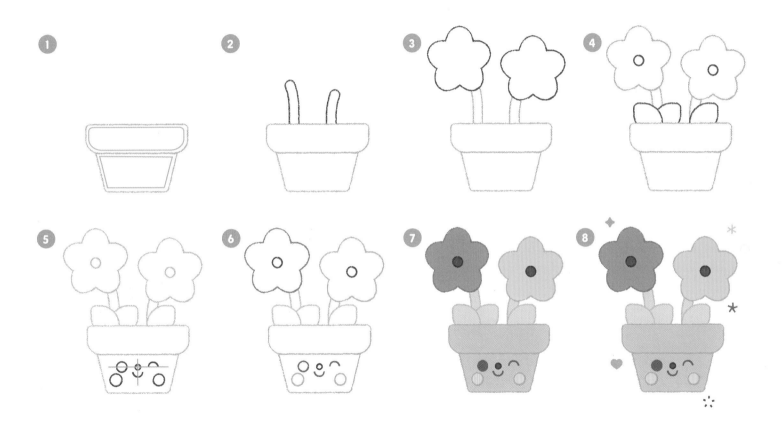

Acorn

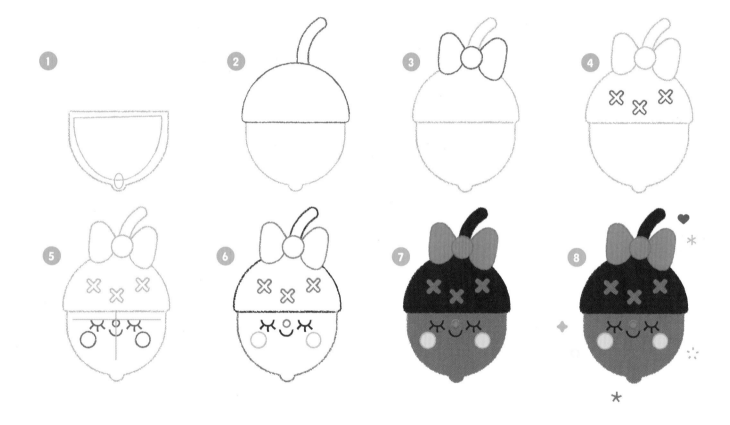

Apple

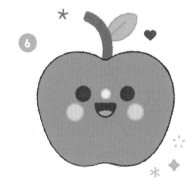

Strawberry

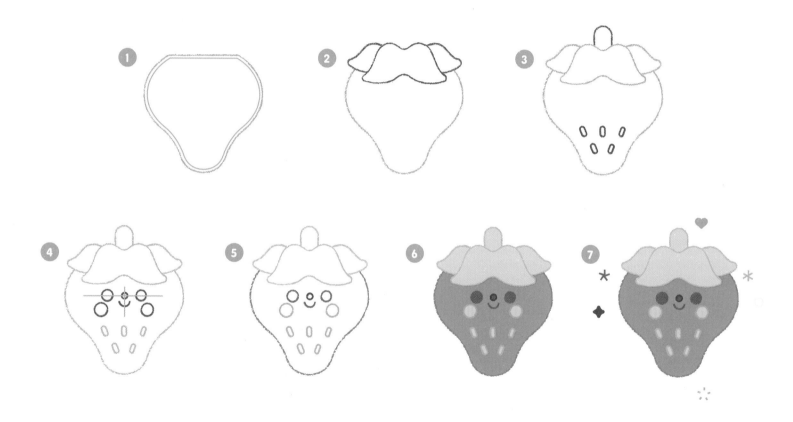

Orange

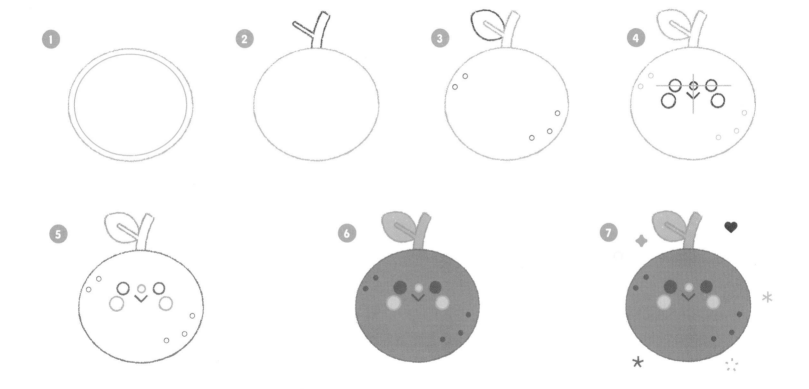

Banana

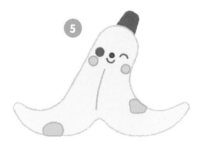

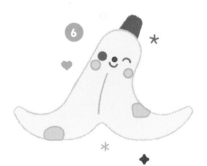

Carrot

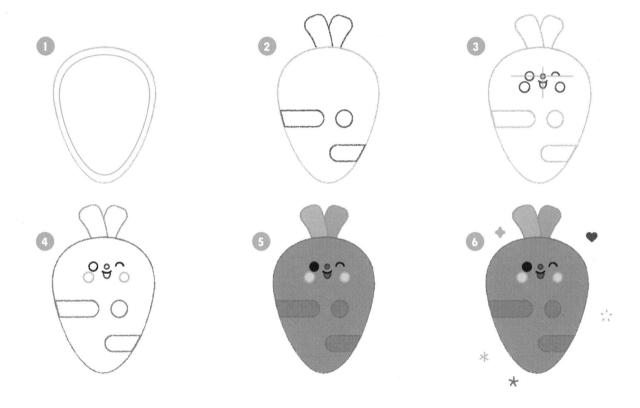

Broken Egg

1

2

3

4

5

6

Egg Timer

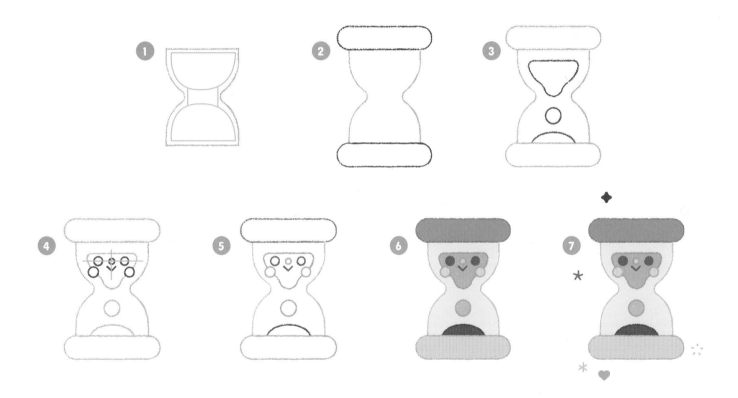

Frying Pan

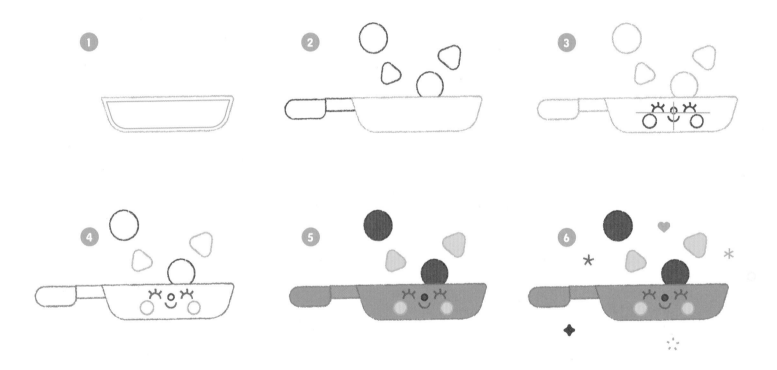

Noodles

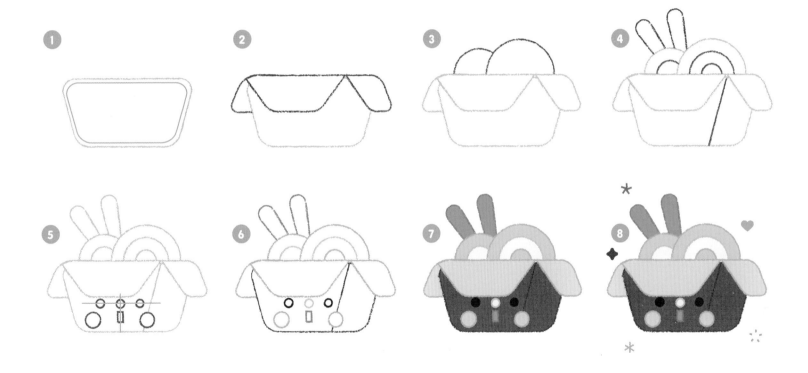

Sushi

Mmm ... looks delicious!

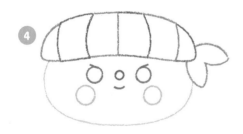

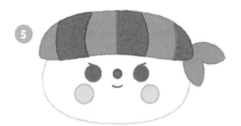

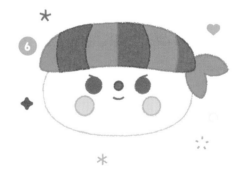

Onigiri

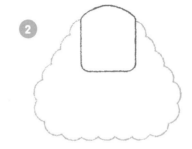

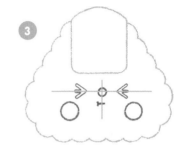

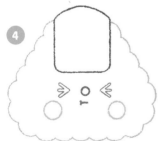

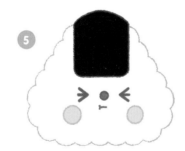

Hot Dog

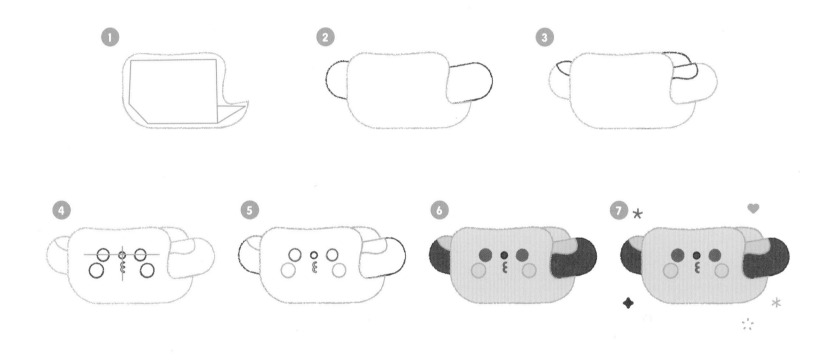

Hamburger

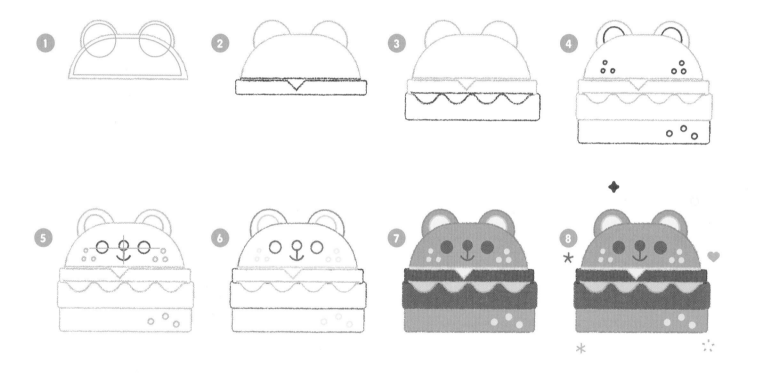

Pizza

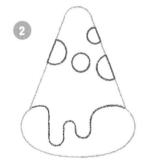

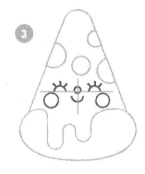

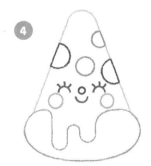

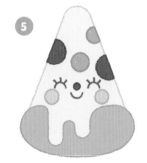

Popcorn

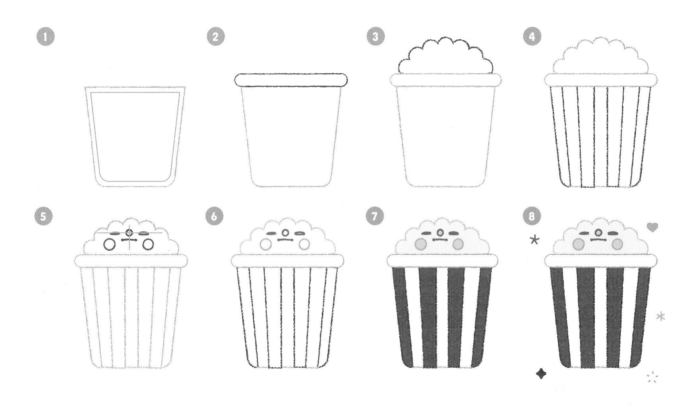

Cupcake

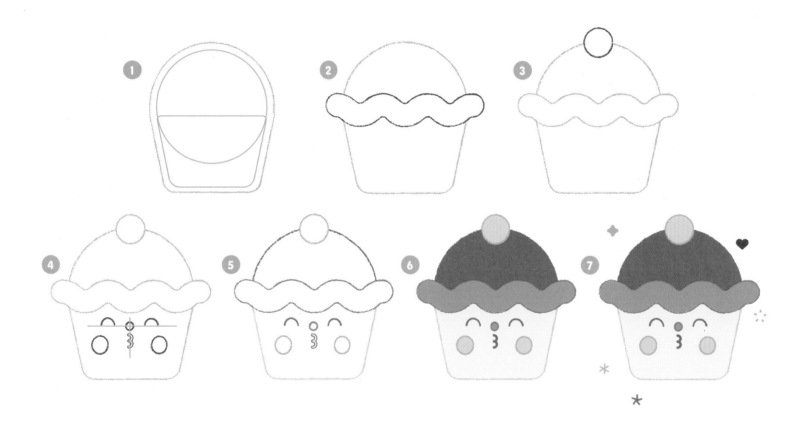

Donut

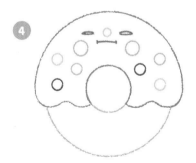

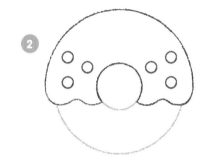

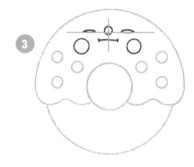

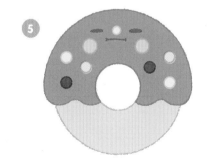

Cookie

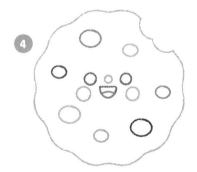

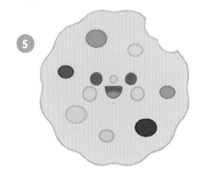

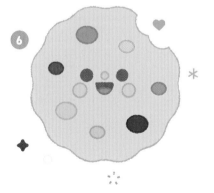

Gingerbread Man

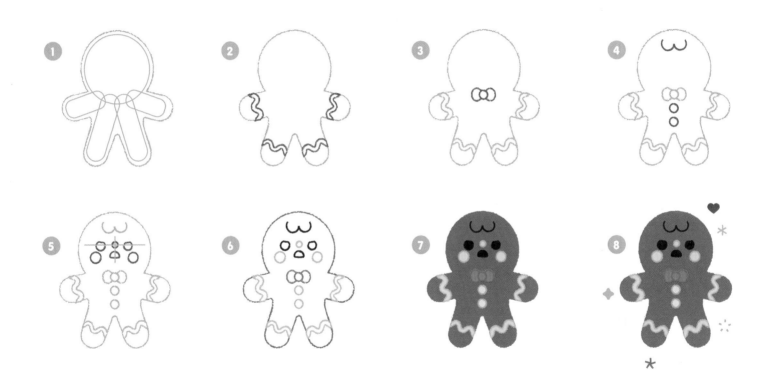

Muffin

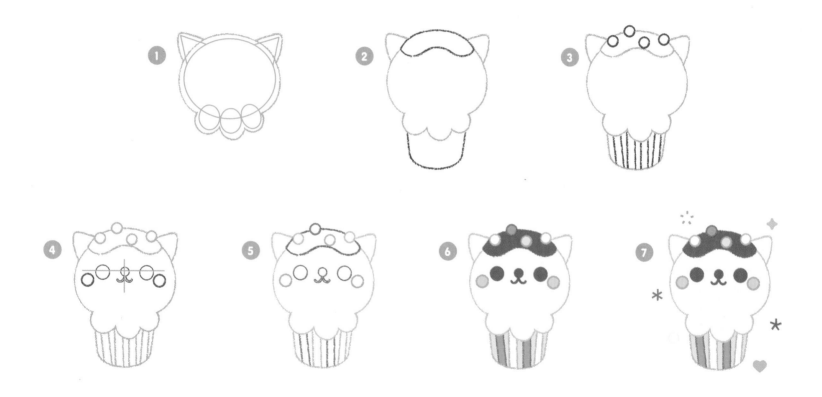

Croissant

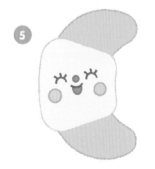

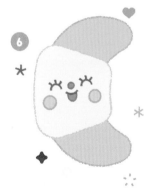

133

Pudding

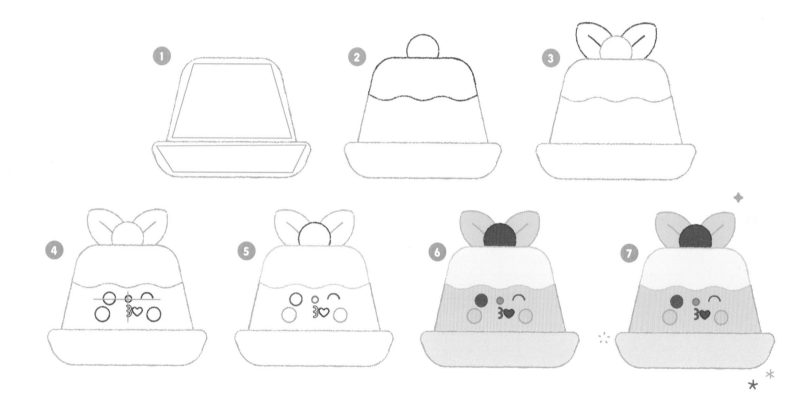

Chocolate Cake

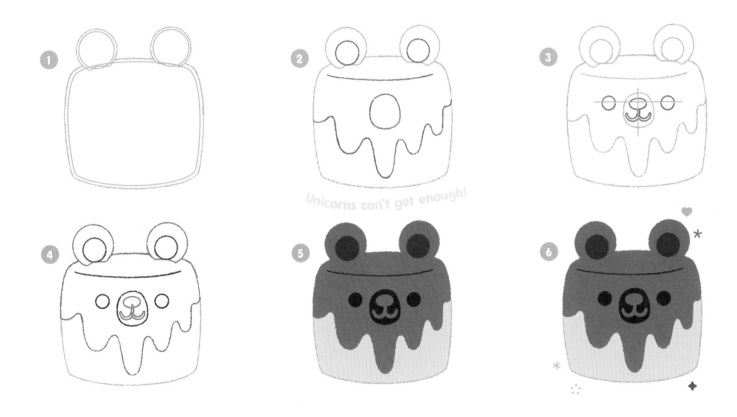

Unicorns can't get enough!

Rainbow Cake

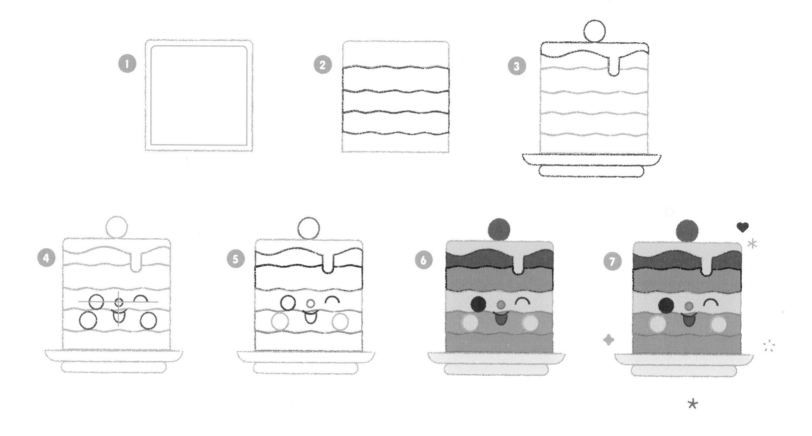

Slice of Cake

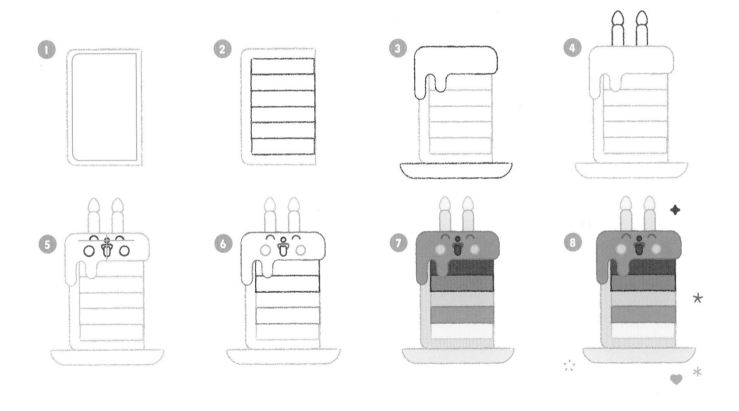

Whippy Ice Cream

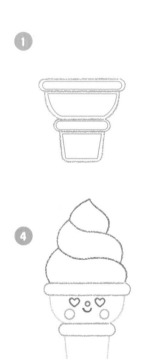

Ice Cream Cone

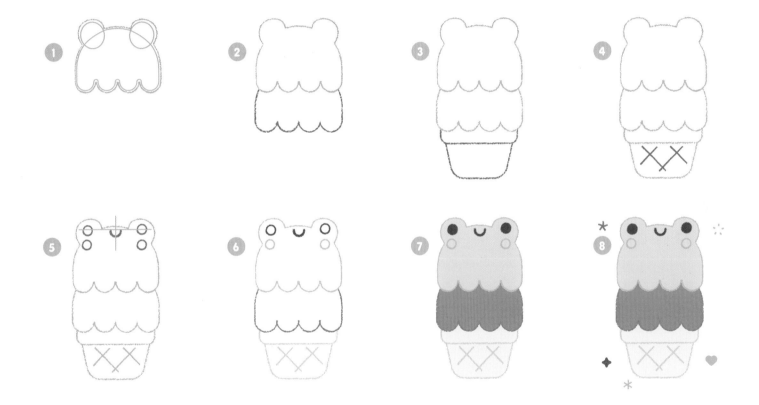

Ice Cream Sundae

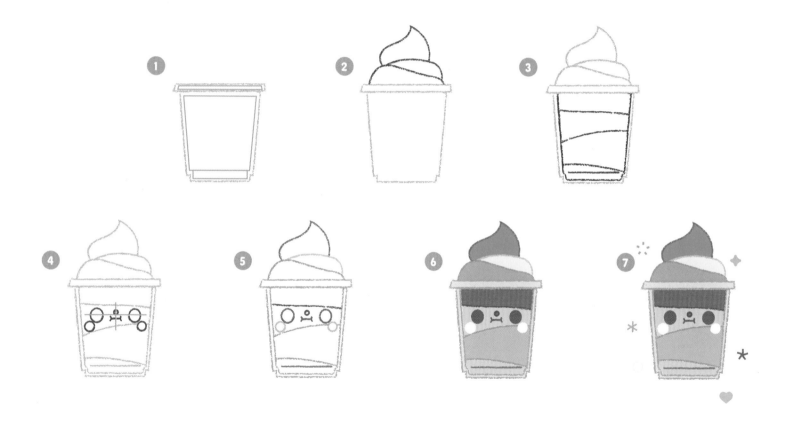

Bowl of Ice Cream

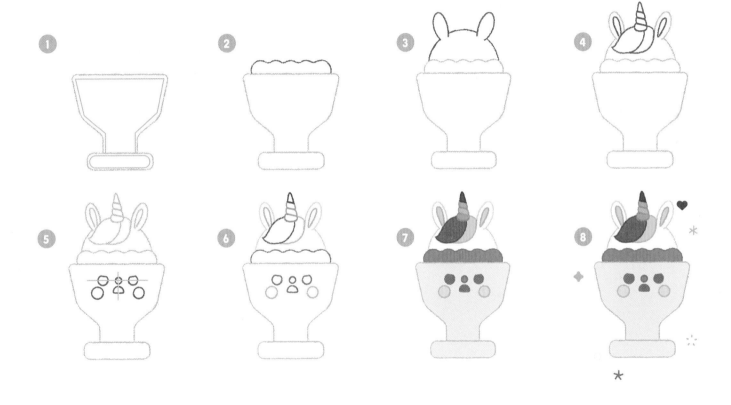

Cotton Candy

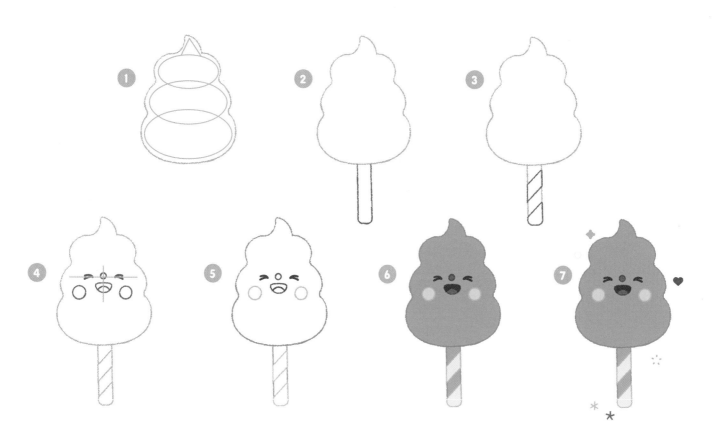

Sweet

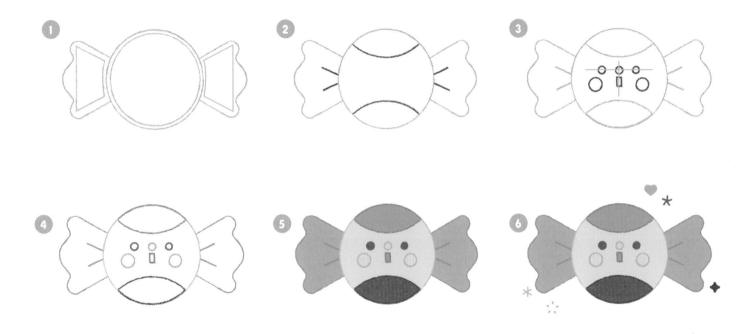

Lollipop

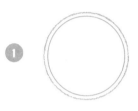

144

Milkshake

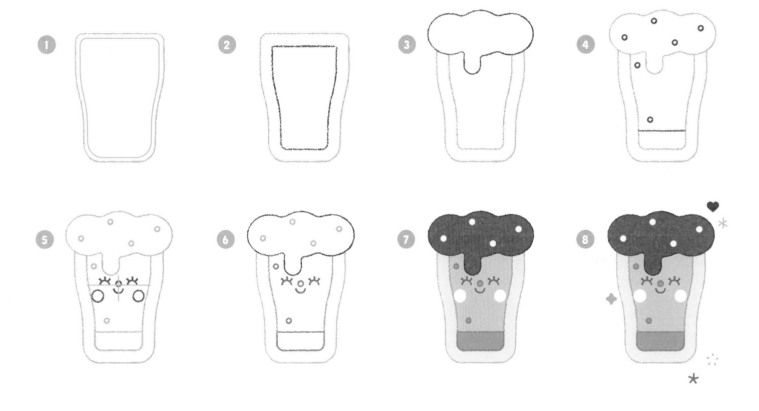

Teapot

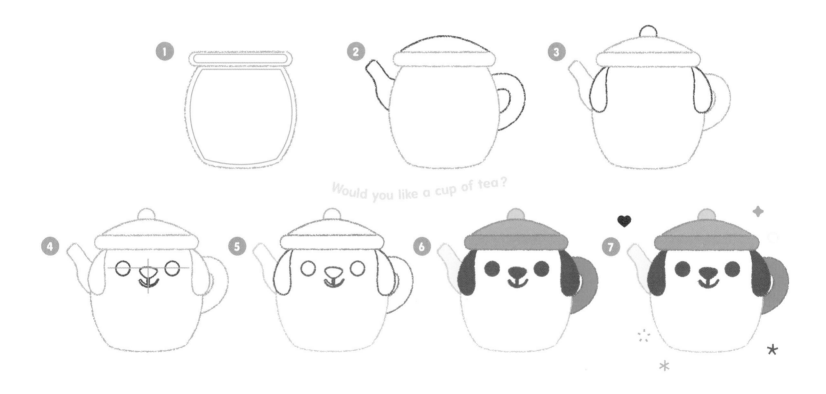

Would you like a cup of tea?

Coffee Cup

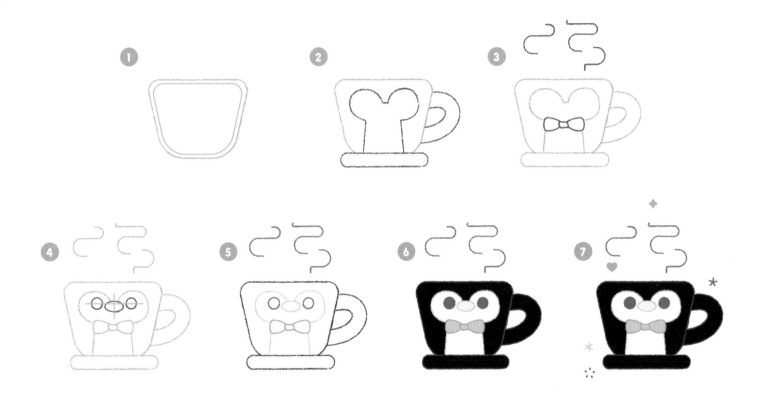

School Bus

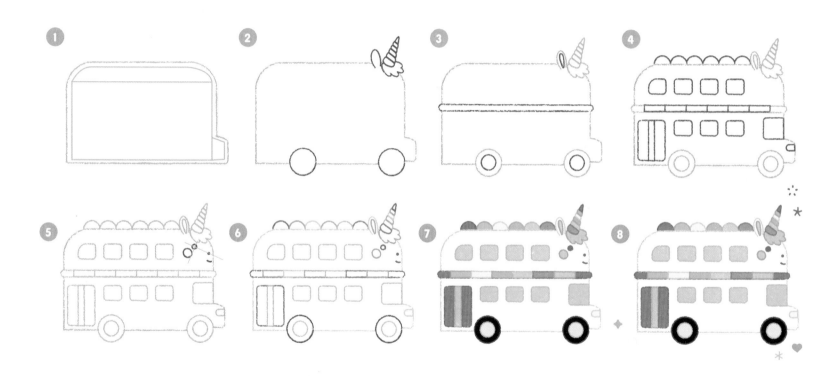

Backpack

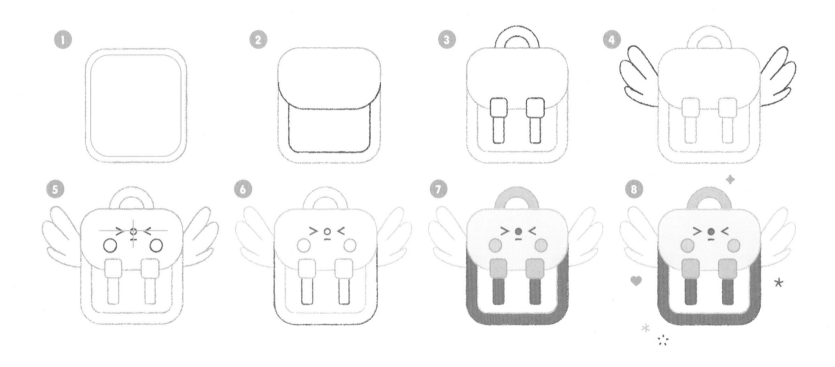

Crayon

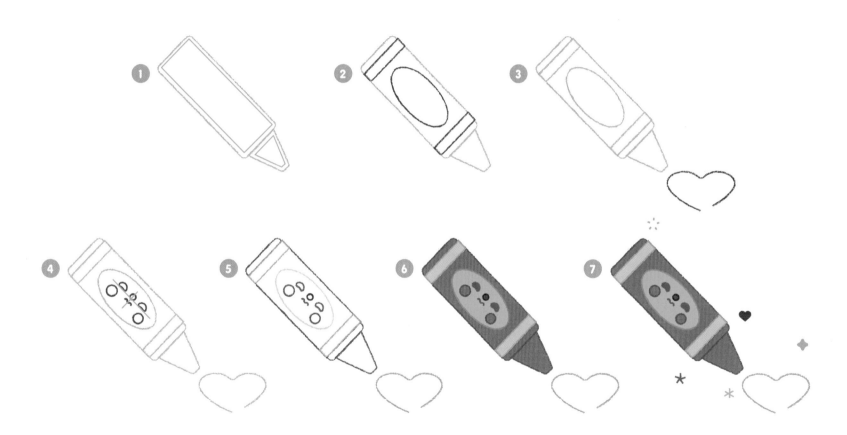

Pencil Pot

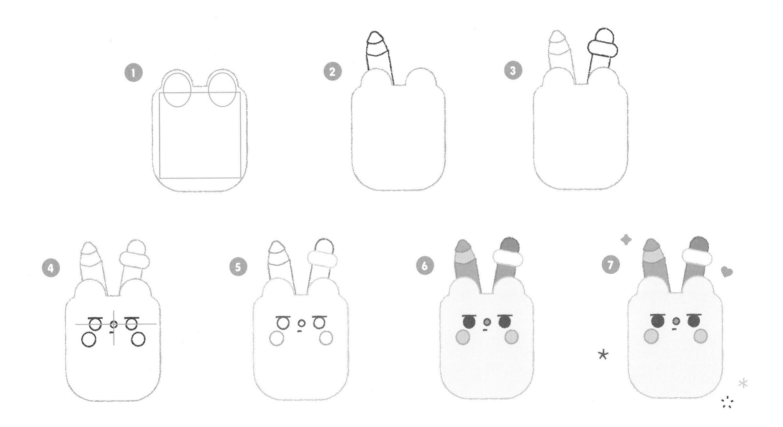

Closed Book

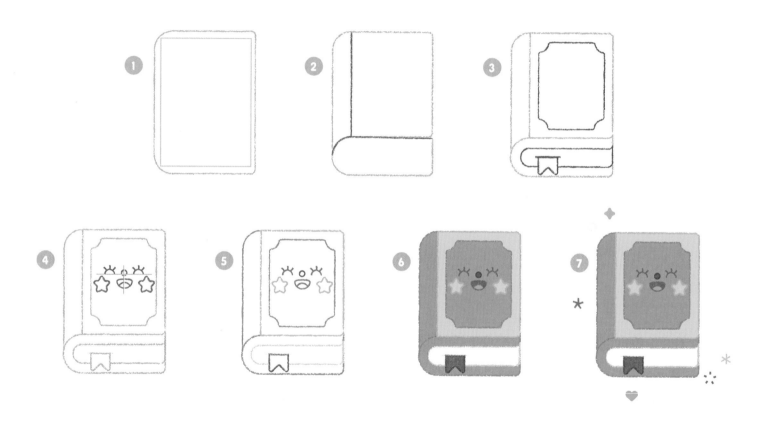

Open Book

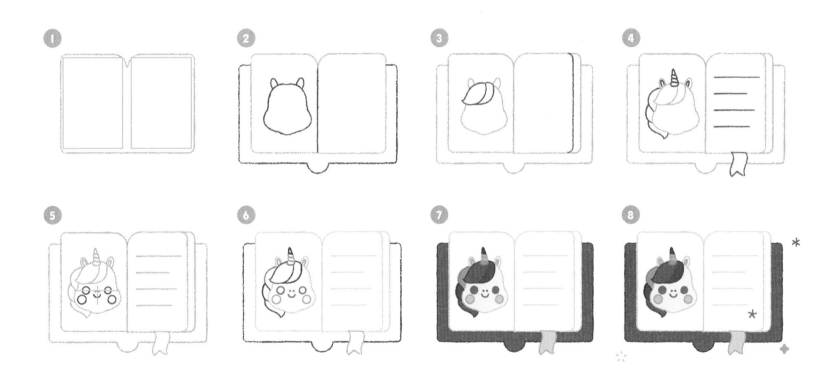

Sneaker

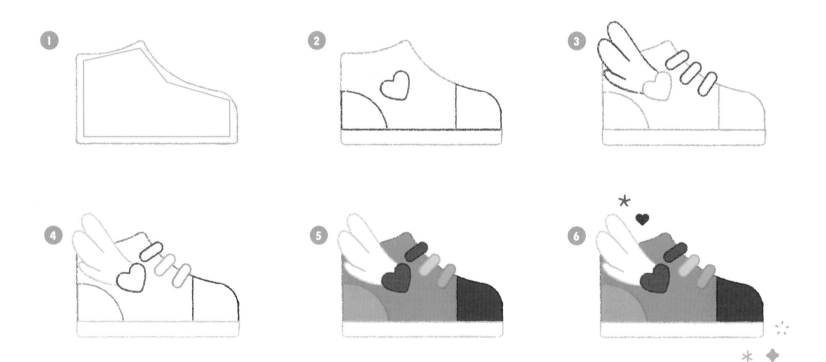

Sock

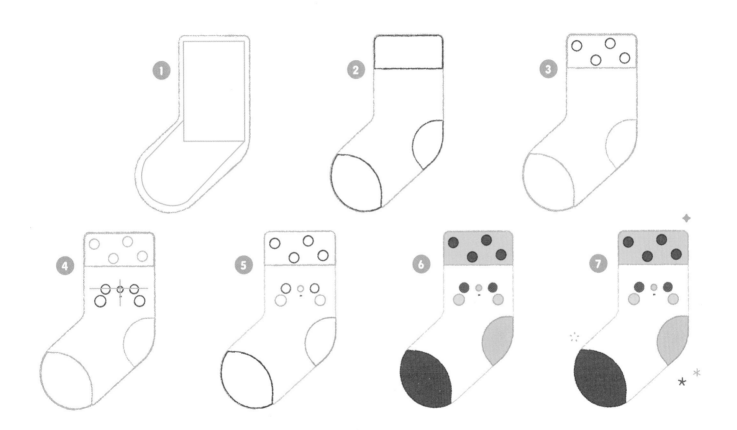

Baseball Cap

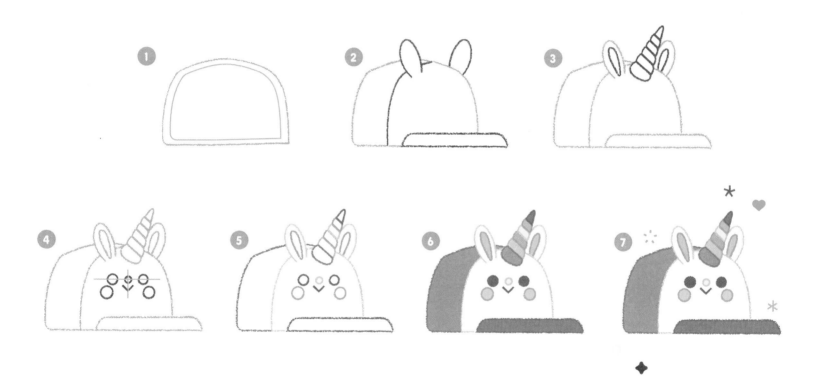

T-Shirt

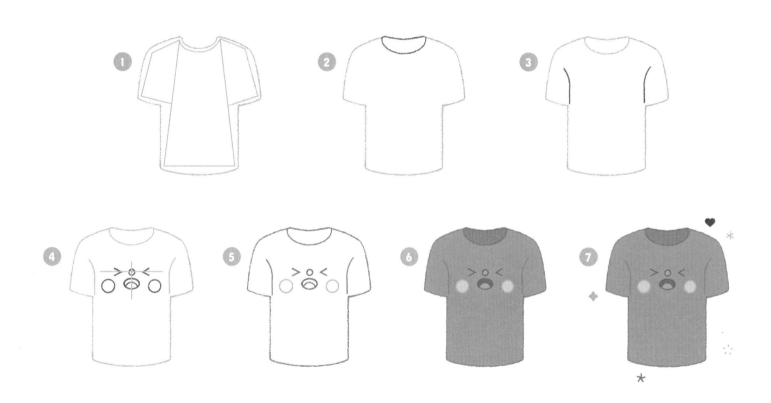

High Heel

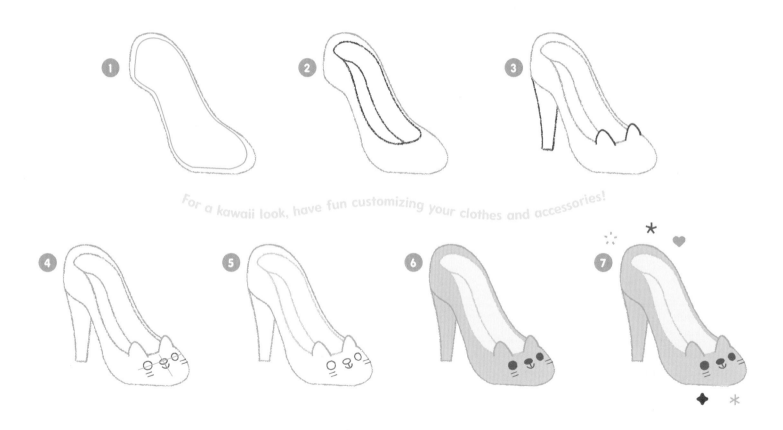

For a kawaii look, have fun customizing your clothes and accessories!

Lipstick

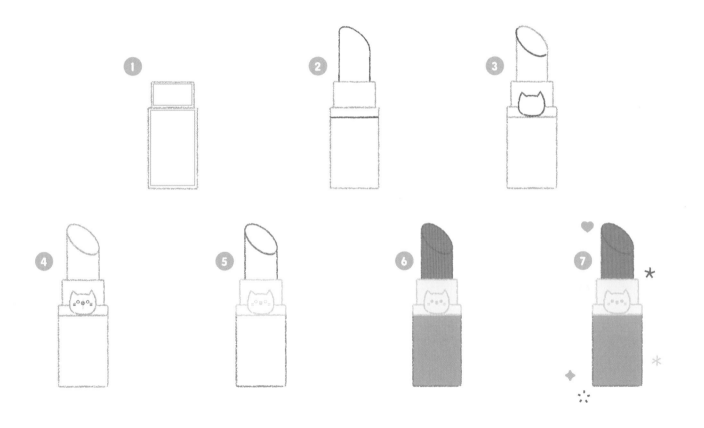

Perfume

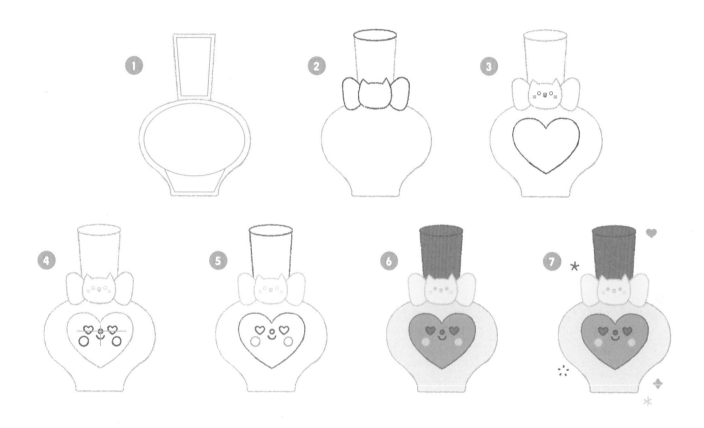

Shopping Bag

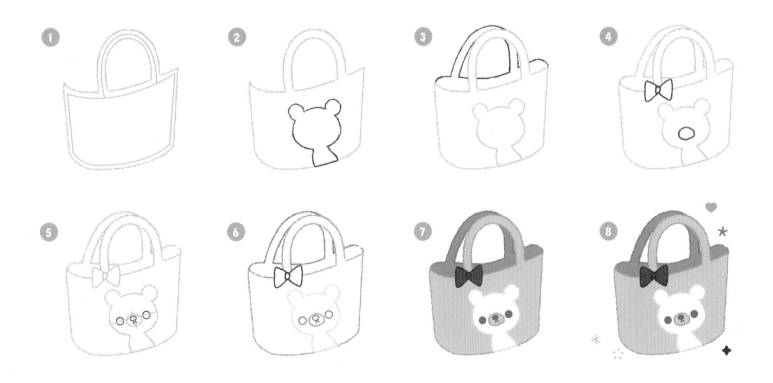

Handbag

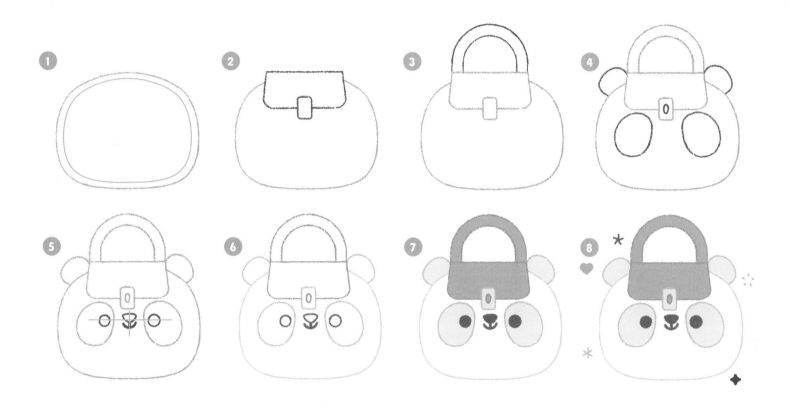

Love Letter

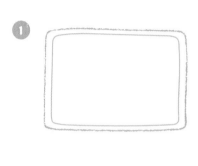

Headphones

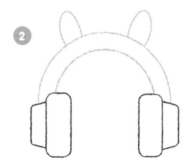

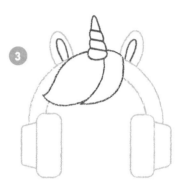

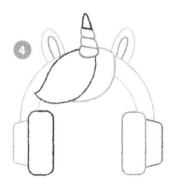

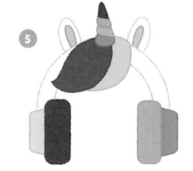

164

Rollerskate

Computer

Cassette

Musical Notes

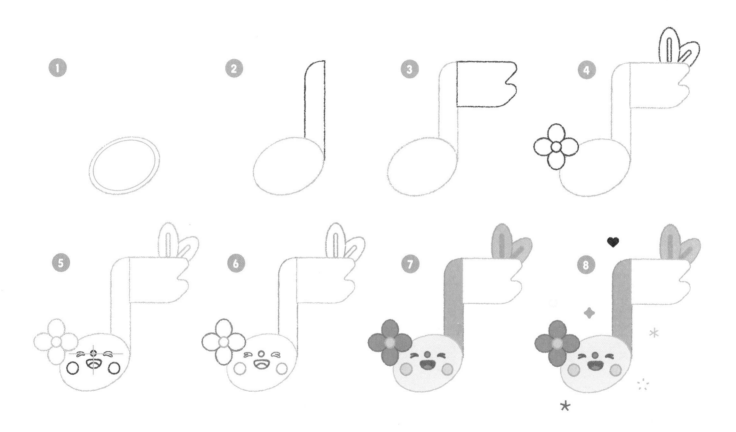

Electric Guitar

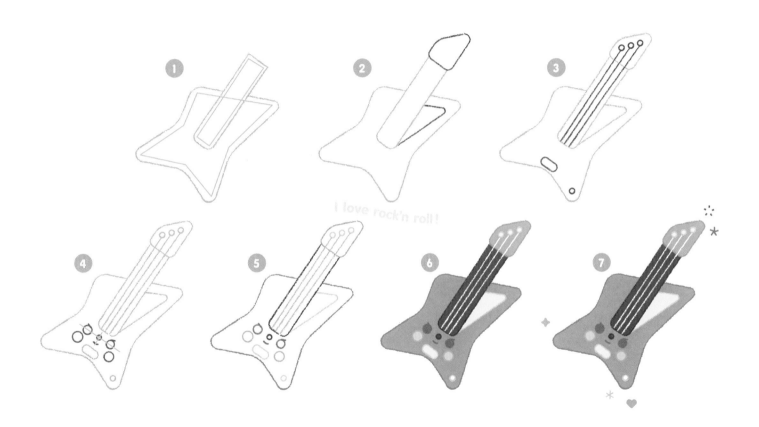

I love rock'n roll!

Drumkit

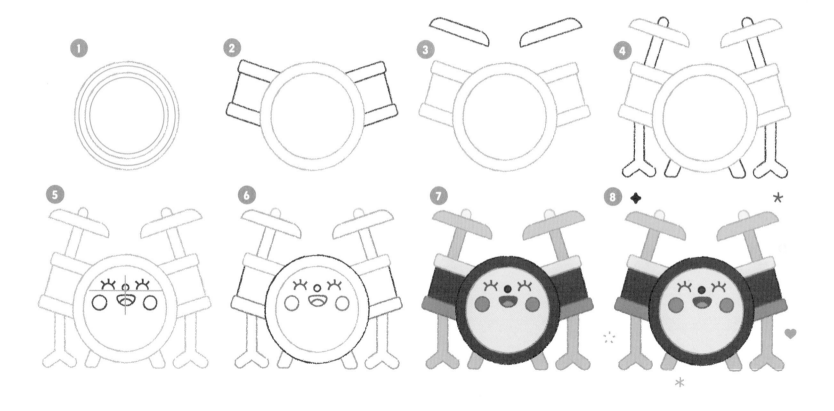

Drum

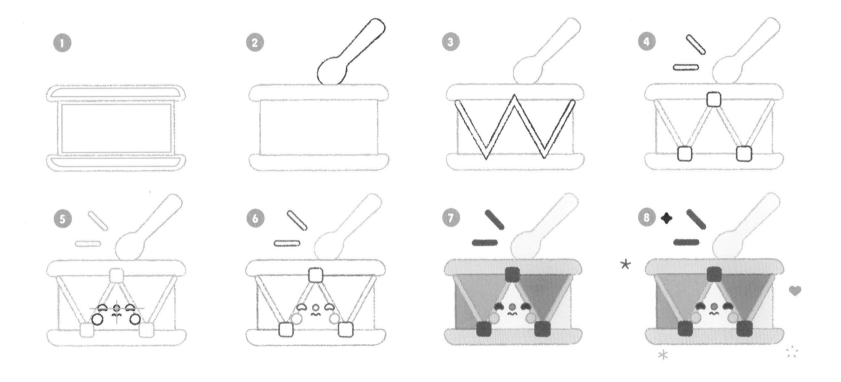

Keyboard

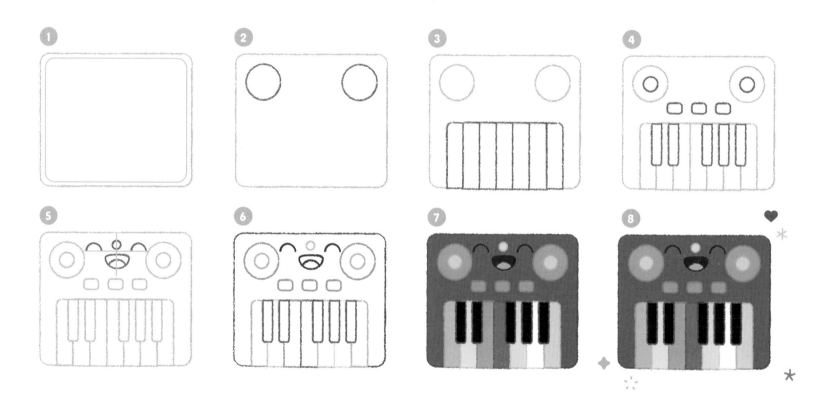

Trumpet

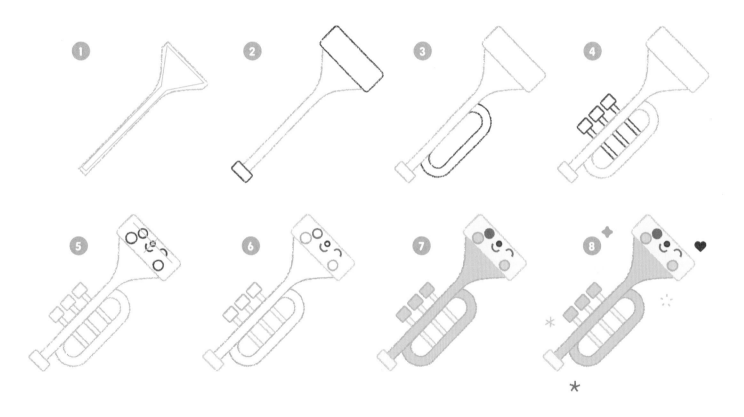

Umbrella

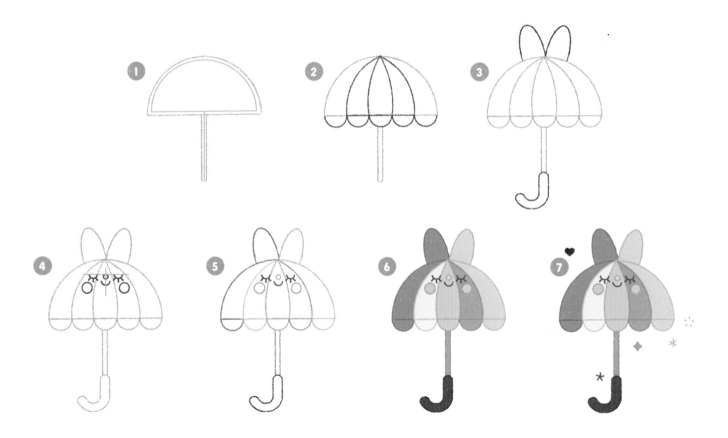

Cloud

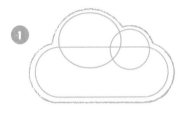

Rainbow Cloud

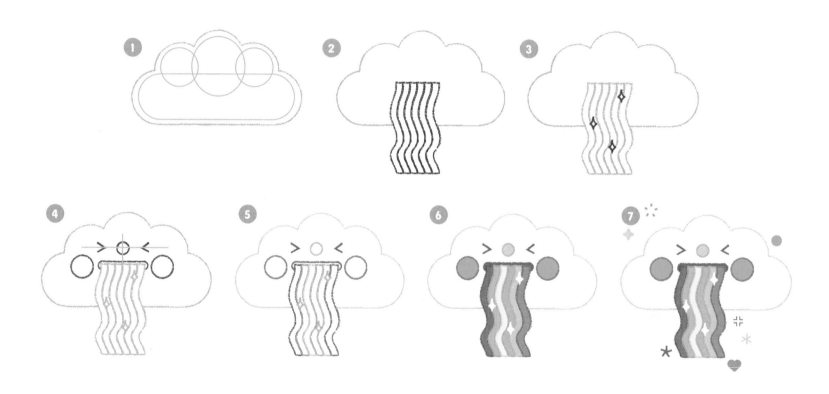

Storm Cloud

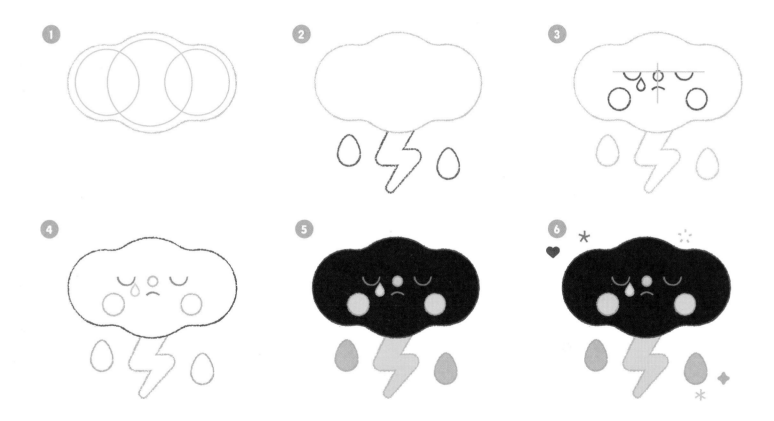

After the Rain

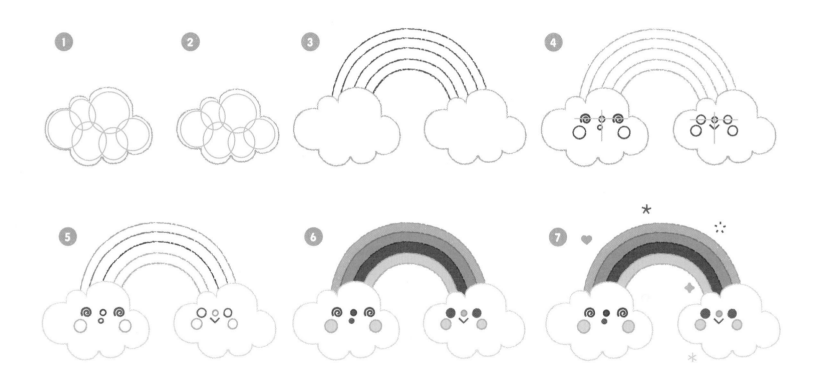

Sunshine

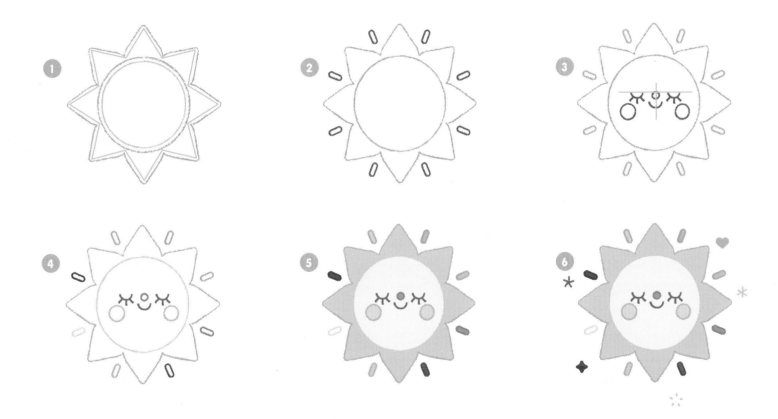

Shooting Star

Waouh!

Bright Star

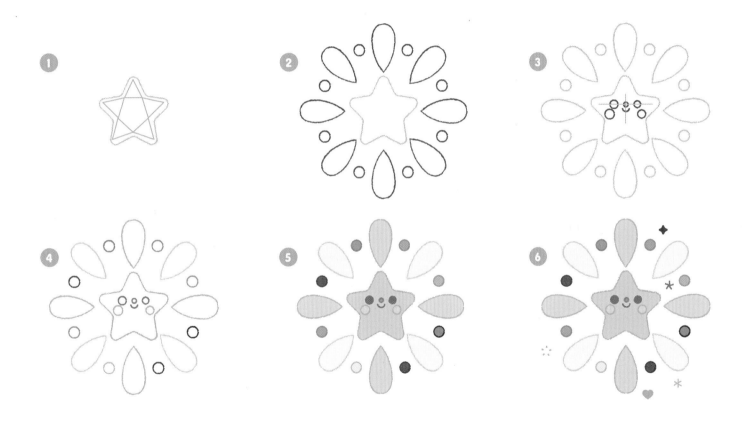

Starfish

1

2

3

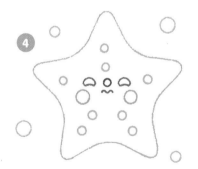

4

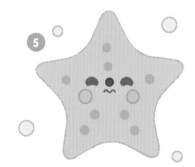

5

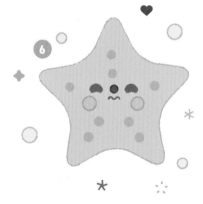

6

Coral

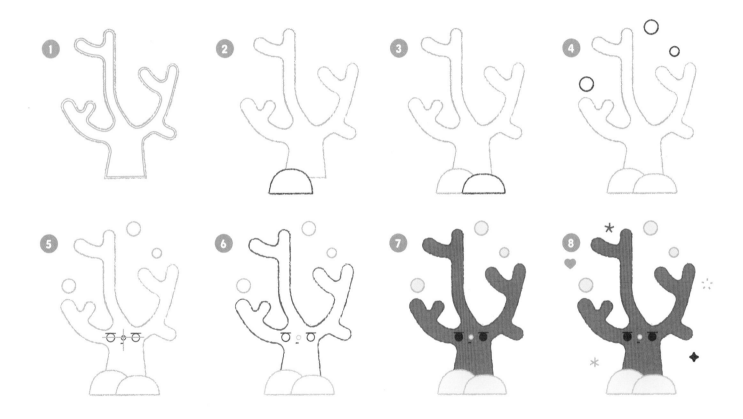

Unicorn Inflatable

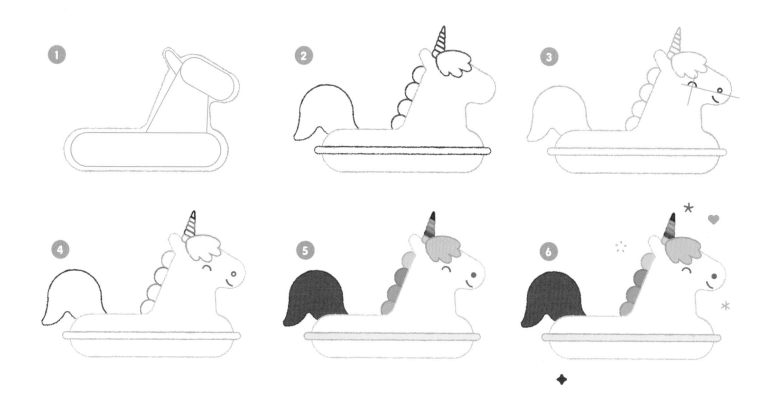

Flamingo Inflatable

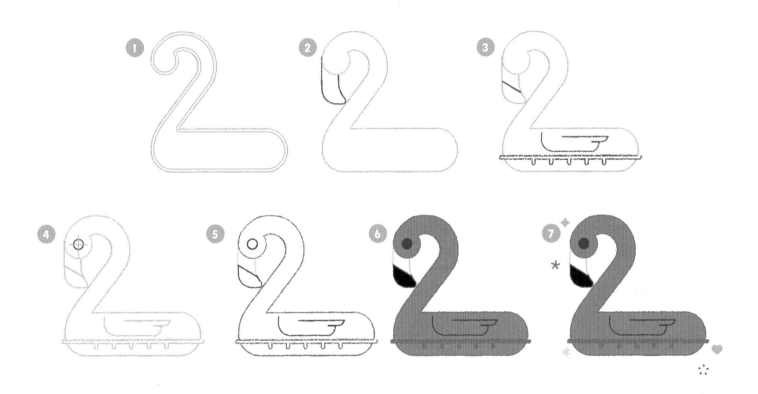

Beach Ball

Bucket and Spade

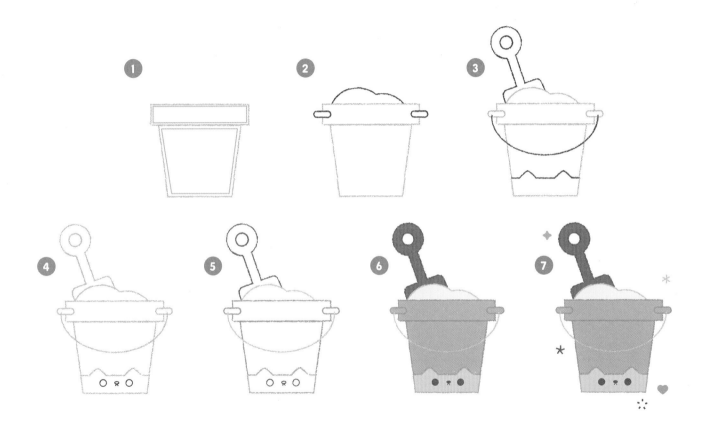

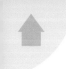

Wind Spinner

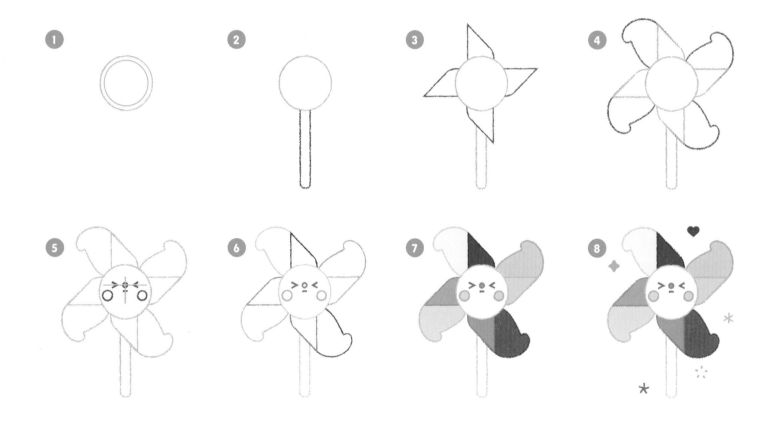

Hot Air Balloon

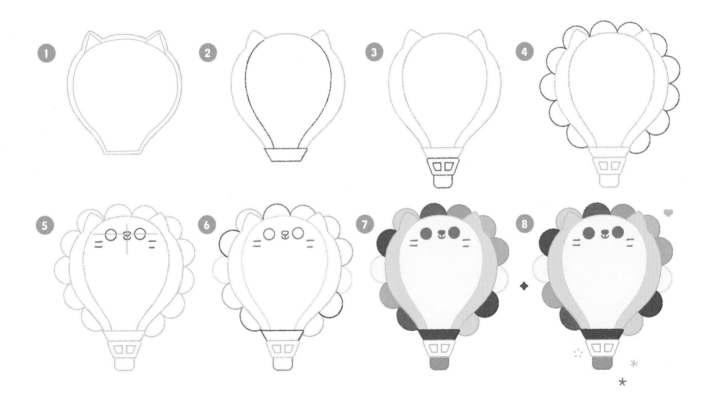

Simple Snowflake

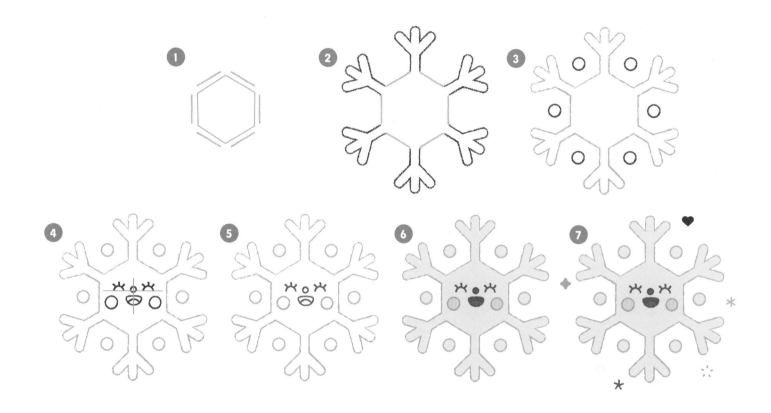

Complex Snowflake

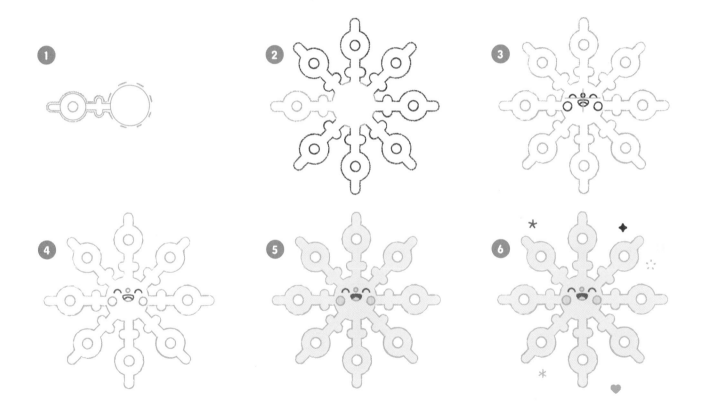

Christmas Tree

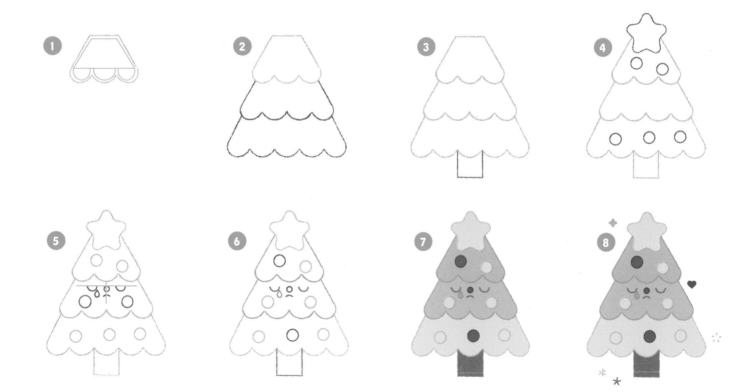

Gift Box

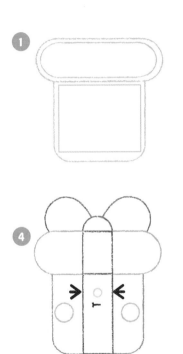

Merry Christmas!

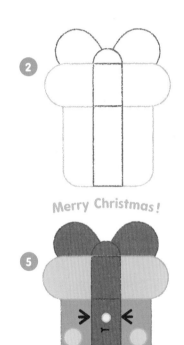

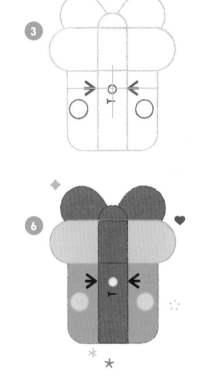

Striped Bauble

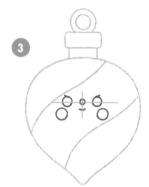

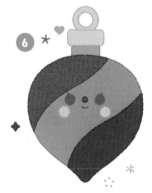

Scalloped Bauble

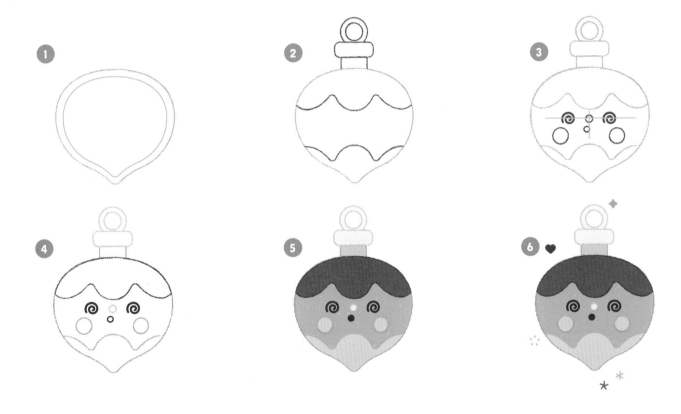

Candle

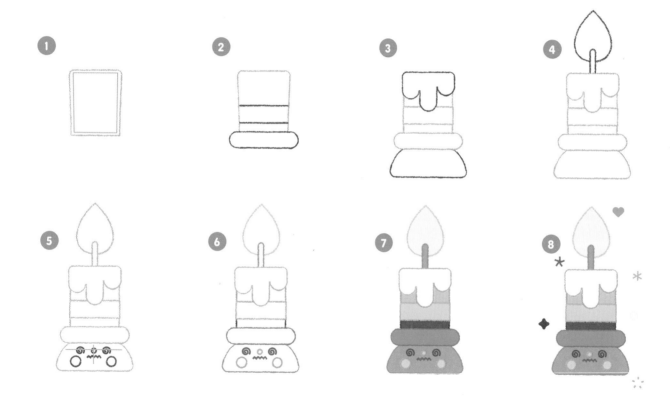

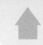

Light Bulb

Fairytale Castle

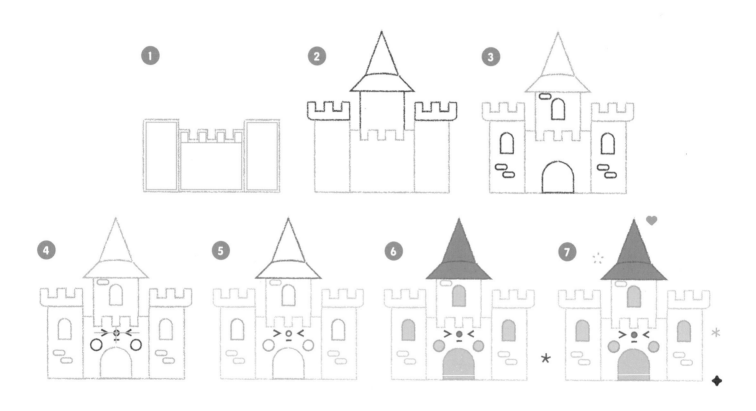

Magic Wand

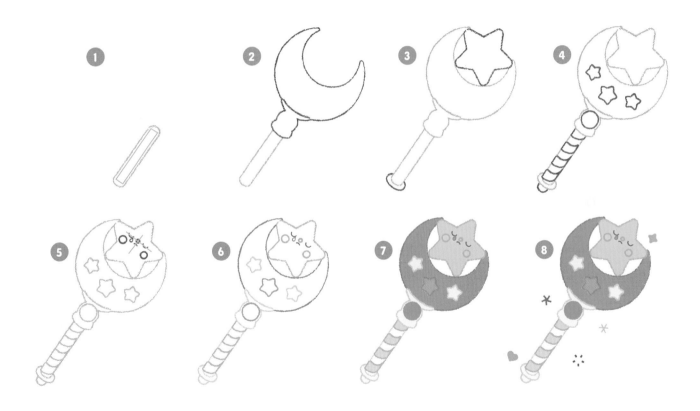

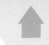

King's Crown

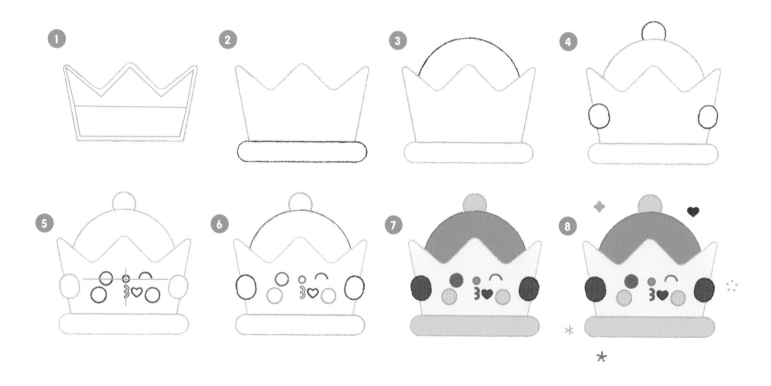

Queen's Crown

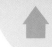

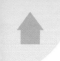

Love Potion

Magic Potion

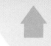

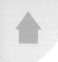

Chinese Lantern

Beckoning Cat

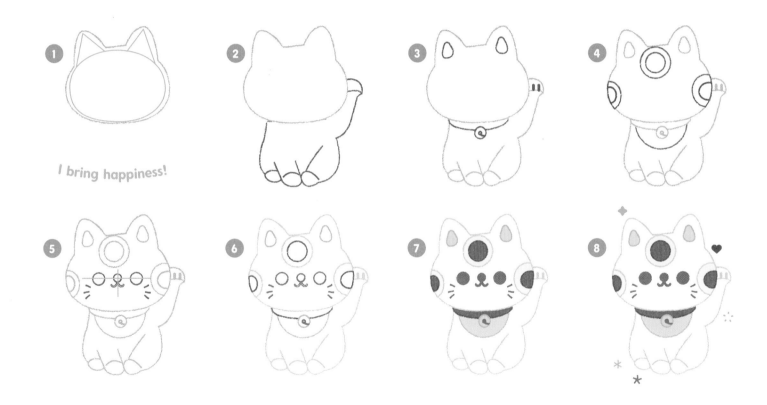

1

I bring happiness!

2

3

4

5

6

7

8

Kokeshi

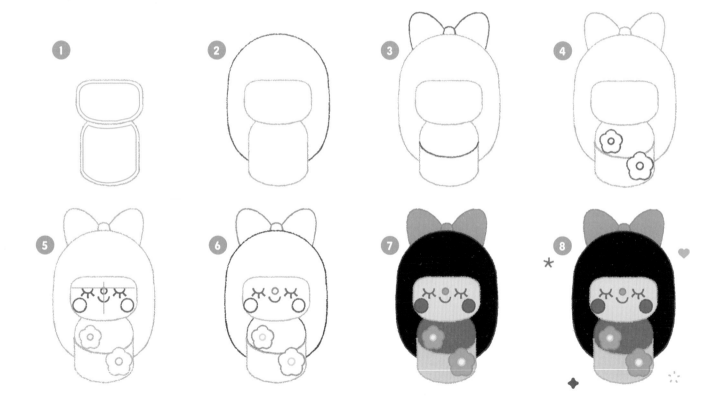

Matryoshka

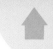

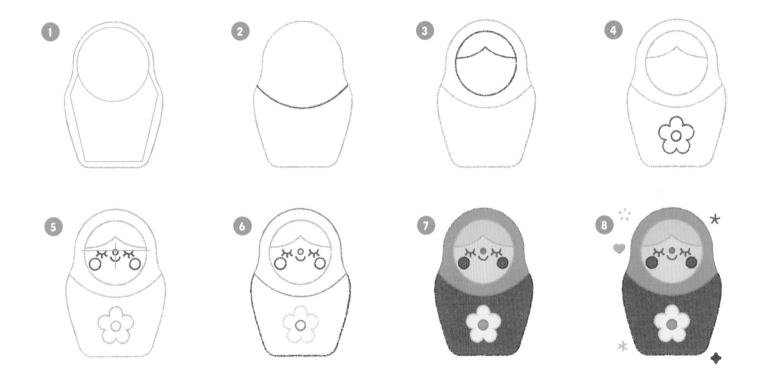

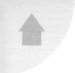

Dreamcatcher

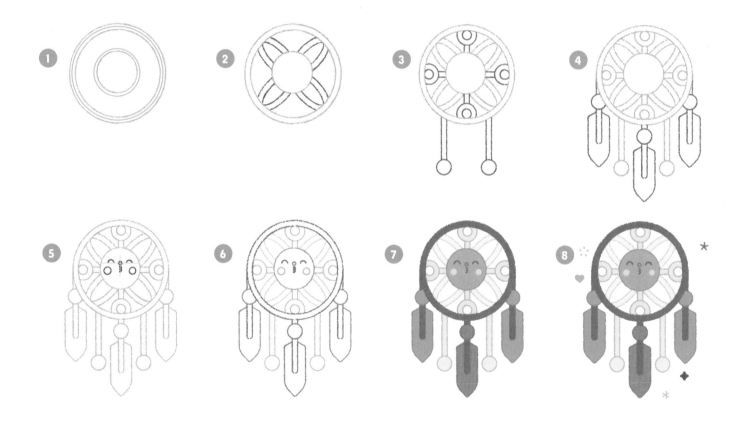

Feather

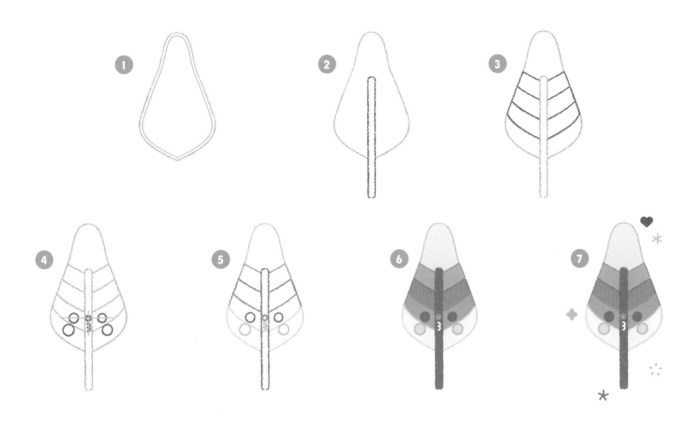

Tooth

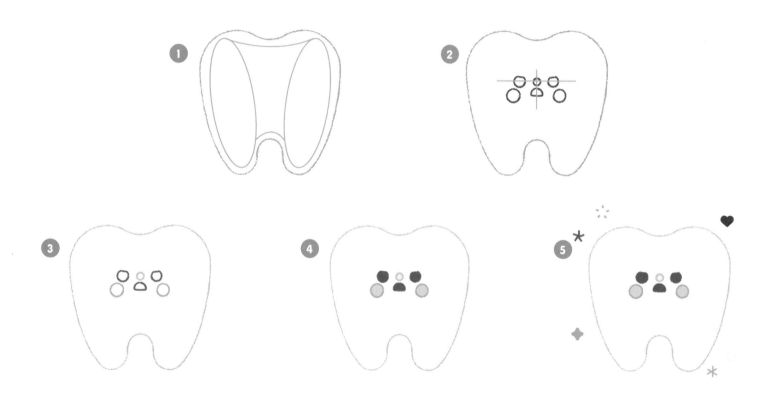

Toothbrush

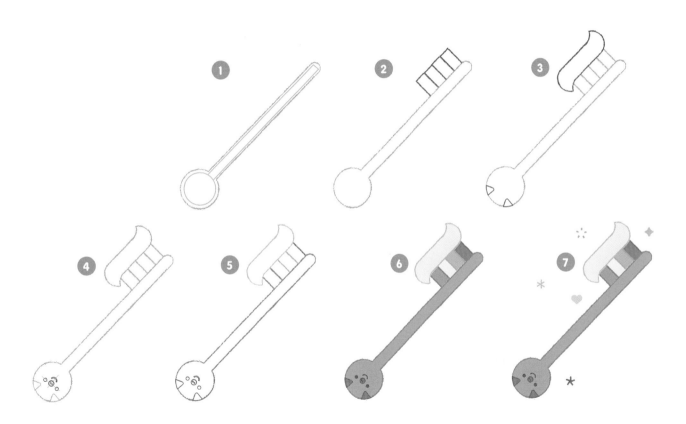

King Bear

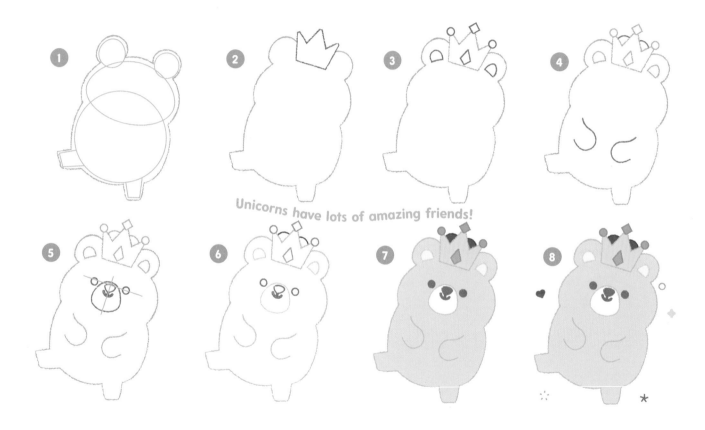

Unicorns have lots of amazing friends!

Uni-Bear

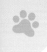

Sitting Uni-Bear

Tanuki

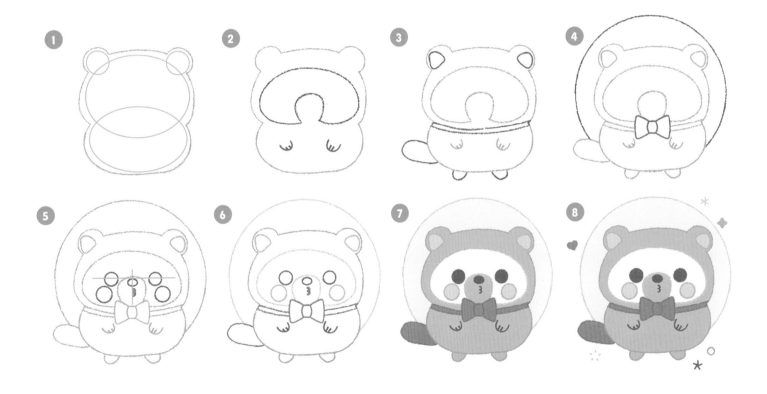

Sitting Uni-Rabbit

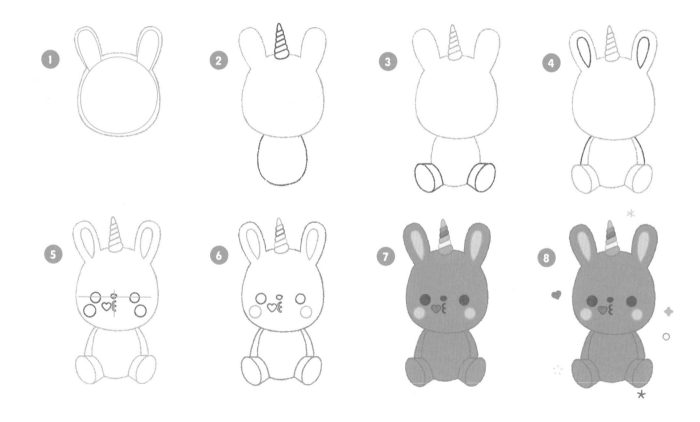

Uni-Rabbit

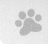

217

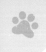

Uni-Cat

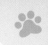

Kitty King

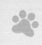

Kitty Queen

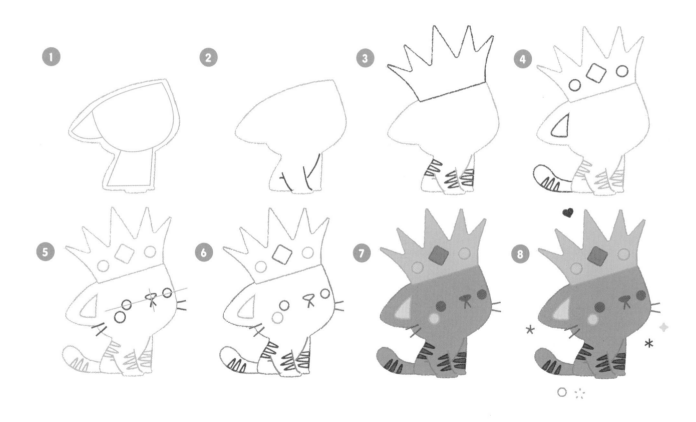

Sitting Uni-Cat

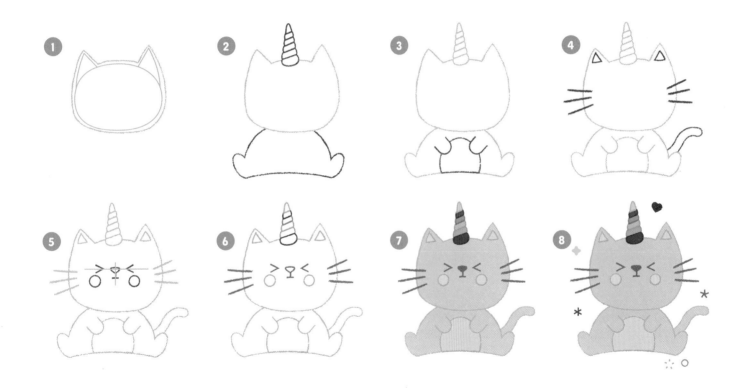

Inu Hariko

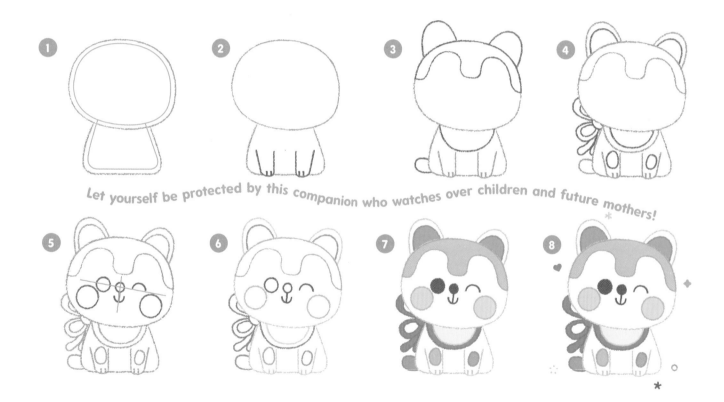

Let yourself be protected by this companion who watches over children and future mothers!

Colourful Puppy

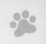

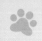

Poodle

Uni-Kitten

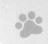

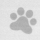

Uni-Puppy

Kitty Princess

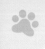

Pink Puppy

King Dog

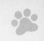

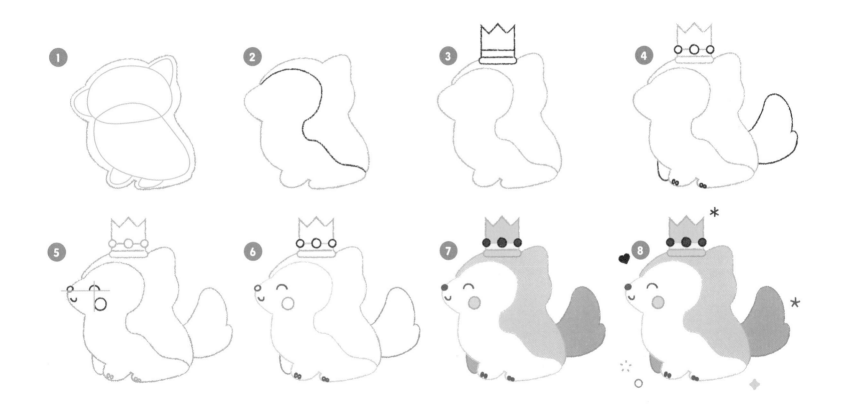

Sleeping Fox

Uni-Fox

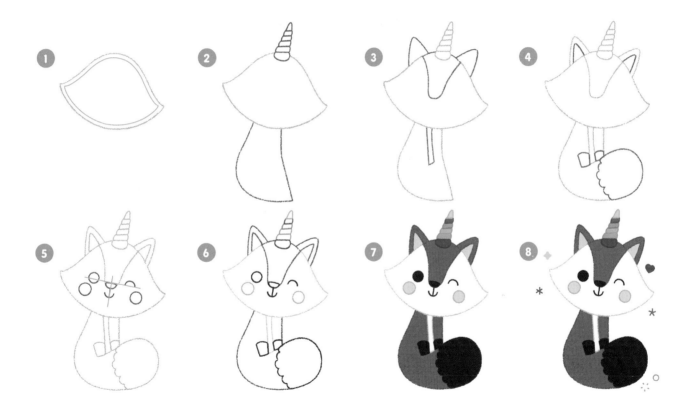

Reindeer

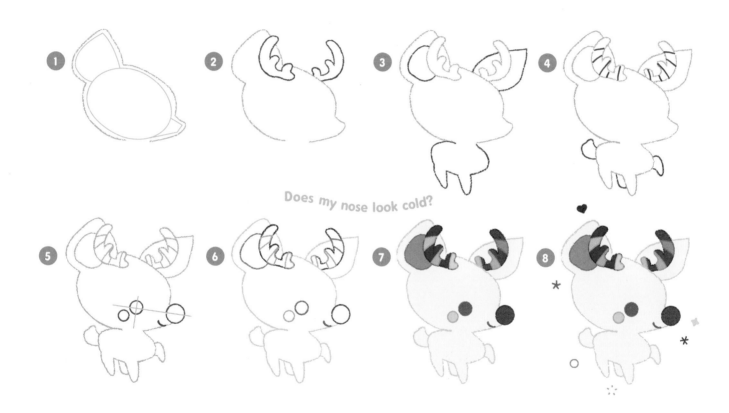

Does my nose look cold?

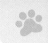

Fawn

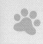

Squirrel

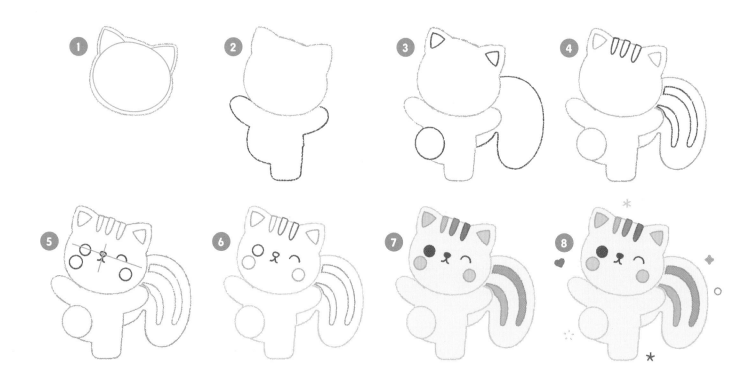

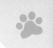

Raccoon

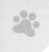

Wild Boar

Hedgehog

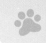

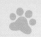

Uni-Pig

Party Pig

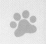

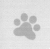

Sleepy Sheep

Cute Cow

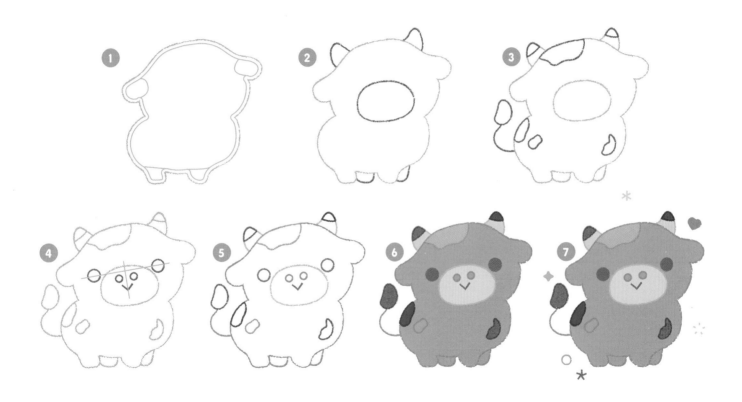

Chicken

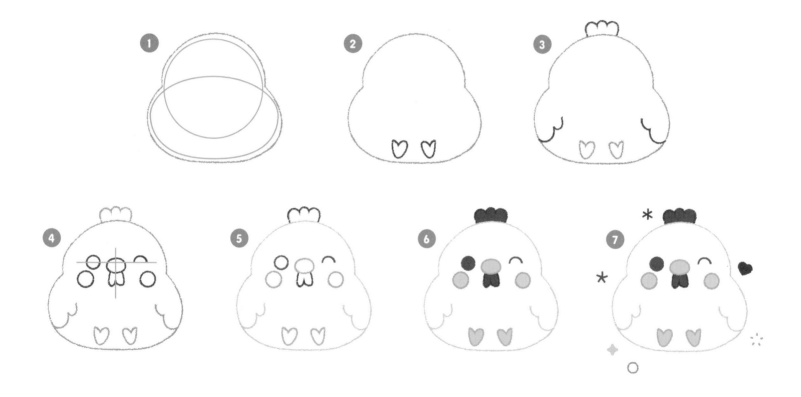

Uni-Chick

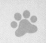

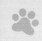

Sparrow

Uni-Bird

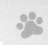

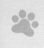

Kappa

Did you know this Japanese mythological animal is a big lover of cucumber?

246

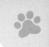

Seagull

1

2

3

4

5

6

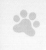

Uni-Kiwi

Uni-Llama

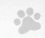

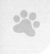

Uni-Sloth

Toucan

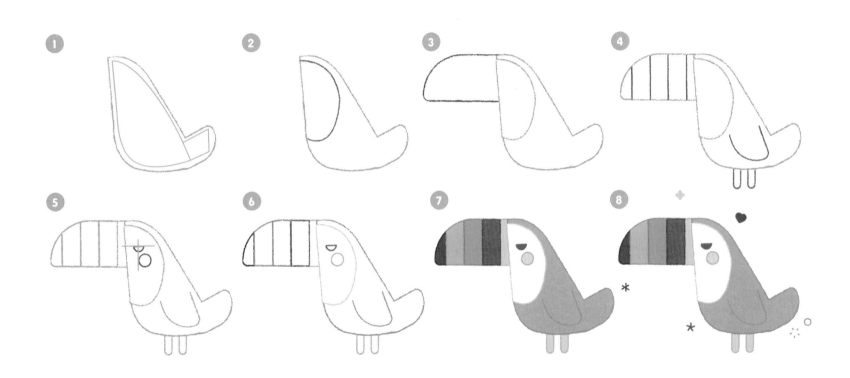

Pink Panda

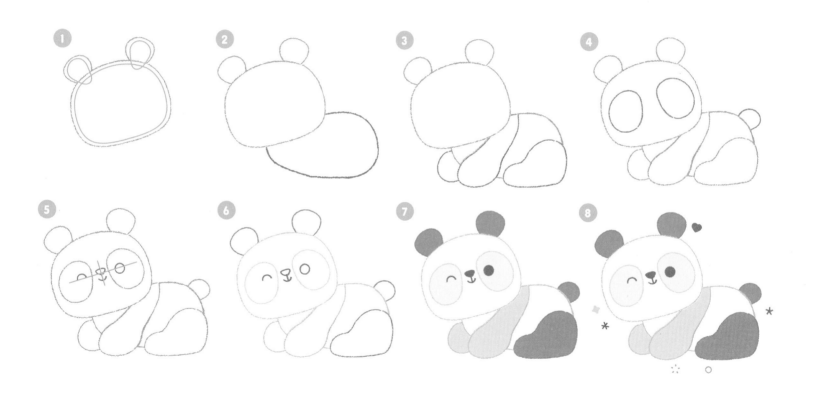

Dancing Panda

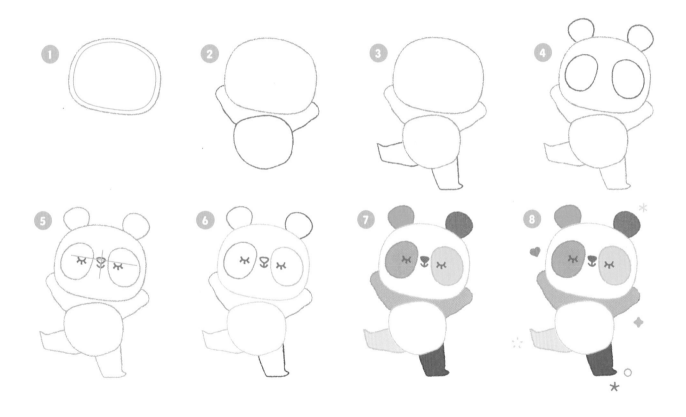

Sad Uni-Koala

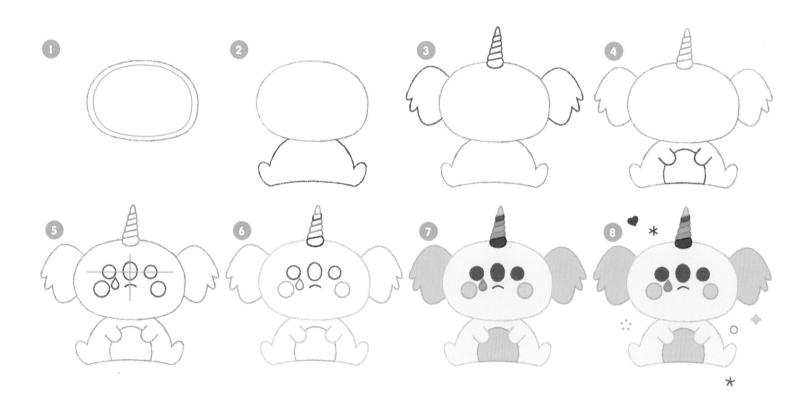

Sleepy Uni-Koala

Uni-Monkey

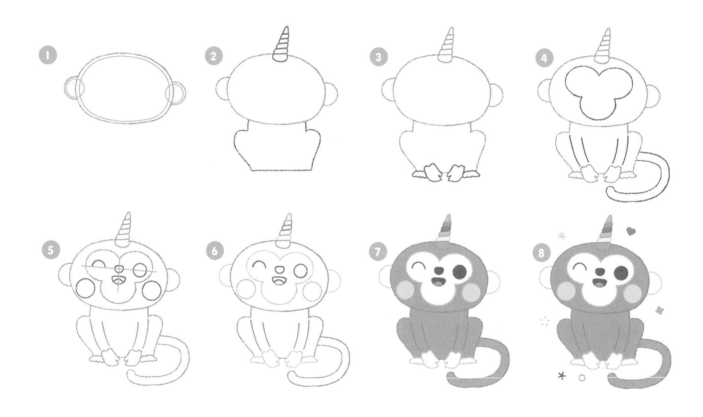

Monkey King

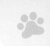

Come on, don't pull faces!

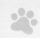

Tiger

Lion

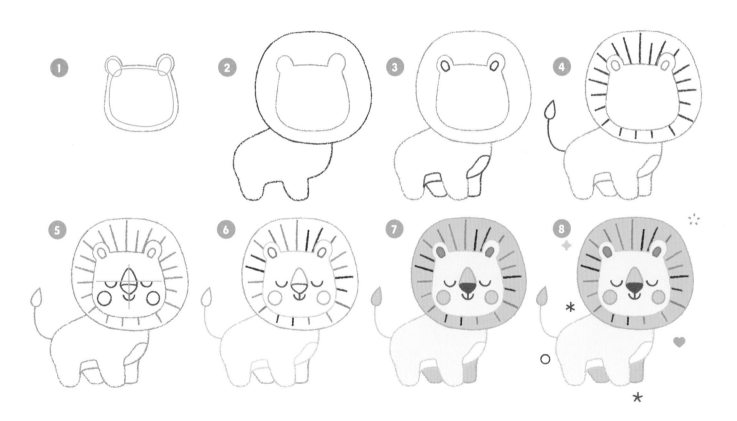

259

Rhino

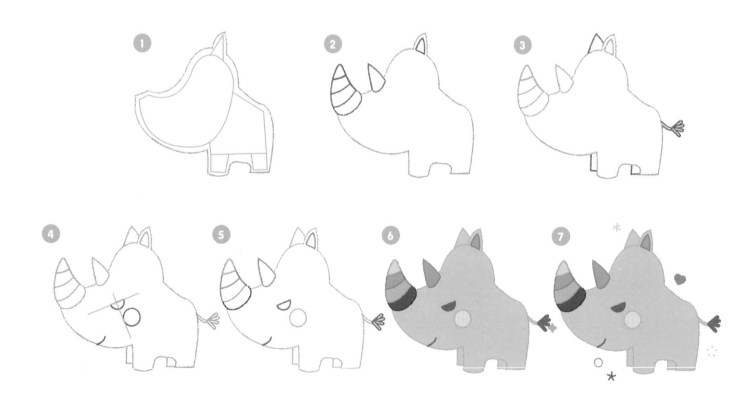

Zebra

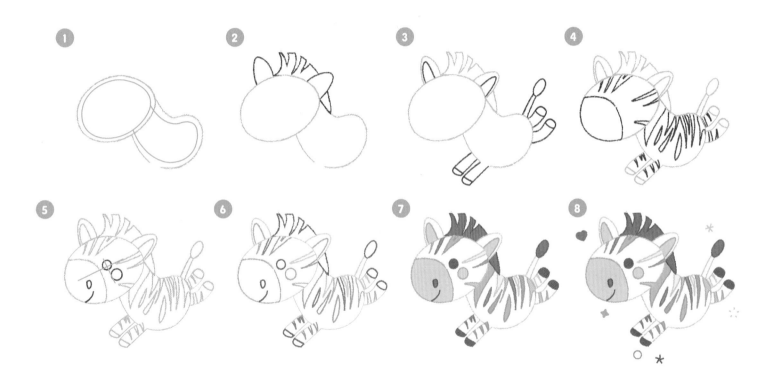

Elephant King

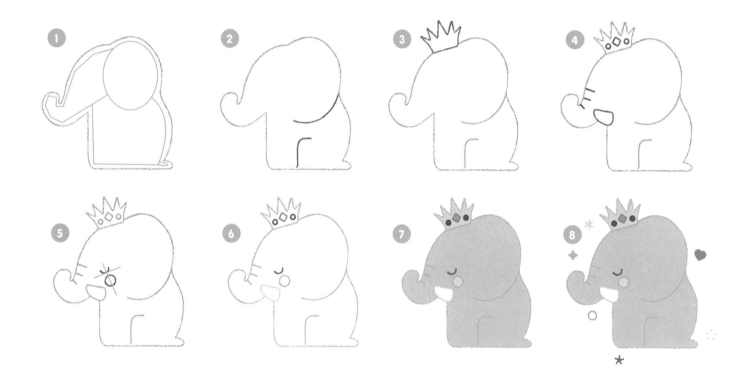

Uni-Phant

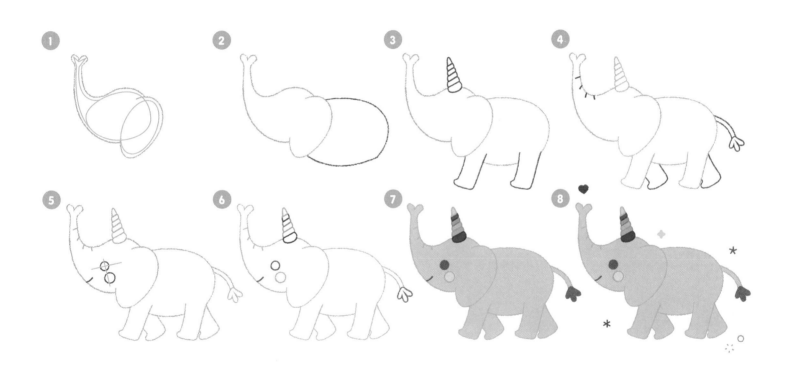

Uni-Bat

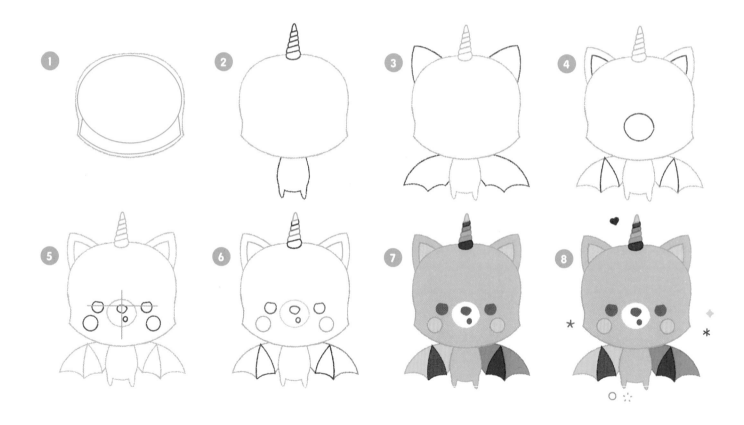

Giraffe

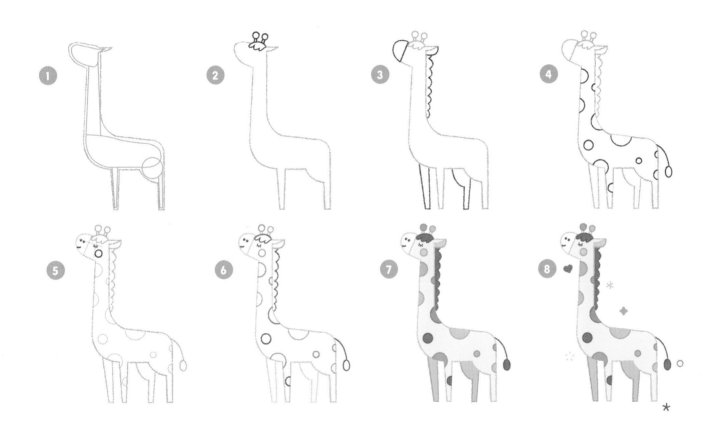

Uni-Seal

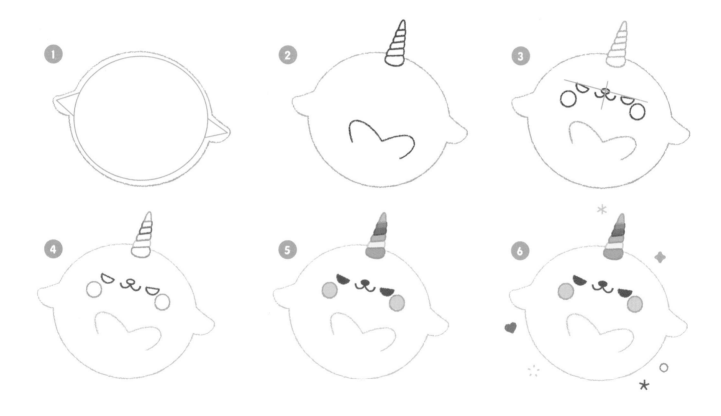

Uni-Sea Lion

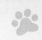

Uni-Platypus

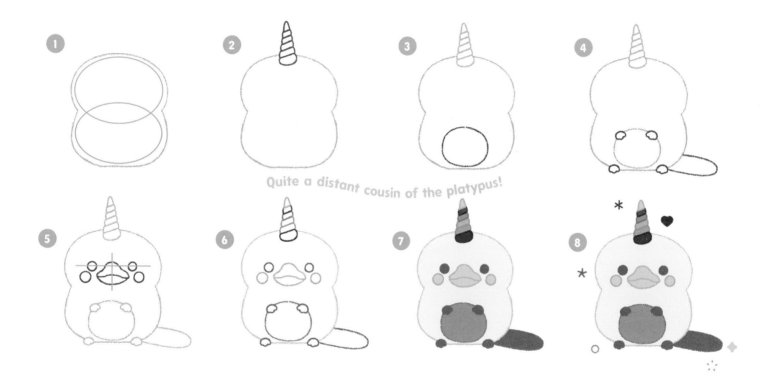

Quite a distant cousin of the platypus!

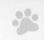

Uni-Otter

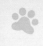

Uni-Penguin

Little Uni-Penguin

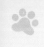

Swan Queen

Duck

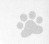

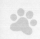

Uni-Flamingo

Pink Dolphin

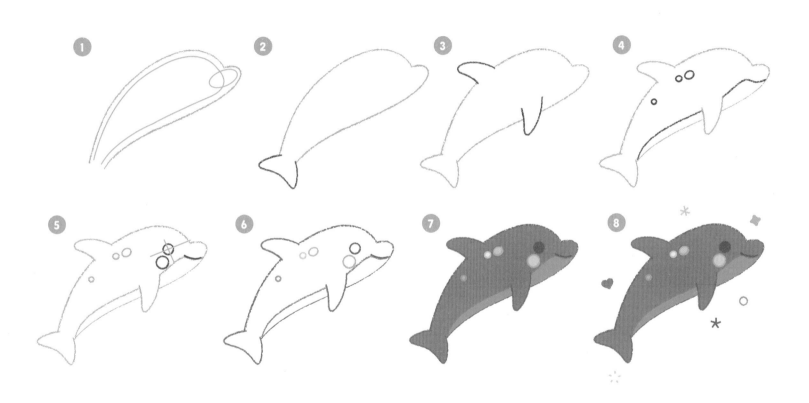

275

Uni-Narwhal

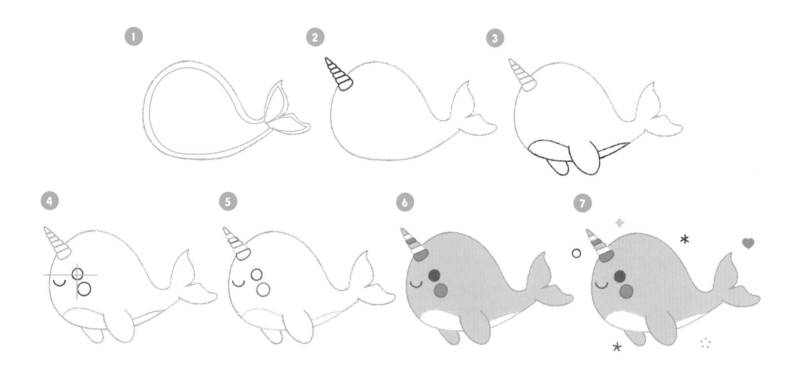

Uni-Shark

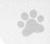

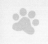

Uni-Jellyfish

Uni-Whale

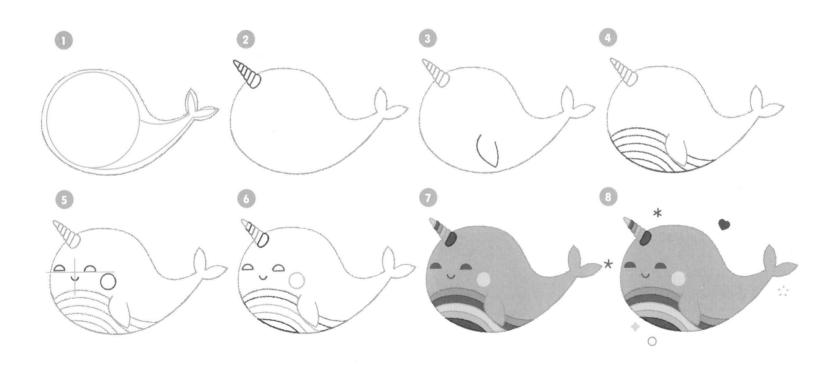

Axolotl

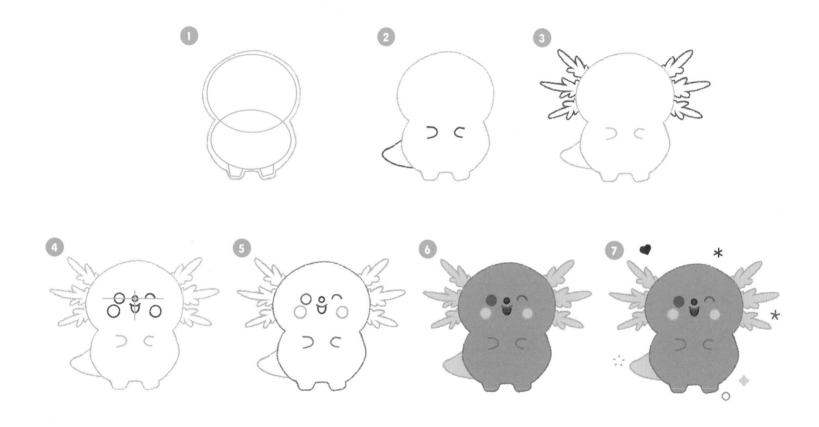

Moon Fish

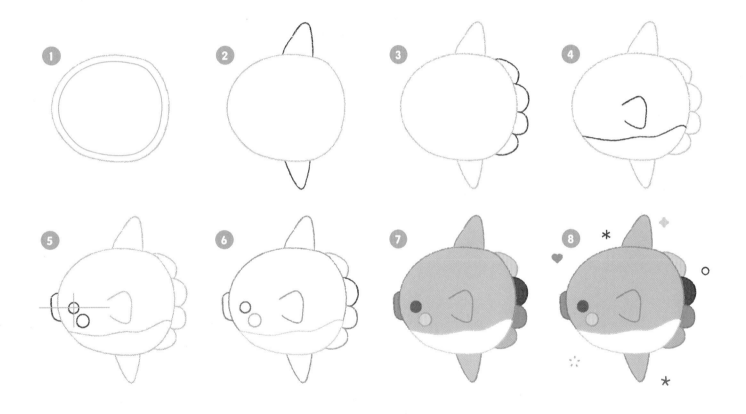

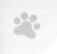

Uni-Octopus

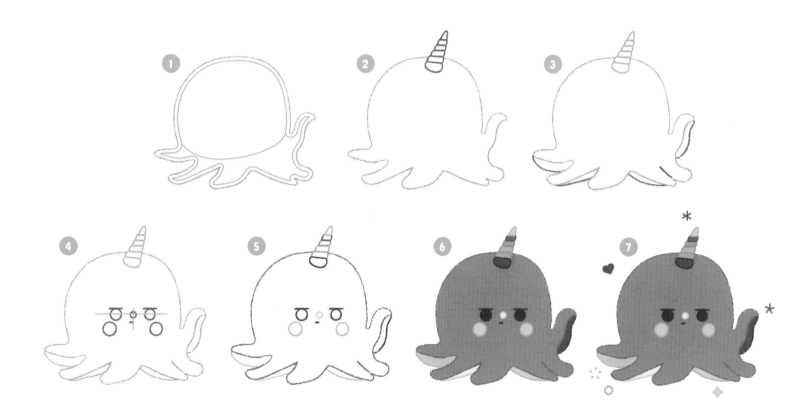

Royal Octopus

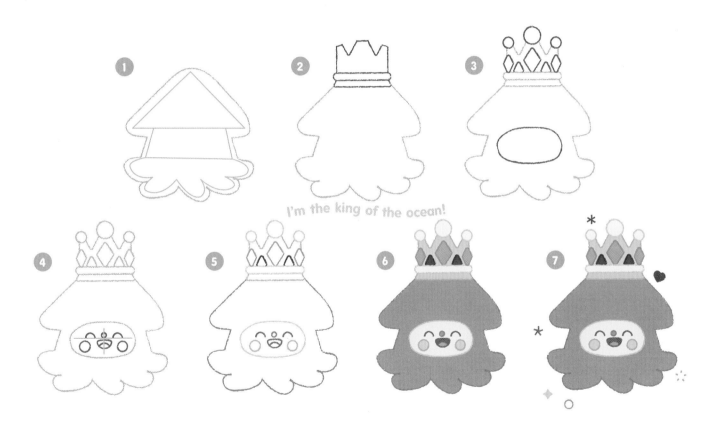

I'm the king of the ocean!

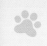

Rainbow Fish

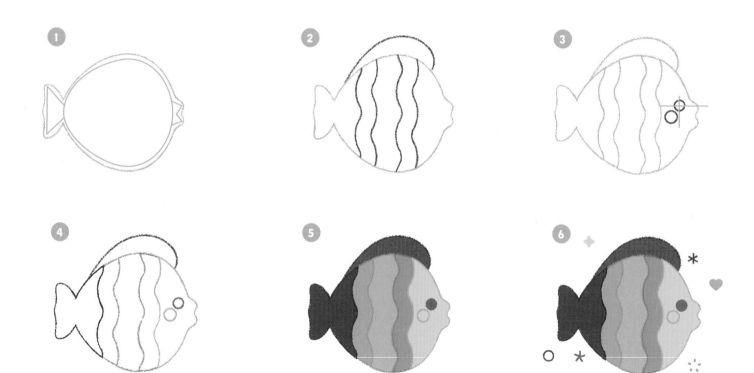

Rainbow Shrimp

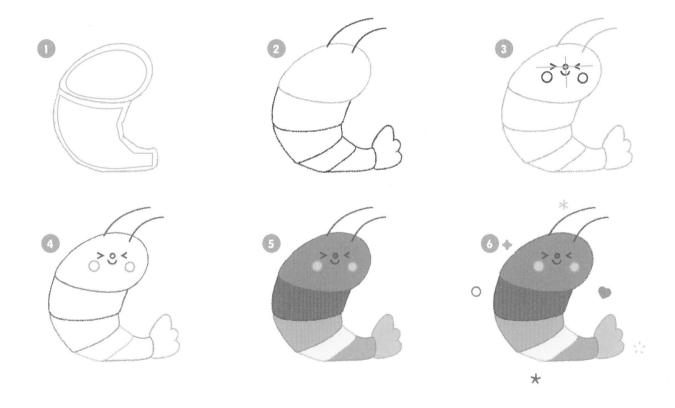

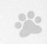

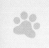

Uni-Fish

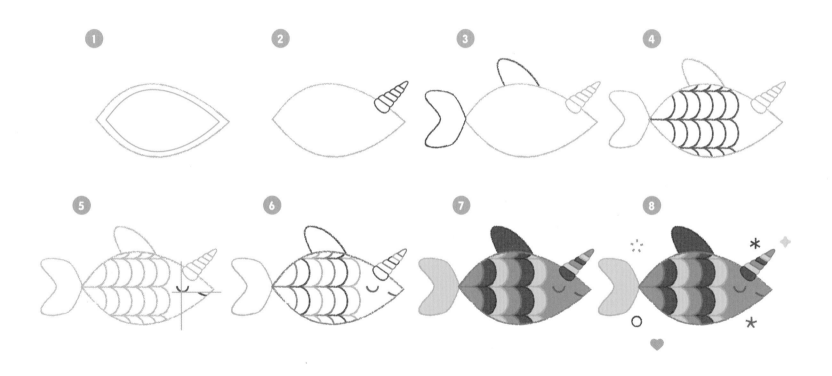

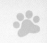

Uni-Seahorse

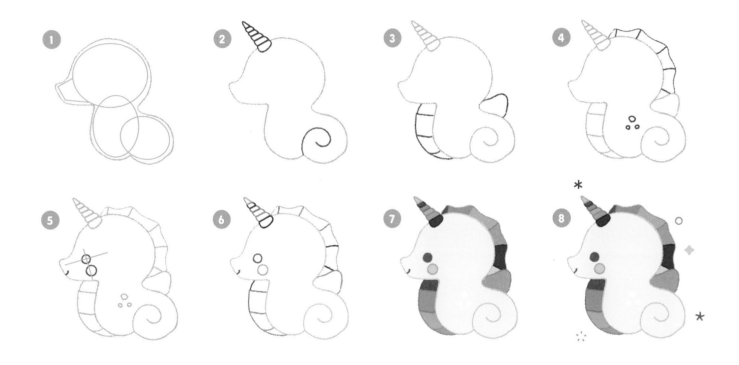

Uni-Turtle

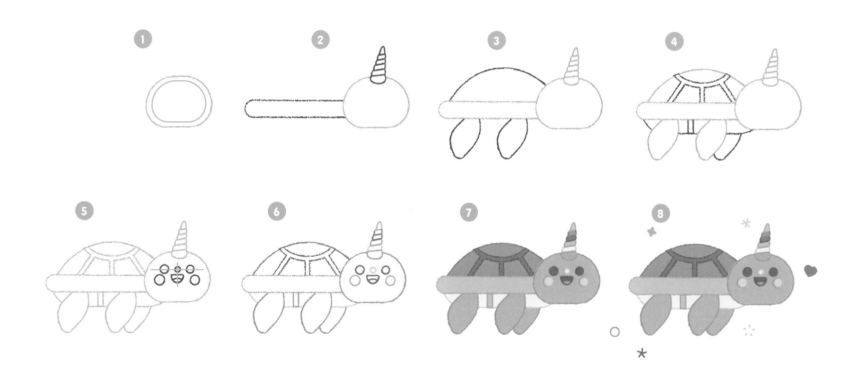

Crocodile

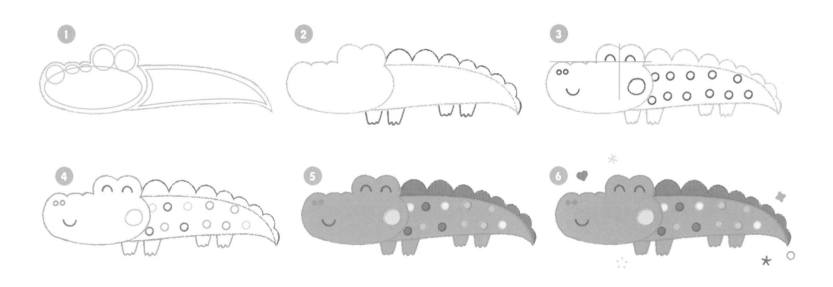

Salamander

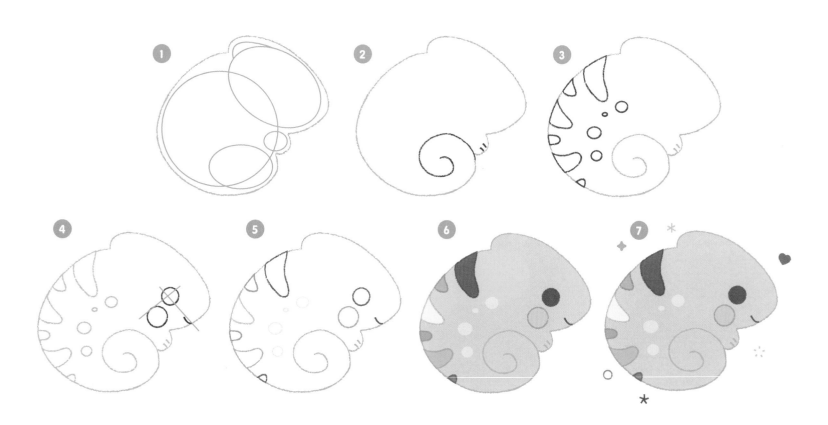

Frog Prince

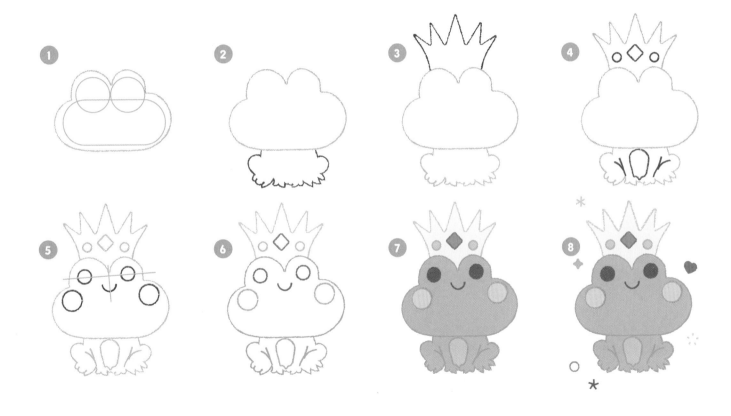

Snake King

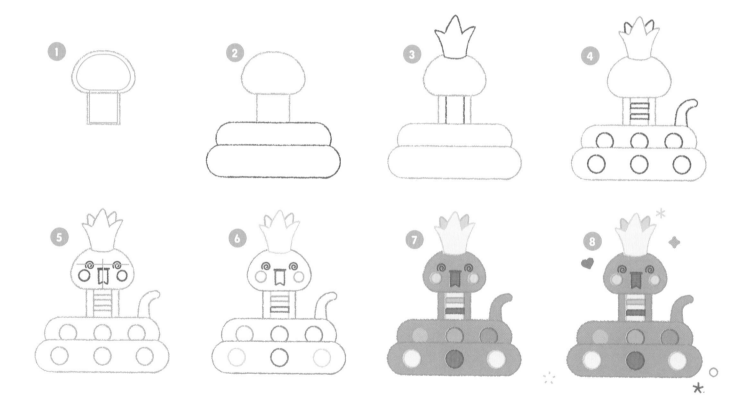

Uni-Dinosaur

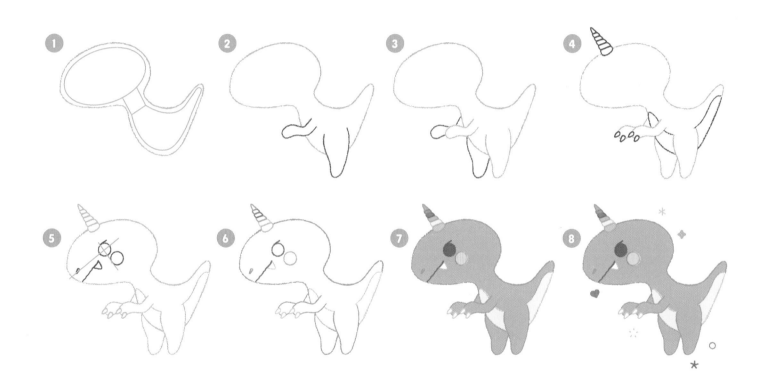

Crab

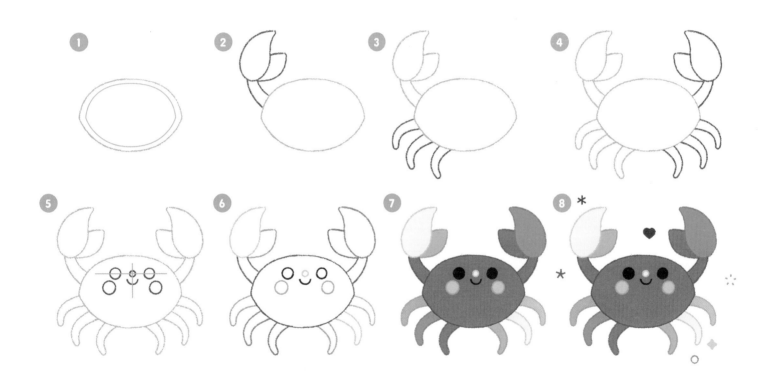

Snail

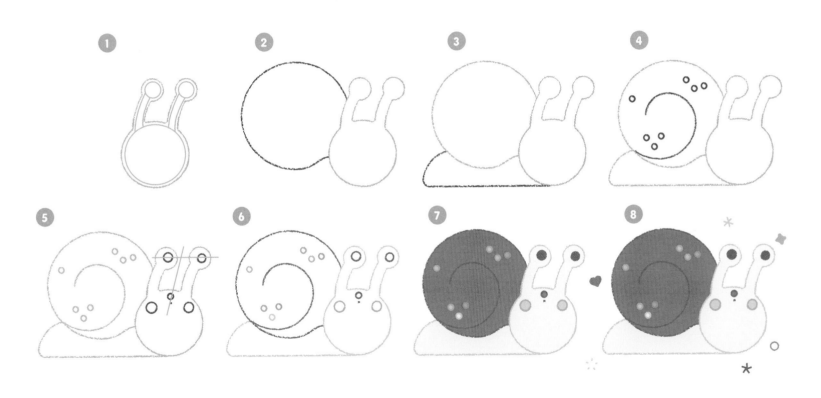

Uni-Worm

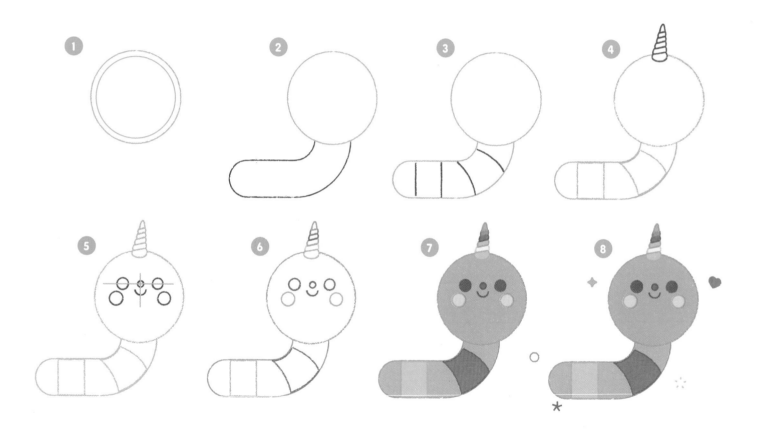

Ladybird

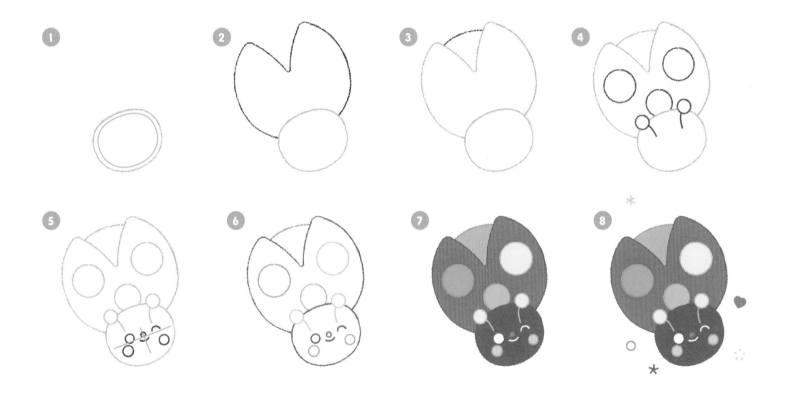

Butterfly

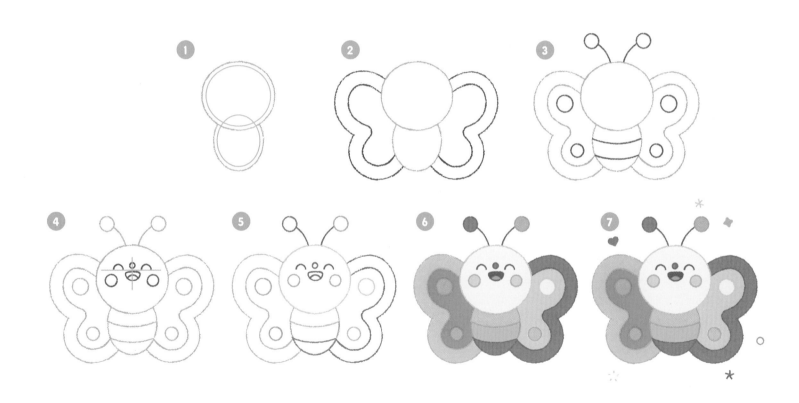

Bee

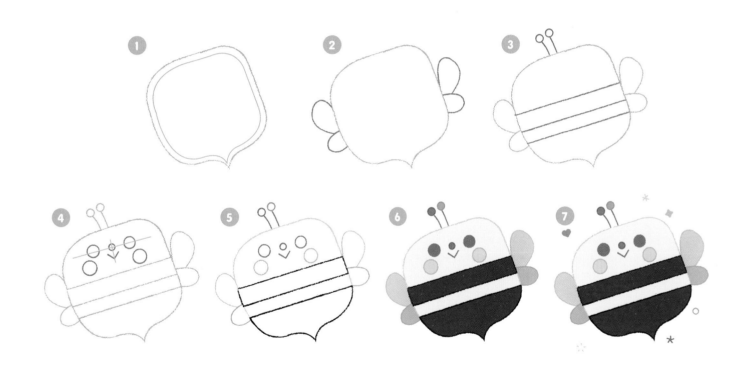

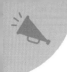

A is for Alligator

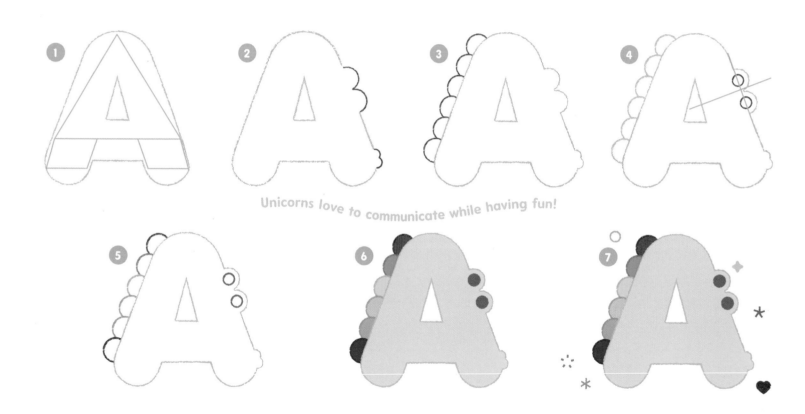

Unicorns love to communicate while having fun!

300

B is for Baboon

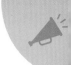

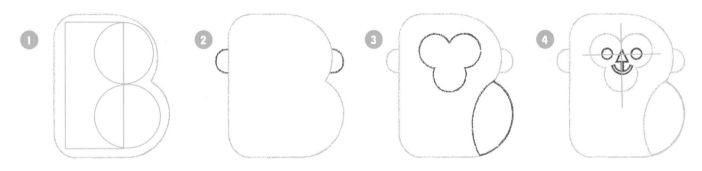

They transform all the letters of the alphabet!

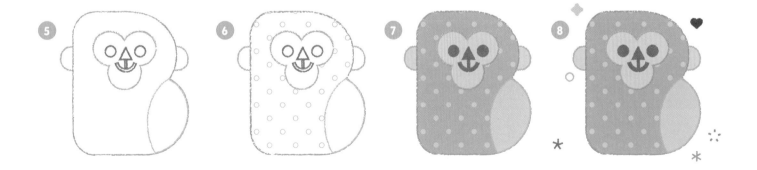

C is for Cat

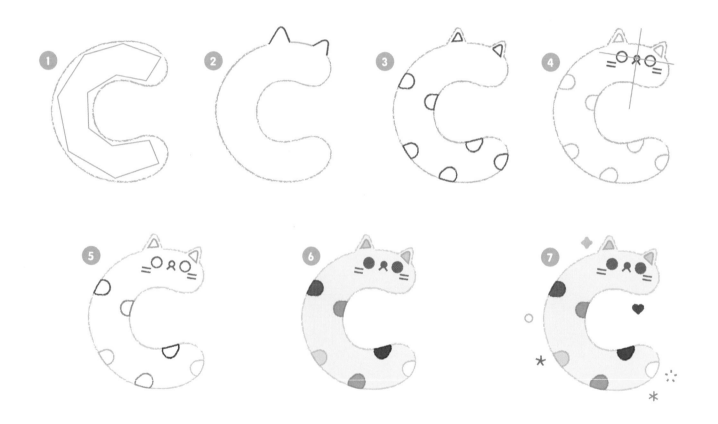

D is for Deer

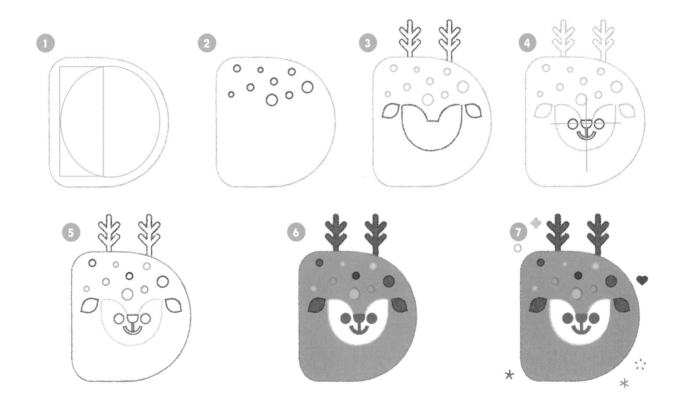

E is for Elephant

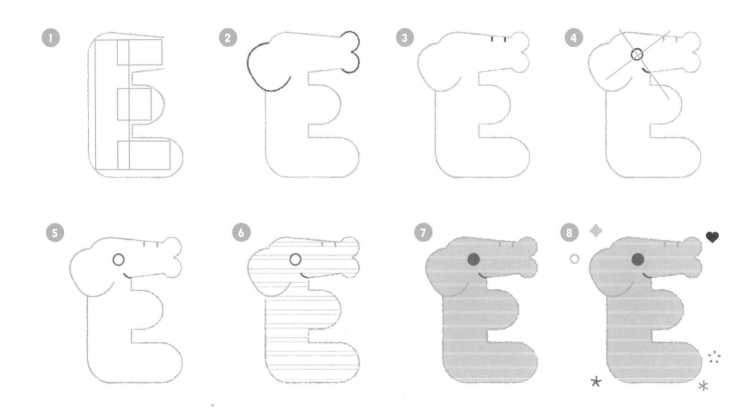

F is for Flamingo

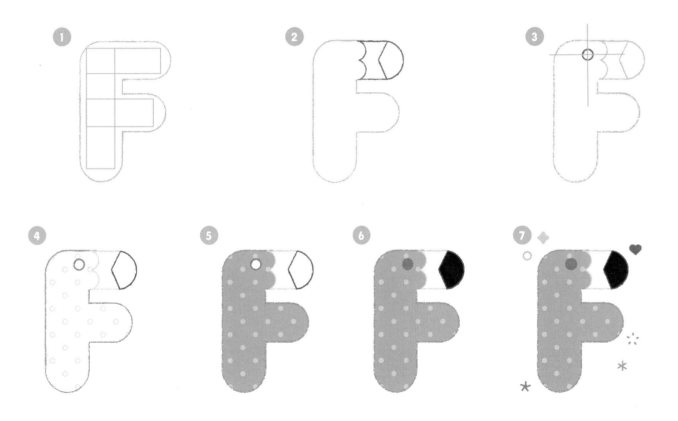

G is for Giraffe

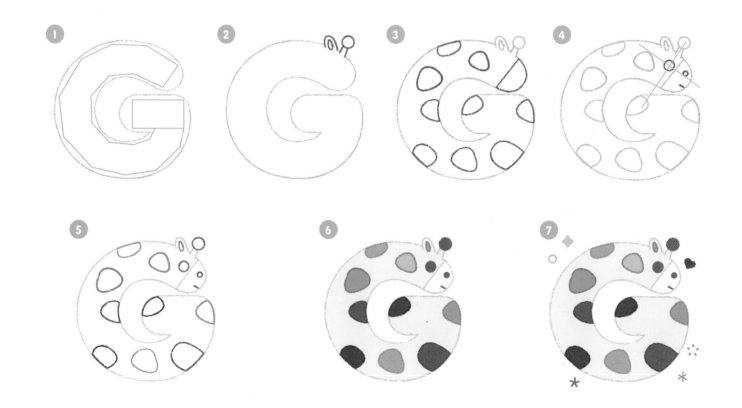

H is for Hippo

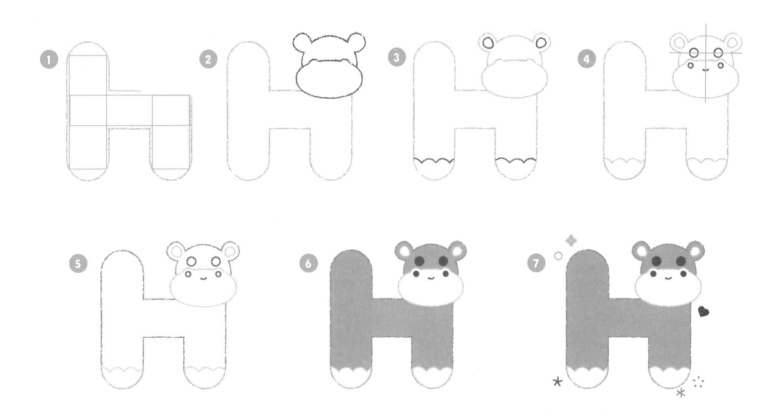

I is for Iguana

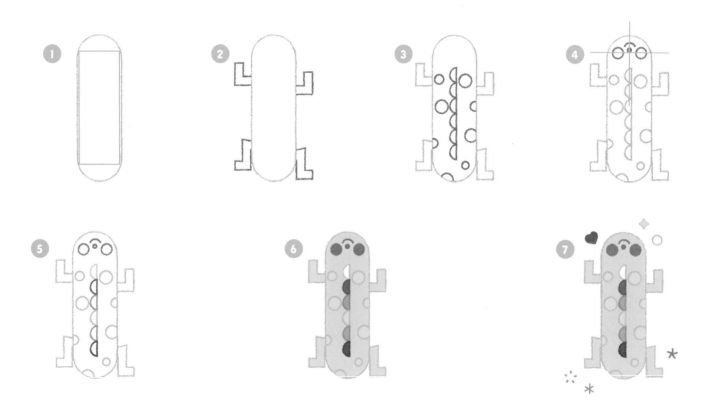

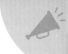

J is for Jellyfish

K is for Koala

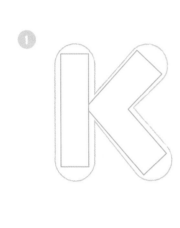

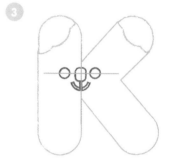

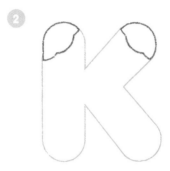

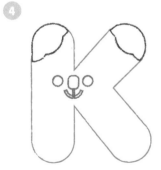

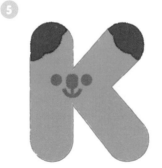

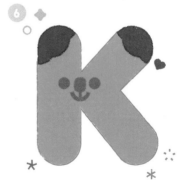

L is for Lion

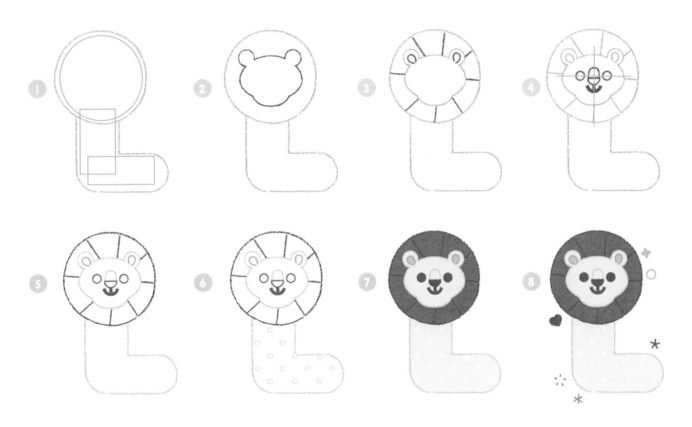

M is for Mouse

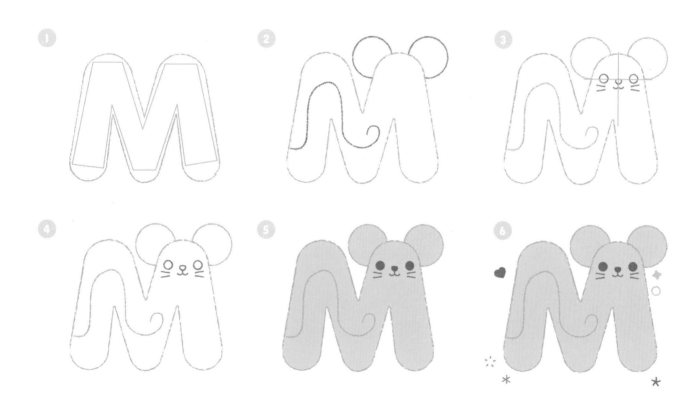

N is for Narwhal

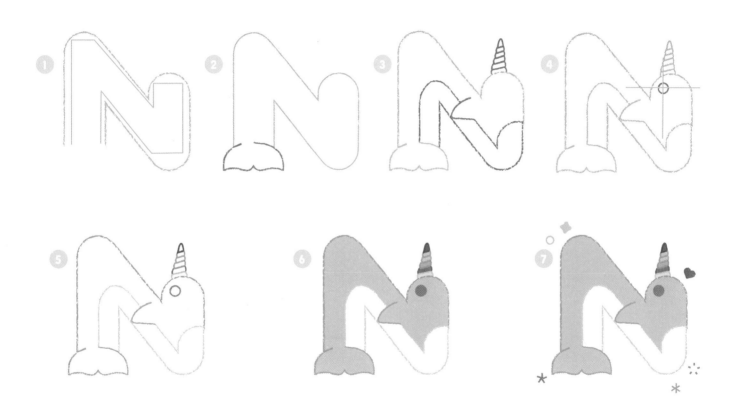

O is for Owl

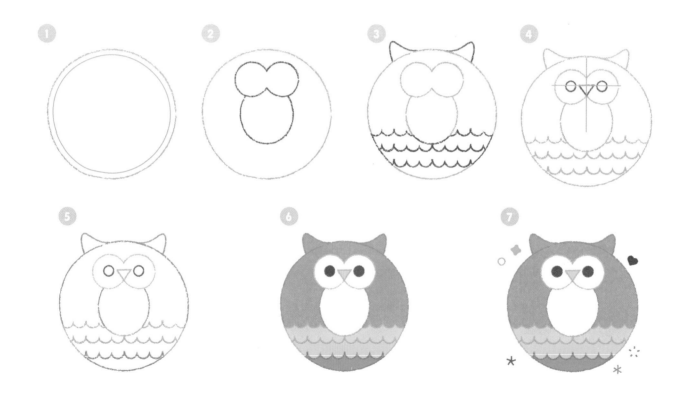

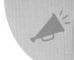

P is for Panda

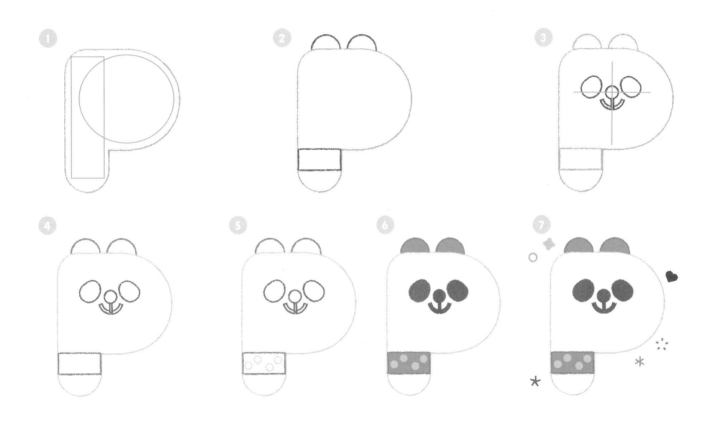

Q is for Quokka

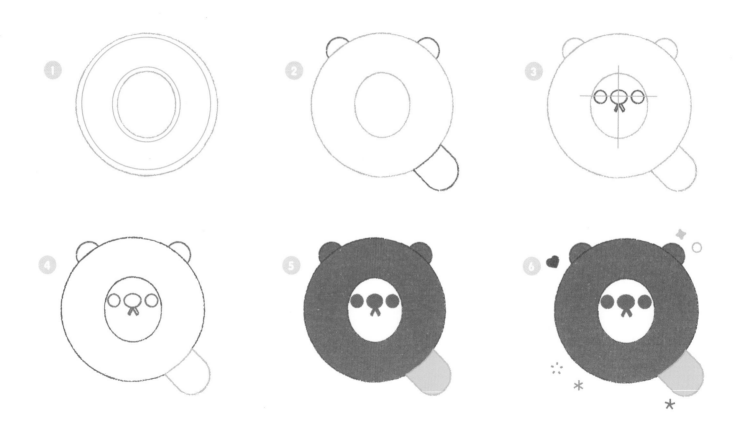

R is for Rhino

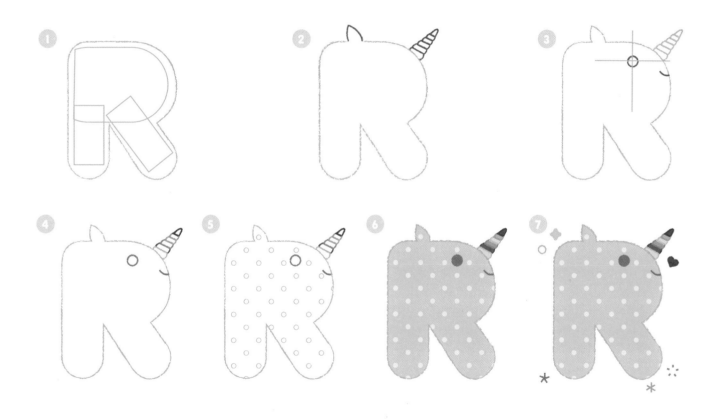

S is for Snake

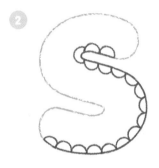

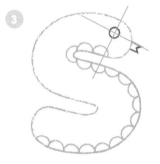

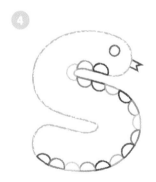

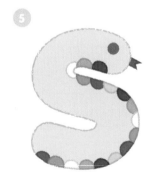

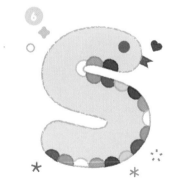

318

T is for Tiger

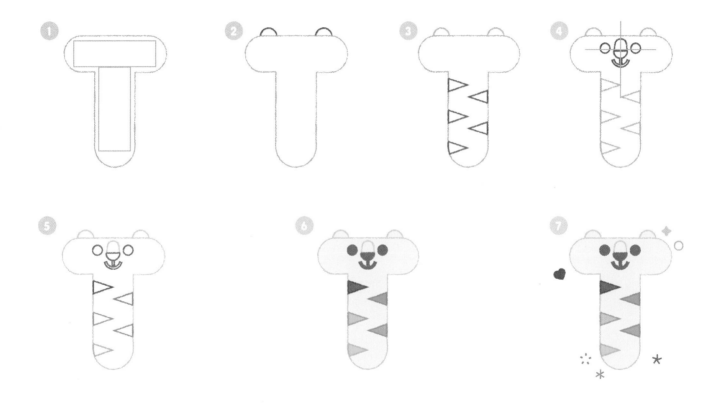

U is for Umbrella Bird

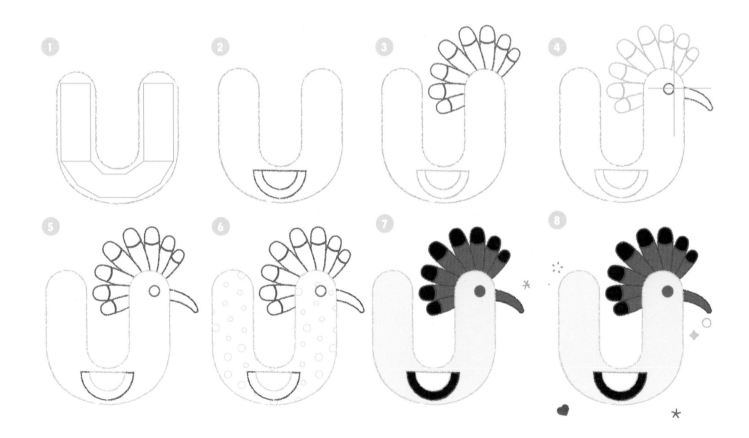

V is for Vulture

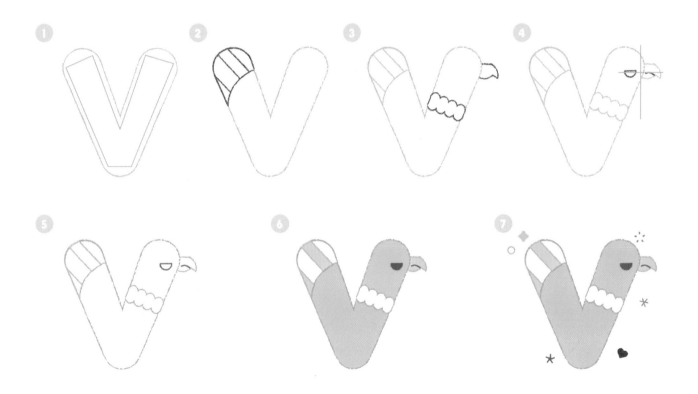

W is for Wombat

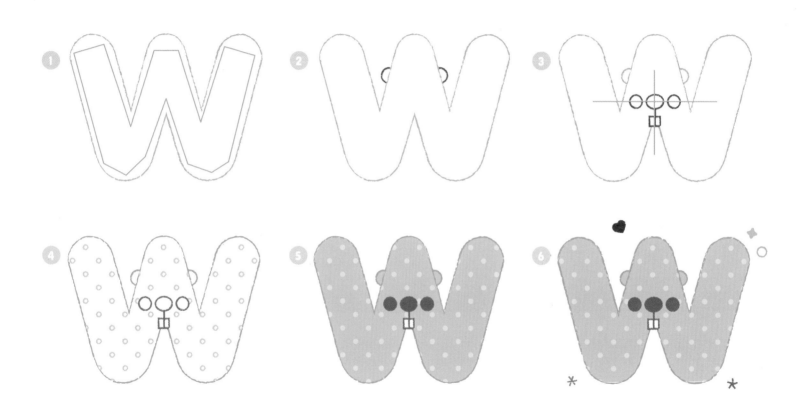

X is for X-ray Fish

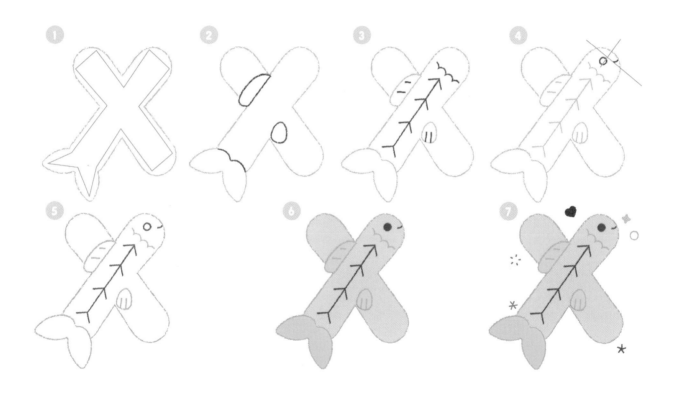

Y is for Yak

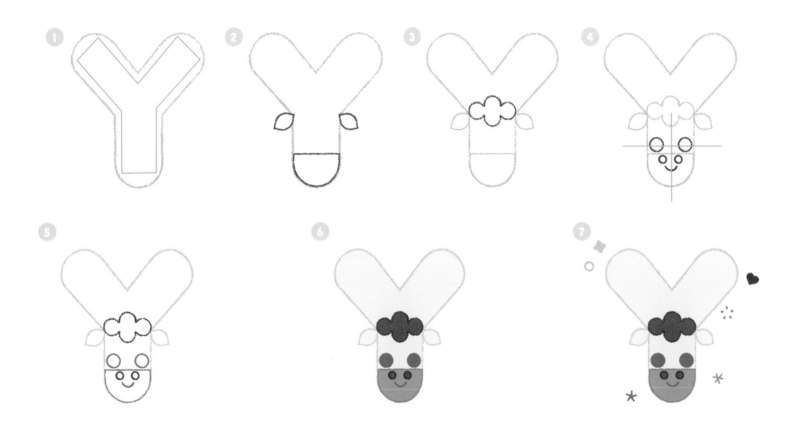

Z is for Zebra

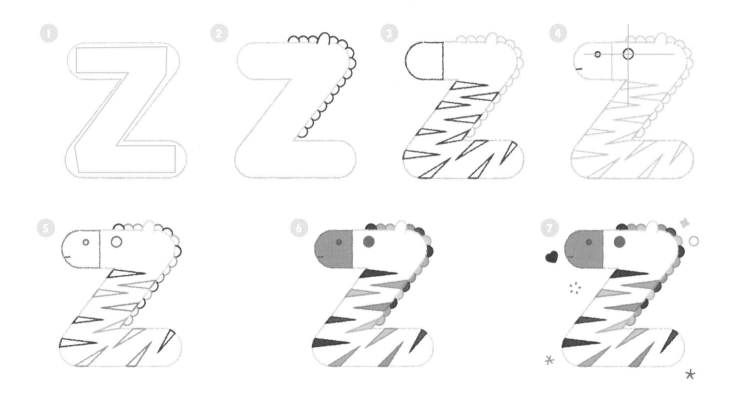

Exclamation Mark

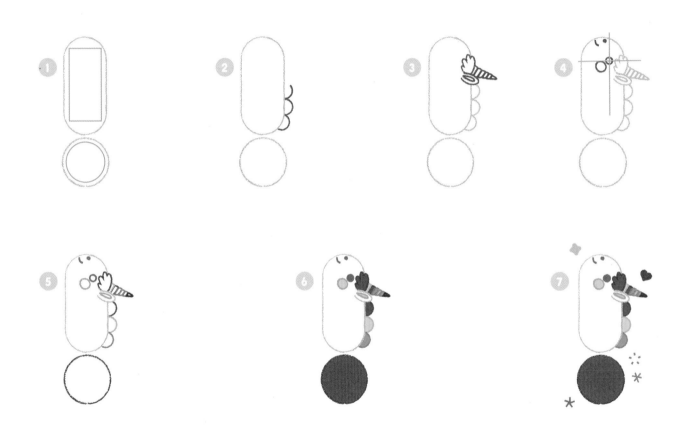

Question Mark

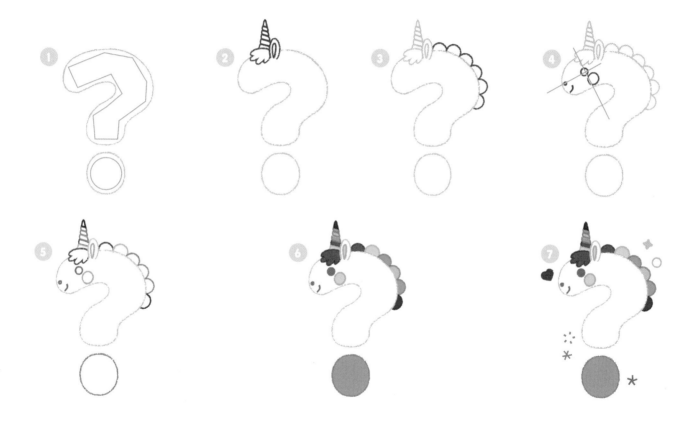

At Symbol

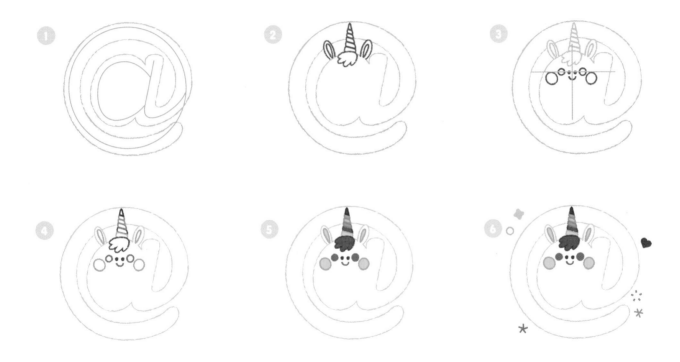

328

Hashtag

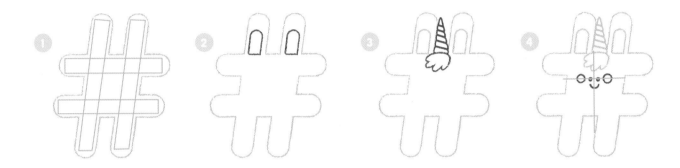

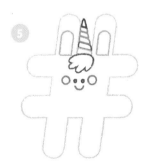

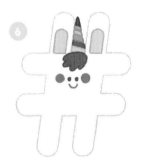

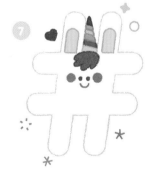

Zero

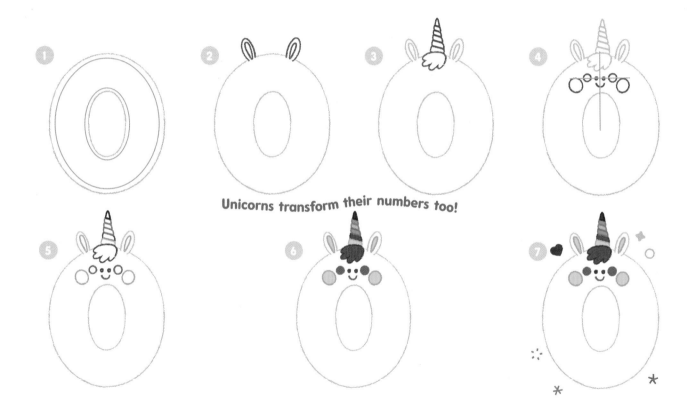

Unicorns transform their numbers too!

One

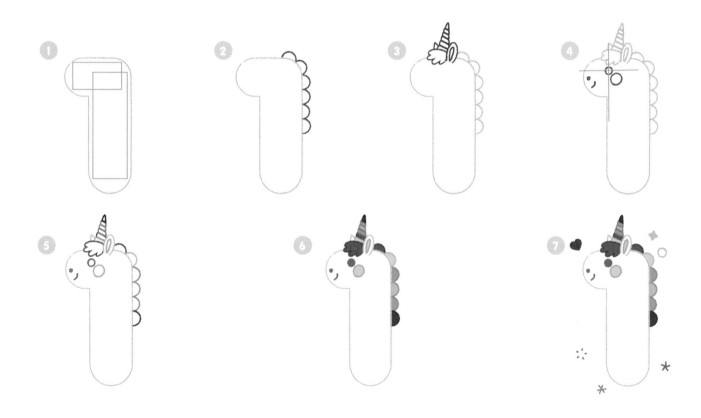

Two

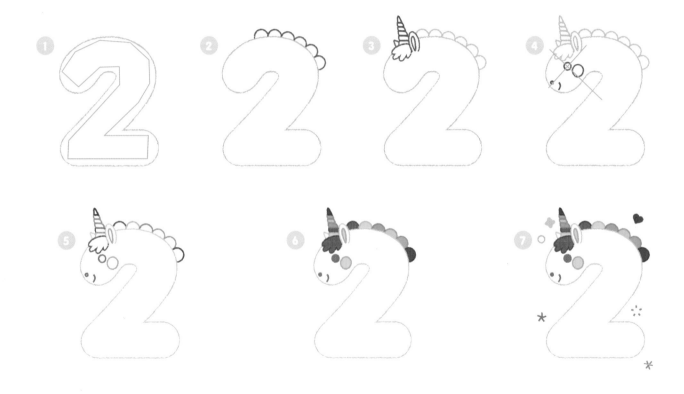

Three

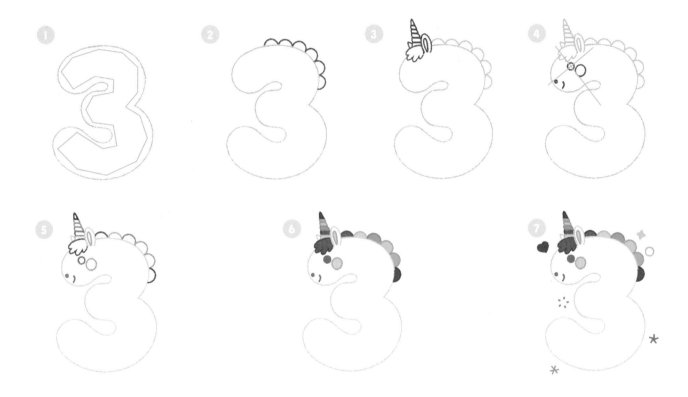

Four

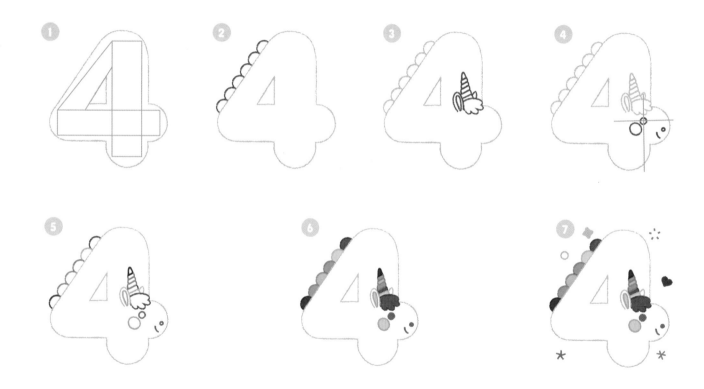

Five

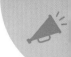

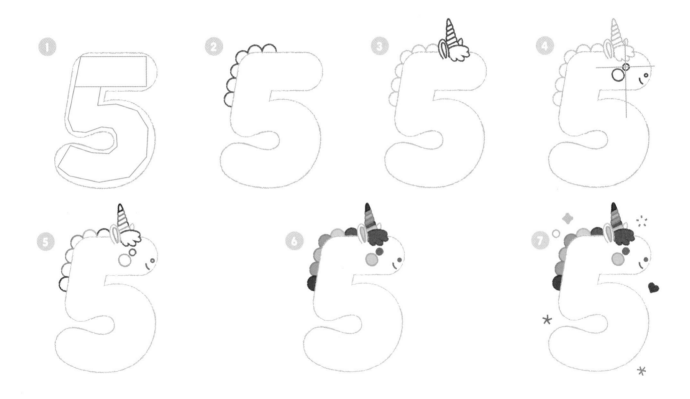

Six

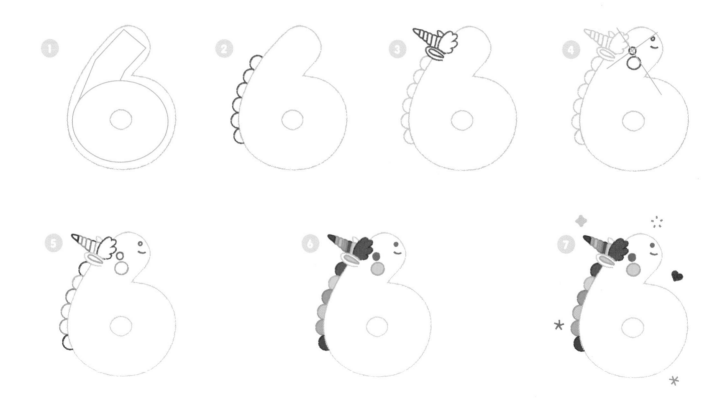

Seven

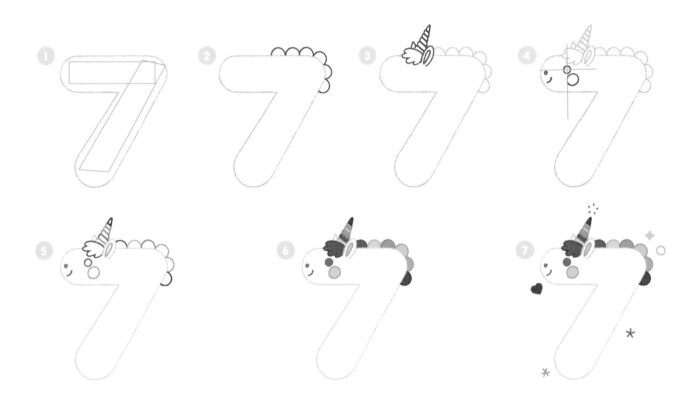

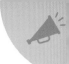

Eight

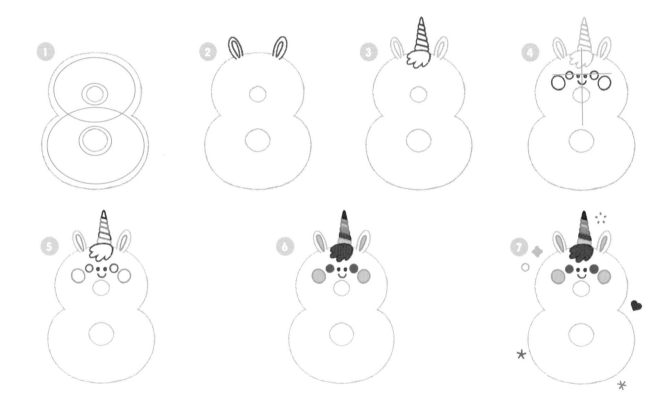

338

Nine

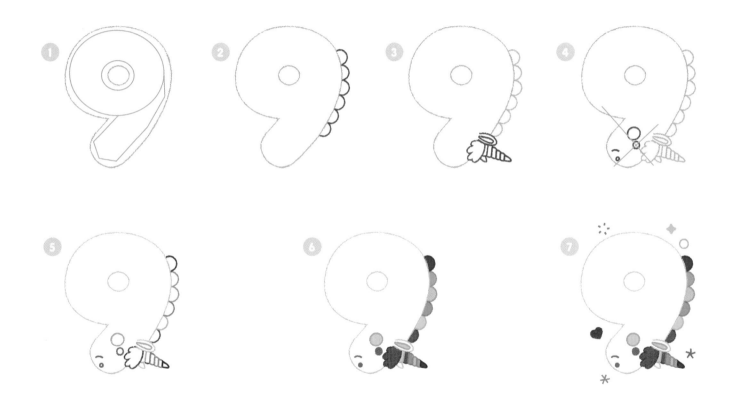

339

Year of the Dog

Find your animal mascot according to Chinese astrology!

 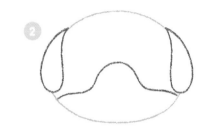 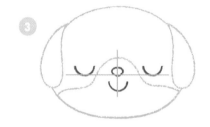

You are a dog if you were born in 1970, 1982, 1994 or 2006.

A loyal and endearing friend, the dog knows how to avoid many traps!

Year of the Pig

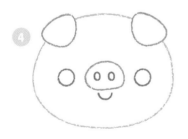

You are pig if you were born in 1971, 1983, 1995 or 2007.

Calm and honest, the pig is a precious friend!

Year of the Rat

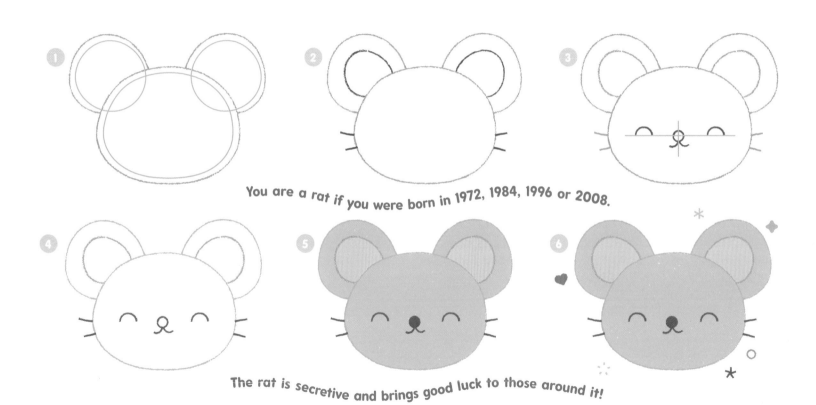

You are a rat if you were born in 1972, 1984, 1996 or 2008.

The rat is secretive and brings good luck to those around it!

Year of the Cow

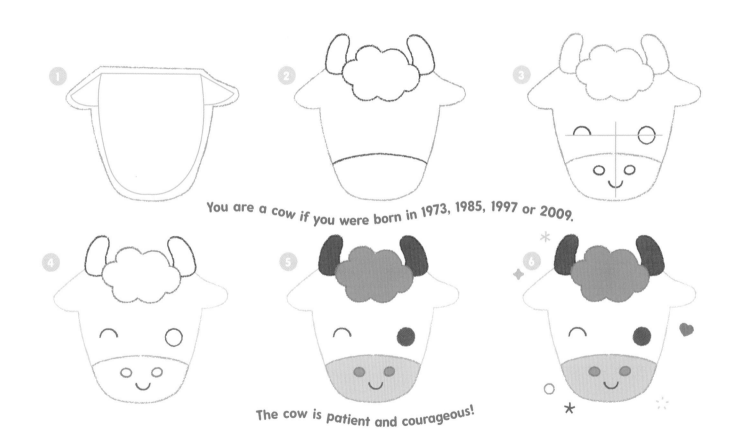

You are a cow if you were born in 1973, 1985, 1997 or 2009.

The cow is patient and courageous!

343

Year of the Tiger

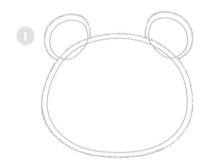

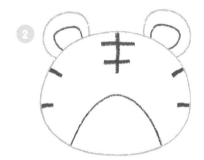

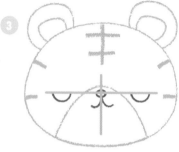

You are a tiger if you were born in 1974, 1986, 1998 or 2010.

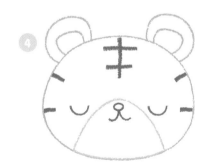

The tiger is a real go-getter!

Year of the Rabbit

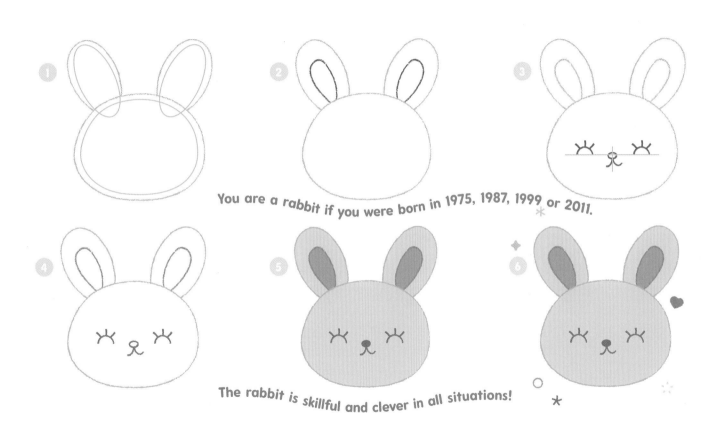

You are a rabbit if you were born in 1975, 1987, 1999 or 2011.

The rabbit is skillful and clever in all situations!

Year of the Dragon

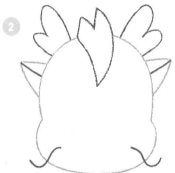

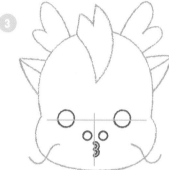

You are a dragon if you were born in 1976, 1988, 2000 or 2012.

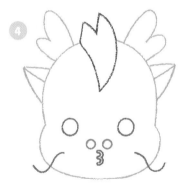

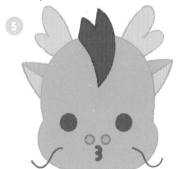

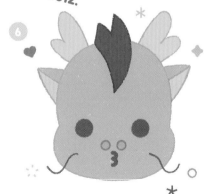

Irresistible, the dragon is a star!

346

Year of the Snake

You are a snake if you were born in 1977, 1989, 2001 or 2013.

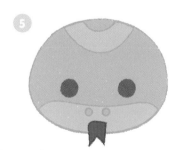

The snake is a symbol of wisdom!

Year of the Horse

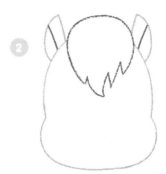

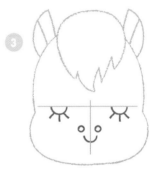

You are a horse if you were born in 1978, 1990, 2002 or 2014.

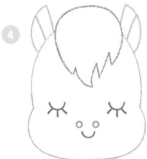

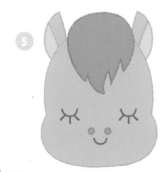

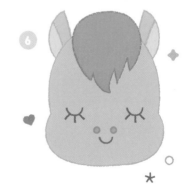

The horse likes to explore new horizons!

348

Year of the Goat

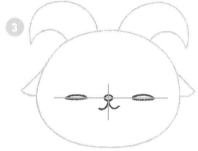

You are a goat if you were born in 1979, 1991, 2003 or 2015.

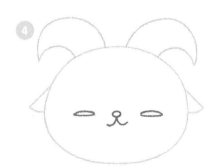

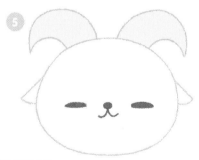

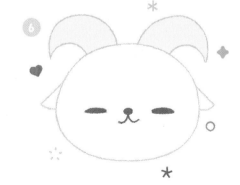

Very creative, the goat is a real artist!

Year of the Monkey

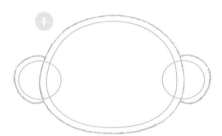

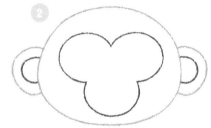

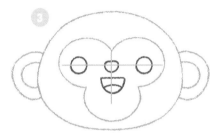

You are a monkey if you were born in 1980, 1992, 2004 or 2016.

Spreading the joy of life, the monkey is never short of ideas!

350

Year of the Rooster

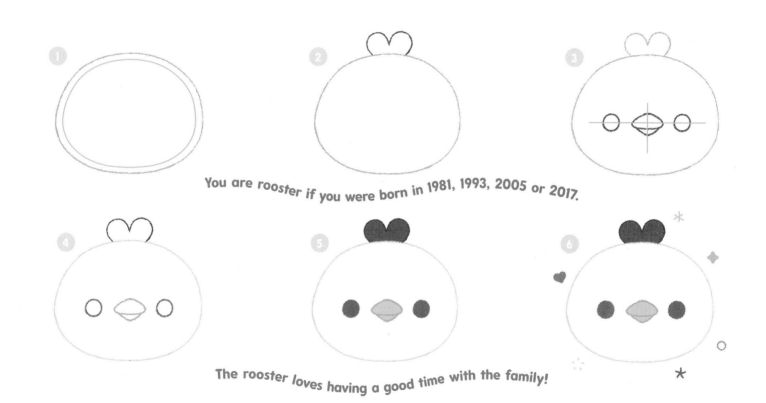

You are rooster if you were born in 1981, 1993, 2005 or 2017.

The rooster loves having a good time with the family!

Unicorn Emoticons

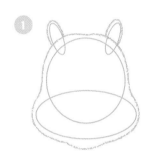
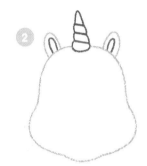
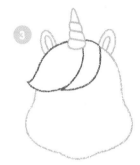
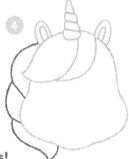

Unicorns even invented their own emoticons to express their emotions!

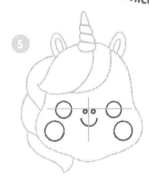
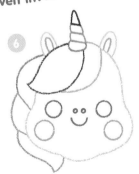
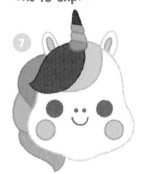

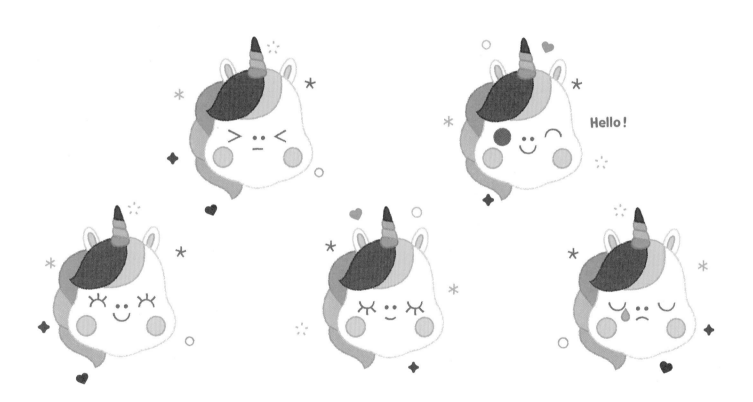

Hello!

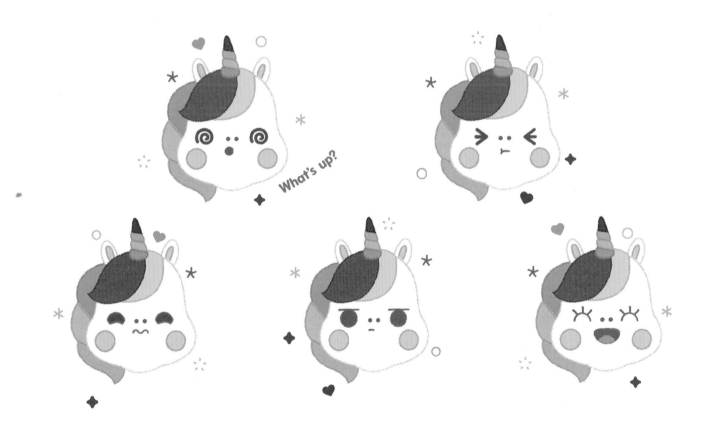

What's up?

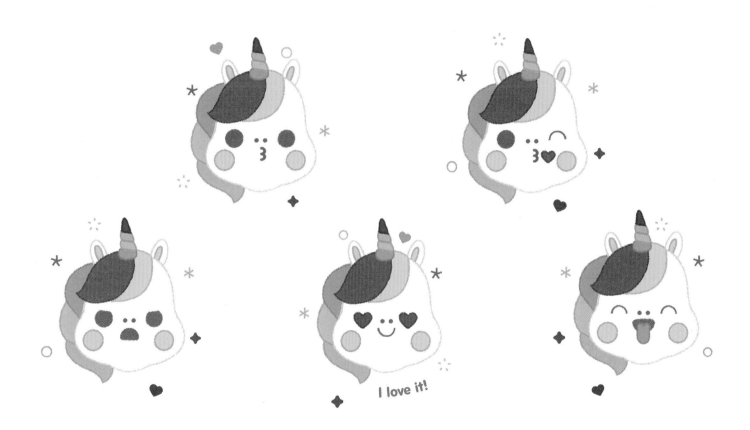

I love it!

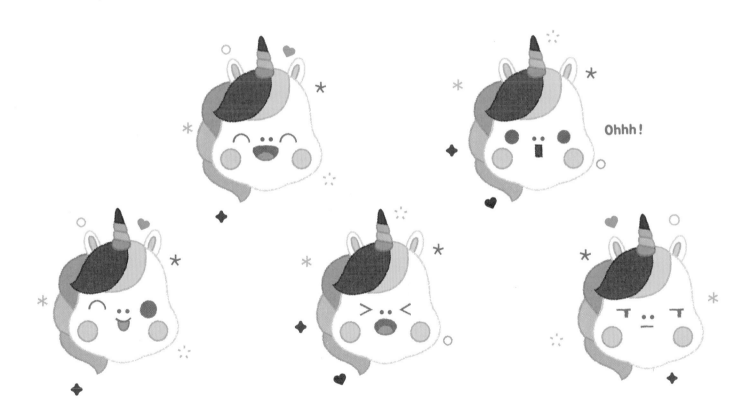

Ohhh!

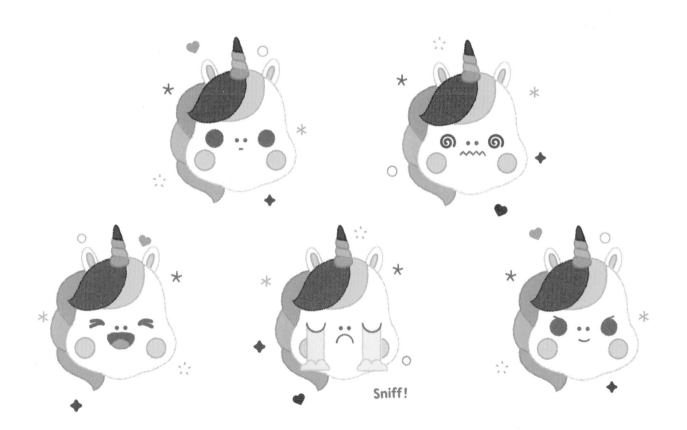

Sniff!

Say it...

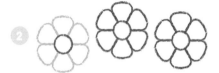
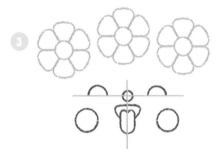

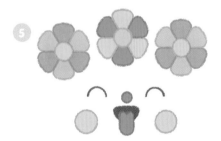
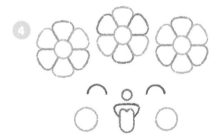
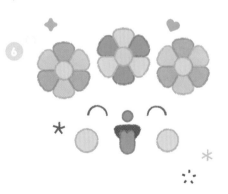

...with Flowers!

359

Little Heart...

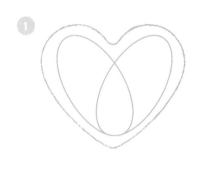

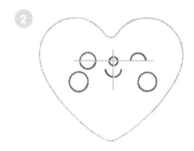

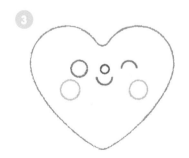

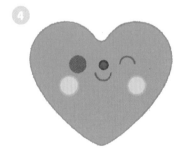

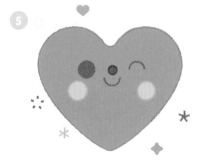

...with a Bow!

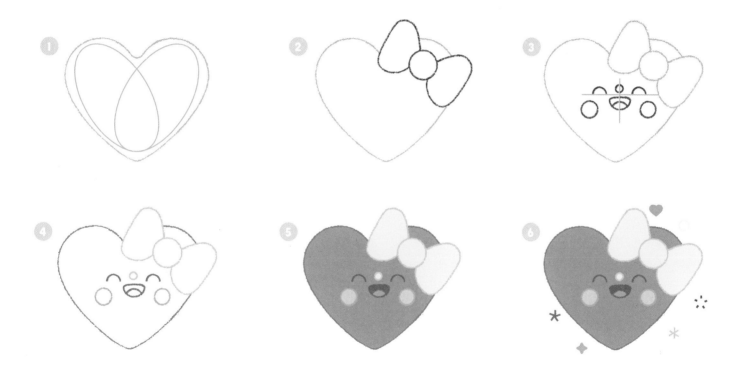

Heart Banner

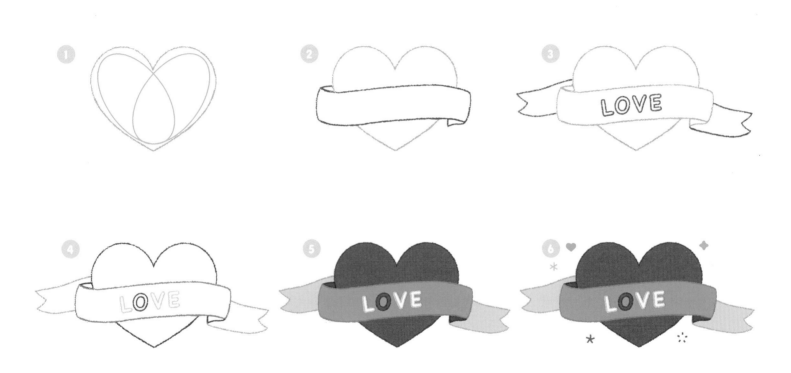

Flower Rosette

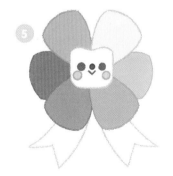

Double Bow

Striped Bow

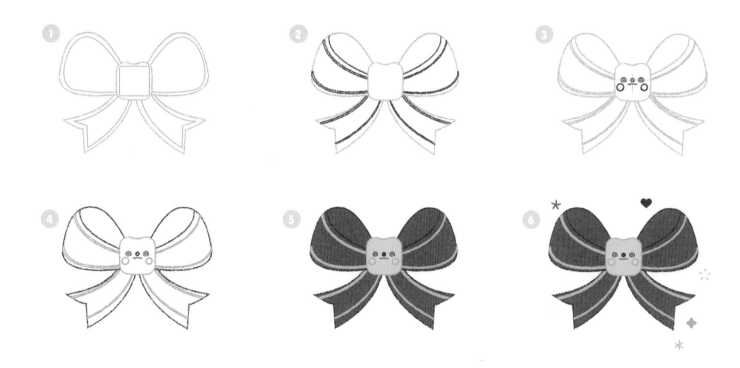

Bunting

366

Banner

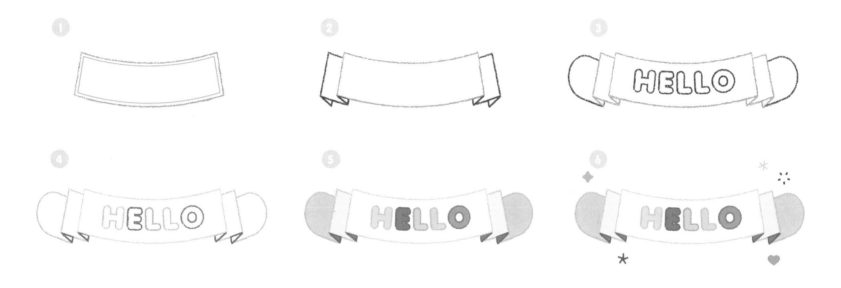

Goodbye!

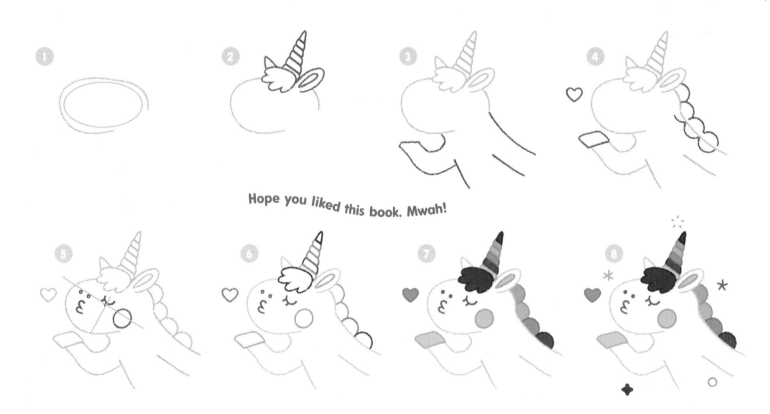

Hope you liked this book. Mwah!